691-3824

NIAGARA

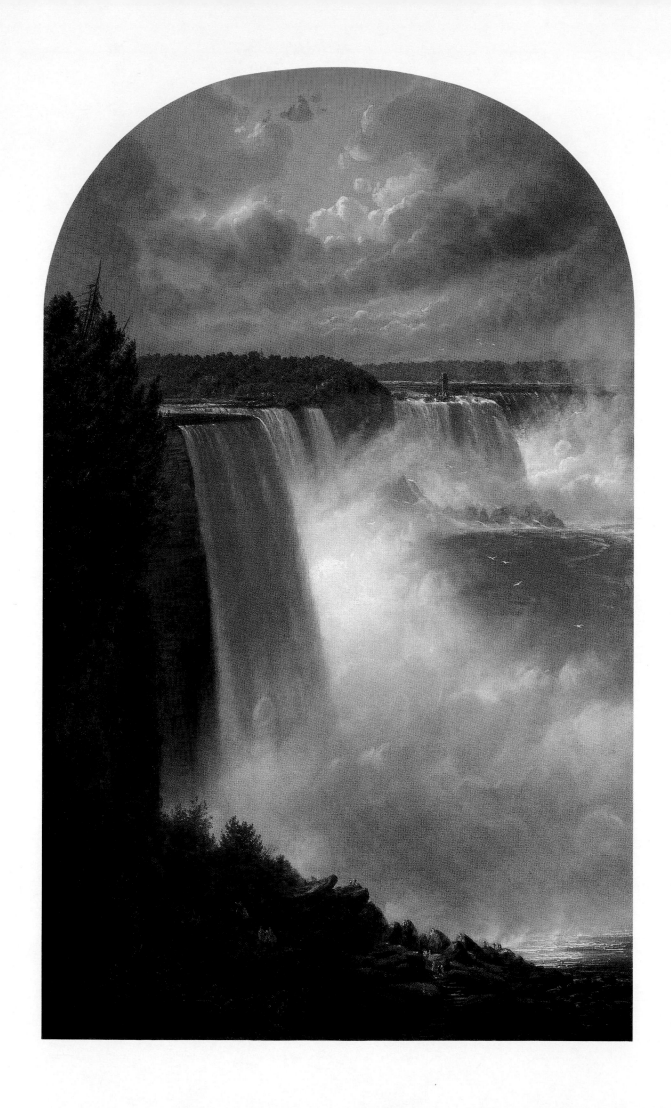

NIAGARA

Two Centuries of Changing Attitudes, 1697–1901

JEREMY ELWELL ADAMSON

with essays by
ELIZABETH McKINSEY
ALFRED RUNTE
JOHN F. SEARS

THE CORCORAN GALLERY OF ART
WASHINGTON, D.C.
1985

Niagara was organized by The Corcoran Gallery of Art and supported by a grant from the National Endowment for the Humanities.

ALBRIGHT-KNOX ART GALLERY
BUFFALO, NEW YORK
JULY 13–SEPTEMBER 1, 1985

THE CORCORAN GALLERY OF ART
WASHINGTON, D.C.
SEPTEMBER 21–NOVEMBER 24, 1985

THE NEW-YORK HISTORICAL SOCIETY
NEW YORK, NEW YORK
JANUARY 22–APRIL 27, 1986

Cover: Frederic Church, detail from *Niagara*, 1857, (fig. 1, cat. no. 49). The Corcoran Gallery of Art, Washington, D.C.

Frontispiece: Ferdinand Richardt, *Niagara Falls*, ca. 1860 (cat. no. 144). Private Collection.

NIAGARA
Copyright © 1985 The Corcoran Gallery of Art, Washington, D.C.
All rights reserved.

Library of Congress Cataloging in Publication Data
Adamson, Jeremy, 1943–
 Niagara.
 Includes index.
 1. Niagara Falls (N.Y. and Ont.) in art—Exhibitions. 2. Art, American—Exhibitions. 3. Art, Modern—19th century—United States—Exhibitions. 4. Niagara Falls (N.Y. and Ont.)—History—Exhibitions. 5. Niagara Falls (N.Y. and Ont.)—Popular culture—Exhibitions. I. McKinsey, Elizabeth R., 1947– II. Sears, John, 1941– III. Runte, Alfred, 1947– IV. Title.

N8214.5. U6A3 1985 760′04436′09730740147 85-11375
ISBN 0-88675-017-2

Edited by Migs Grove, Washington, D.C.
Designed by Staples & Charles, Washington, D.C.
Typeset by Composition Systems Inc., Falls Church, Virginia
Printed by Garamond-Pridemark Press, Inc., Baltimore, Maryland

Contents

Michael Botwinick
Director
The Corcoran Gallery of Art

Foreword

Among the masterpieces of American painting in the Corcoran's permanent collection, Frederic Church's *Niagara* is perhaps the institution's most celebrated work and thus a logical stimulus for this exhibition. Painted in 1857 when Church was thirty-one years old, *Niagara* represents one of the great achievements of the artist's career. After its successful showing in New York City, the painting was exhibited in London and at various locations in the British Isles and the American South, drawing acclaim as the greatest picture produced on this side of the Atlantic. And, perhaps most importantly, the painting came to embody the promise and fulfillment of America.

Even today, Church's *Niagara* remains one of the sensational visual icons of nineteenth-century America, a symbol of the country's primeval wilderness. Yet this painting was just one of a flood of images of the Falls that began around 1700 and continued in earnest production until the later years of the nineteenth century. As this exhibition shows, the great cataract was a subject for artists, writers, entrepreneurs, photographers, engravers, and tourists themselves during its almost 200-year reign over the imagination of contemporary society. Depicted in sweeping panoramas, paired in contrasting views, and shown in moonlight, during every season, and in its many moods, Niagara Falls was an incredible visual challenge. This exhibition gives us an opportunity to see the outpouring of Niagara imagery that places Church's work and the other objects in the show in the rich context they deserve.

We are, however, in receipt of much more with this show. It allows us to celebrate the centennial of the declaration of Niagara Falls as a state park. And more than just an anniversary, the exhibition tells us a great deal about what we have been and what we have become. Even as it stood as the emblem of America, Niagara Falls also turned into a tourist mecca —a public entertainment—and then became a source for industrial power. Niagara's odyssey from the exalted role of national icon to its democratization and later industrialization has taught us much about natural preservation.

Niagara has been an enormous project. We are grateful to all of the lenders who have shared their objects so generously and to our colleagues both in the United States and Canada for their support. We would like to thank The New-York Historical Society; the Buffalo and Erie County Historical Society and its Curator of Iconography, Clyde Eller; the Library of Congress and its staff members Donna Elliot, Bernard Riley, and George Hobart; and the Niagara Falls, New York, Public Library and Donald Loker there. We also want to extend our appreciation to Joseph Martin, Director, Brydon C. Smith, Assistant Director, and Charles Hill, Curator of Canadian Art, National Gallery of Canada; Mary Allodi and Honor de Pencier of the Royal Ontario Museum in Toronto; Jim Burant,

Chief, Collections Management, Public Archives of Canada; and Ella M. Foshay at The New-York Historical Society for their support and contributions to the project.

Among those whose commitment to *Niagara* has ensured the exhibition's wide availability are the show's participating museums, and we are grateful to Douglas Schultz, Director of the Albright-Knox Art Gallery in Buffalo, and to Dr. James Bell, Director of The New-York Historical Society, for their efforts in making the tour of *Niagara* a success. Our consultants have been of enormous importance, and we extend our gratitude for their work to: Elizabeth McKinsey, Associate Professor of English and American Literature and Language, Harvard University; Alfred Runte, Assistant Professor of History and Adjunct Assistant Professor of Environmental Studies, University of Washington, Seattle; John F. Sears, former Director of the Eleanor Roosevelt Centennial Conference Center at Vassar College; and Carl Bode, Department of English, University of Maryland. We also want to thank individuals who contributed to the project: Gerald L. Carr, Merl M. Moore, Jr., John Davis Hatch, Ingrid Maar, and Anthony Bannon; and Corcoran staff members who have been involved in every aspect of the project, especially Anne Prager, secretary to the Curator of Collections; Barbara Moore, Curator of Education; Robyn Asleson, research assistant; and Elizabeth Beam, Registrar.

Three keys to the success of the *Niagara* project remain. First, we would like to thank Jeremy Elwell Adamson, Associate Curator of Later Canadian Art at the National Gallery of Canada. This exhibition very much reflects the depth of his research and perceptions on the subject. Second, we are very much in the debt of Edward Nygren, Curator of Collections at the Corcoran for overseeing the entire project, giving it both support and direction. With his typical sensitivity and calm, he brought together the diverse elements that go into a major exhibition and catalogue and ensured that each part reached its full potential even as it was integrated into a focused whole. Third, we want to thank the National Endowment for the Humanities for the wide-ranging support that has been so important to the realization of this project.

Edward J. Nygren
Curator of Collections
The Corcoran Gallery of Art

Preface

Revered and exploited in the two hundred years covered by this exhibition, Niagara elicited thousands of visual and verbal responses that mirrored changing attitudes toward nature and America. Even from the first published eyewitness account and exaggerated view of the Falls at the end of the seventeenth century, Niagara was considered more than just another waterfall. Endowed by artists and writers with supranatural significance, it became the most famous natural wonder in the world and symbol, in its magnitude and power, of the New World's limitless potential. This concept of Niagara effectively ended with the Pan-American Exposition of 1901, which marked the harnessing of the cataract's enormous hydroelectric energy. By then, Niagara had ceased to command any significant artistic interest and had been replaced as a symbol of America's promise by the Statue of Liberty.

Today, although the Falls remains an impressive sight and popular tourist attraction, Niagara's urban industrial environs are so totally different from the wilderness setting of the eighteenth and early nineteenth centuries that it is difficult for us to appreciate the complex associations —political, religious, aesthetic, psychological—that Niagara itself and images of the Falls aroused in the visitor or viewer of the last century. But there is another obstacle to our responding as our ancestors did to Niagara or depictions of it. Intellectual ideas and aesthetic ideals affect what and how we see. Concepts of the beautiful, sublime, and picturesque were integral to Romanticism's spiritual interpretation of nature in general and of the Falls in particular. Today, we may take as much visual delight in a waterfall as our forefathers did, but we invest it with far less meaning.

A major purpose of the present exhibition is to place artistic and cultural attitudes toward Niagara in a broad intellectual and social context. Works of art are juxtaposed with mementos to provide a sense of the breadth and scope of Niagara's impact on the nineteenth-century imagination. Although the exhibition extends from 1697, the year in which the first rendering of the Falls was published, to the 1901 Exposition, the greatest concentration of material is from the nineteenth century. That century witnessed the transformation of Niagara from wilderness outpost to tourist mecca, from nature's grandest scene to western New York's source of industrial power. In that century, Niagara also came to be equated with the promise of the United States, with its democracy and its destiny. And it was later in the century that Niagara was rescued from gross exploitation by the establishment of the Niagara State Reservation. The catalogue's essays by Jeremy Adamson, Elizabeth McKinsey, John Sears, and Alfred Runte document this change as the authors explore visual, literary, social, and environmental responses to the Falls.

This year, 1985, marks the 100th anniversary of the creation of the reservation and provides an appropriate occasion for a historical examina-

tion of Niagara's place in American life and art. With over 250 objects, this exhibition highlights Niagara's centrality in American intellectual and artistic history of the last century. What emerges from this vast array of material ranging from breathtaking compositions by America's leading artists to commercial souvenirs, from thoughtful accounts to popular guidebooks, is a sense of Niagara's mythic as well as real place in nineteenth-century thought. As the number and variety of pieces in this show suggest (and they represent only a small fraction of the numerous images and objects produced), Niagara was for several generations of Americans more than just a tourist attraction. It was also a compelling subject, perhaps the most compelling and enduring subject the country has ever had, for it embodied the aspirations of a young and vigorous nation. It is hoped that the exhibition *Niagara* has placed this extraordinary natural and cultural phenomenon in a new light.

by Jeremy Elwell Adamson

Nature's Grandest Scene in Art

Niagara Falls was the most frequently described and depicted natural wonder in North America. No other site in the New World was represented so many times by so many artists in so many ways. From 1760 to 1900, countless amateur sketchers and professional painters, foreign and native-born alike, swarmed over the location, picturing the waterfalls from every possible vantage point. There are views from close-up and far away, from above and below on both sides of the gorge, upstream and down, from islands and promontories adjacent, and from boats, bridges, and observatories downriver. There are even constructed bird's-eye views.

The fact that there are two widely separated cataracts more than doubled the possibilities. Artists vied with one another to depict the Falls from unfamiliar angles in order to reveal novel aspects of their varied scenic grandeur. The artists were attracted not only to the two enormous waterfalls but the great mile-long stretch of rapids upstream, the enormous whirlpool three miles below, and other phenomena, substantially augmenting the number and diversity of Niagara views. The cataracts were pictured in every season and at all times of the day: there are spring, summer, autumn, and winter views as well as dawn, noon, sunset, and moonlight compositions. They were represented under serene blue skies and lightning-riven thunderclouds, during moments of peace and times of tumult.

Produced in every pictorial medium, views of the Falls varied in size from the minute dimensions of the miniature to the vast proportions of the moving panorama. By the 1850s, images of Niagara were to be encountered everywhere; it was virtually impossible not to know what the Falls looked like. Paintings of Nature's Grandest Scene could be found in public exhibitions and private collections while popular prints could be purchased in city bookstores and rural emporia. Engravings were published in expensive giftbooks and illustrated weeklies, literary journals and penny magazines. Views of Niagara decorated theater curtains, scenic wallpapers, dinnerware, sheet music, commercial advertising labels, lamp shades, and stock certificates. Niagara Falls also proved to be the single most popular landscape subject among the millions of mass-produced stereographic photographs that flooded the parlors of the Old and New Worlds after 1860. It was truly a theme for Everyman, appealing equally to all classes and levels of taste on both sides of the Atlantic.

Pictorial representations of Niagara Falls from the 1760s through the end of the nineteenth century constitute a distinctive chapter in the history of landscape art—one that was familiar in the 1800s but virtually unknown today. In retrospect, this period proves to be surprisingly coherent in its arrangement: there is a beginning, a gradual development, a grand climax (Frederic Church's famed *Niagara* of 1857), a denouement, and conclusion at the turn of the twentieth century. The inherent neat-

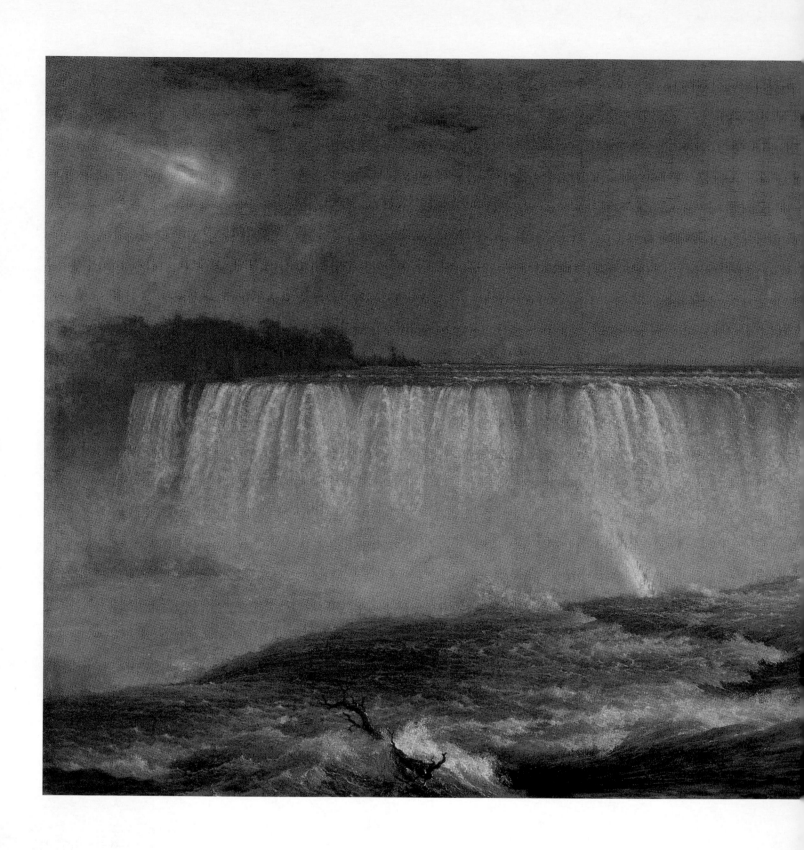

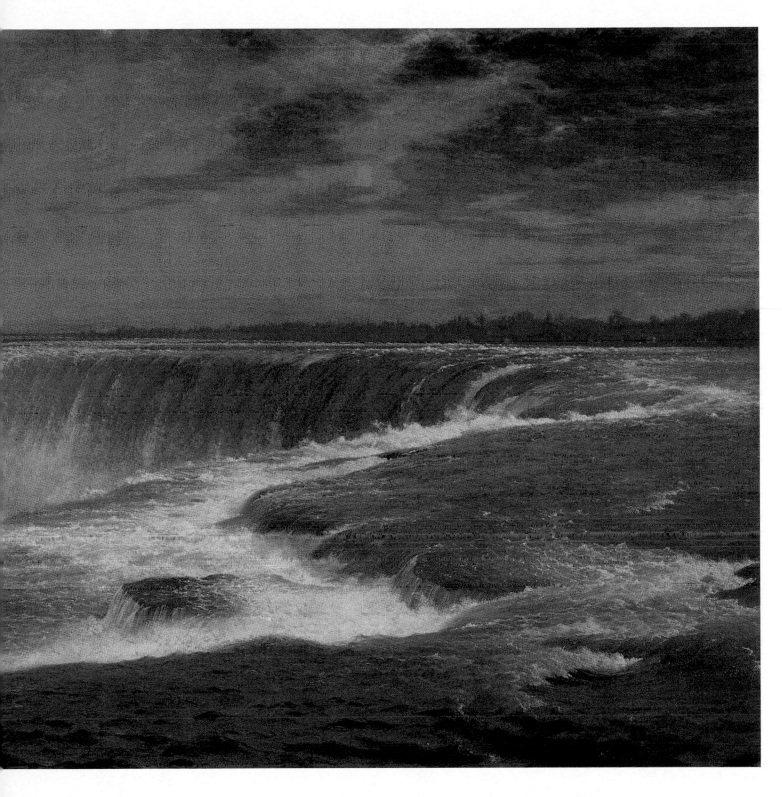

Fig. 1. Frederic Church, *Niagara*, 1857 (cat. no. 49). The Corcoran Gallery of Art, Washington, D.C.

ness of this structure depends on the connection between the pictorial tradition and the waxing and waning of one of the greatest themes of the Romantic era—the sublime. Without the notion of sublimity to infuse the scene with meaning, Niagara Falls would have remained little more than a spectacular display of falling water, but with it, Niagara became the ultimate Romantic landscape, pregnant with meaning of the most transcendent sort. For the vast majority of painters, Niagara Falls was the "sublimest of sublimities,"[1] the terrestrial world's grandest symbol of divine omnipotence.

In the latter half of the eighteenth century, the sublime denoted a category of aesthetic emotion aroused by objects or ideas that were overwhelming in scale or force. By 1830, the sublime had evolved from an aesthetic experience to a religious one in which the perceived immensity of natural phenomena directly suggested the infinitude of God. As an aesthetic concept, the sublime was the opposite of "the beautiful" and was devised in the mid-1700s to provide a theoretical justification for the intense delight evoked by vast and often terrifying subjects or ideas. As the Scottish philosopher Hugh Blair put it in 1783, the "impression [which] great and sublime objects [make] consists in a kind of admiration and expansion of the mind; it raises the mind much above its ordinary state; and fills it with a degree of wonder and astonishment that it cannot well express."[2] In the early 1800s, the uplifting nature of the sublime experience became the chief point of focus, and writers increasingly expressed that experience in religious terms. By the 1830s, it was commonplace to assert that God communed directly with man through the immensity and magnificence of nature.

Just as travel writers discovered Niagara's sublimity to be their "Ulyssean bow,"[3] so landscape painters found it to be their greatest challenge. In fact, it was declared the most defiant of all natural subjects. To give appropriate visual form to the incomparable grandeur of the Falls seemed impossible: it was too impressive, too overwhelming. For most, it appeared to be an incontrovertible axiom that Niagara's sublimity was located far beyond the reach of art. Not only the incomparable scenic splendors but, more importantly, the terrifying yet exalting impact that Niagara Falls had upon the mind seemed artistically inexpressible. Writers found it indescribable and landscapists unpaintable. Neither group was deterred, however, in its attempt to capture the cataracts' elusive sublimity.[4] Just as "Niagara's of ink"[5] were spilled in the literary endeavor, so a continuous stream of views was produced in the artistic attempt. In the final analysis, one descriptive account and one canvas stand alone as the preeminent statements of the essential spirit of the scene as experienced in the nineteenth century—Charles Dickens's reaction in his *American Notes* (1842)[6] and Frederic Edwin Church's *Niagara*. The former was the most commonly reprinted verbalization and the latter the most widely acclaimed pictorialization. Each best expressed the Romantic era's conception of Niagara's sublimity as an exalting and peace-inspiring experience of divinity.

On Friday, May 1, 1857, a short notice appeared in the *New York Times:* "Church's magnificent picture of Niagara, just completed, is on exhibition (free) for a few days at Williams & Stevens."[7] The advertisement proved to be the initial spark that ignited a veritable firestorm of enthusiasm that swept the city that month. Within days, increasing crowds overflowed the exhibition rooms of the New York firm of art dealers, Williams, Stevens & Williams at 353 Broadway Avenue. In the rear, gas-lit showroom, visitors

encountered an astonishing creation—a seven-foot-long, three-and-one-half-foot-high panoramic view of the Horseshoe Fall seen from close-up on the Canadian shore entitled *The Great Fall, Niagara* (fig. 1).[8] So faithful was the representation and so powerful its impact upon the imagination that a reporter for the *Home Journal* concluded breathlessly that "this *is* Niagara, *with the roar left out!*"[9] The *New York Times* likewise extolled the artist's remarkable achievement of illusionism: "Behold!" it intoned grandiloquently, "the marvel of the Western World [is] before you."[10]

Critics were disarmed. Their typical fault-finding abilities were overpowered by the picture's *"vraisemblance."*[11] "The more one looks at it," announced the *Albion,* "the less there is to say about it; the deeper and more absorbing the enjoyment."[12] According to Boston's *Weekly Traveller,* "to say 'How beautiful it is!' is like saying the same thing of a perfect June day."[13] Another journalist reported, "to write of this picture is like writing of the Falls themselves. You think of it and your pen hangs idly in your hand, as your imagination brings back to you the grandeur and the grace you gazed upon."[14]

News of Church's triumph[15] spread through the city. Almost immediately, thousands were crowding into the Broadway gallery daily[16] to see what the *Albion* declared on May 2 to be "incontestably the finest oil picture ever painted on this side of the Atlantic."[17] The exhibition was a sensation. "Seldom if ever," commented the *New York Daily News,* "have the 'art circles' of our city been aroused to such a high point of enthusiasm in their praise of any work of art"[18]; a visit to Williams & Stevens became the rage. *Niagara* was unanimously applauded as an epoch-making production in the history of American art. The New York *Courier & Enquirer* solemnly stated that "we know of no American landscape which unites as this does the merits of composition and treatment."[19] According to another journal, "ordinary praise [was] impertinent" for the young American had not only "rivalled Turner's light [but] equalled the Pre-Raphaelite detail."[20] For most, *Niagara* seemed a veritable watershed in the history of American painting.

Journalists all reiterated one outstanding point—Frederic Church's picture was the finest representation of Niagara Falls ever painted. Finally, after 160 years of pictorial attempts and failures, the celebrated scene had been interpreted by an artist who fully comprehended it.[21] Church had succinctly conveyed that most resistant and ineffable of themes—"the absolute spirit of the place."[22] Nature's Grandest Scene had at last revealed itself to an artist-seer who had the necessary skill and insight to replicate its ever-changing forms and unlock its innermost meanings and display them clearly for all to see and understand. Church's *Niagara* was decreed "the great painting of the grandest subject of Nature!"[23] It was "the *chef d'oeuvre* of Niagaras upon any canvas,"[24] and was "universally acknowledged [to be the] best representation of Niagara Falls ever painted."[25] Not only was it the finest yet created, but likely the best *ever* to be produced: "future pictures of the Cataract may be different but they cannot be superior to this."[26] Such eulogies previously would have been unthinkable for it had become an article of faith that the successful delineation of Niagara Falls was outside the reach of human art. "What proposition has been more universally acknowledged as an axiom in American art than this," demanded the *New York Times*; "that Niagara could not be reproduced upon the canvas? Everybody has echoed this remark—everybody has believed it—nobody could question, because nobody disproved it."[27] Simply put, "Mr. Church came, and saw, and conquered."[28]

In June 1857, *Niagara* crossed the Atlantic and was placed on view in a London gallery before being chromolithographed for popular consump-

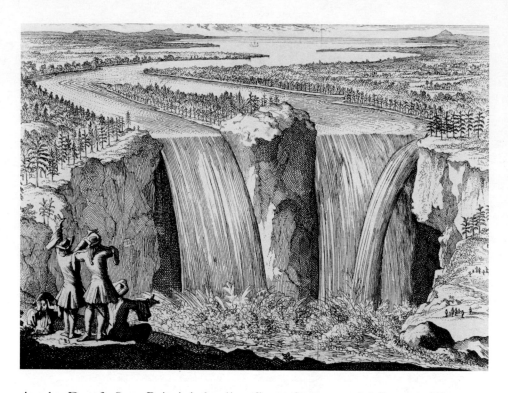

Fig. 2. Unidentified, *Chute d'eau de Niagara*, 1697 (cat. no. 170). Private Collection.

tion by Day & Son, Britain's leading firm of commercial fine art print-makers. Among the first of "a few connoisseurs" privileged to preview the picture in London was none other than John Ruskin, the chief exponent of scientific naturalism in art and, with the publication of his landmark *Modern Painters*,[29] the leading critic of landscape painting in the English-speaking world. According to one report proudly relayed back to America, Ruskin was surprised by the uncanny realism of Church's painted rainbow and went to check the windowpanes to assure himself that it was not the accidental result of sunlight refracting through glass and falling on the canvas.[30]

The English press was also unanimous in its praise of Church's *Niagara*—especially his unprecedented ability to replicate the myriad forms of running water. The painting was perceived as a harbinger of artistic things to come from across the ocean. According to the *Spectator*, Americans had reason to be proud of Church's achievement for, on the evidence of this single work, there could be "no doubt [as to the] future" of American art.[31] The London *Art Journal* published a lengthy and studious review that was the most complimentary of all English commentaries. The editors accounted *Niagara* "one of the most striking and interesting pictures the hand of the artist has ever produced," and moreover asserted, "it seems to us that no other work of its class [landscape painting] has ever been so successful." Seldom had they "examined a picture which so nobly illustrates the power of art" and it was, they solemnly affirmed, "an achievement of the highest order."[32] The sensational[33] canvas garnered wider celebrity when it was taken on a triumphal tour of the British provinces in the summer of 1858. On exhibit in Glasgow, Manchester, and Liverpool, *Niagara* drew throngs of admirers and fresh outbursts of critical praise.

Upon its return to New York in September 1858, the monumental picture was once again displayed to enthusiastic crowds made well aware of its transatlantic success by a brochure that contained reprinted English press reports.[34] The *Cosmopolitan Art Journal* was proud to inform its nationwide readership that *Niagara* was "now regarded as the finest painting ever painted by an American artist."[35] Williams & Stevens organized a

tour of the South in 1858–59 (essentially a lure to attract subscribers for the chromolithograph) so that the "great National Work"[36] became familiar to audiences in Baltimore, Washington, Richmond, and New Orleans.[37]

The unprecedented success of *Niagara* was directly related to the celebrity of its subject and its place in the lengthy tradition of depicting the Falls. Had Church chosen to paint a lesser phenomenon—say Trenton Falls, near Utica, New York—such a picture, however lifelike, would not have occasioned such an outpouring of adulation. Nor would it have helped to raise him from relative obscurity to international stature as the artistic heir to J. M. W. Turner's majestic mantle of the greatest living landscapist.

The very first image of Niagara Falls was a 1697 engraving illustrating Father Louis Hennepin's immensely popular travel book, *Nouvelle Découverte d'un très grand pays Situé dans l'Amérique* (fig. 2).[38] It is among the earliest depictions of an identifiable scene in North America and was certainly the most widely known. Created by an unidentified Dutch printmaker for the Utrecht publisher of Hennepin's tome, the arrangement of land forms was based upon the missionary priest's description of the local geography. The geologically ignorant author had described the "wonderful Downfall" as composed of "two great Cross-streams of Water, and two Falls, with an Isle sloping along the middle of it."[39] The "Gulph" into which the river dropped, he declared, was 600 feet deep.[40] There were no mountains in the vicinity, he noted, and from its commencement at the eastern end of Lake Erie, the broad stream flowed gently over a flat plateau. Unexpectedly and "all of a sudden," the river plunged over the "horrible Precipice," terrifying the priest with the ferocity of its fall. Although it is an imaginary view, this initial image nonetheless presents a surpris-

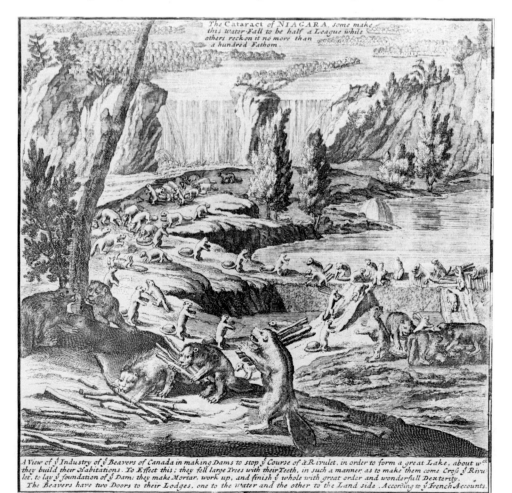

Fig. 3. Herman Moll, Detail from *A New and Exact Map of the Dominions of the King of Great Britain on Ye Continent of North America*, 1715 (cat. no. 227). Library of Congress, Washington, D.C.

17

ingly successful solution to the basic question confronting all artists who visited the site itself: how to suggest the vast dimensions of the cataracts and extensiveness of their setting, yet, at the same time, express the psychological impact of the scene. Relying on the late mannerist conventions of a high horizon and elevated viewpoint, the unidentified artist effectively evoked the sweeping breadth of the vast country that Hennepin, as a member of LaSalle's expedition of western exploration from 1678 to 1682, had discovered. It also allowed him to show the long stretch of the upper Niagara River wending its way across the flat landscape. The immensity of the scene is conveyed by juxtaposing small figures against the waterfalls. The "surprising and astonishing"[41] effect Niagara had upon the mind is suggested by the gesticulating Europeans in the left foreground.

Like the Falls themselves, this composition had an immediate and lasting impact upon the European imagination. For the first time, the Old World had a specific image with which to conjure the awesome wildness of the New. The distinctive engraving was soon utilized and reprinted for a variety of purposes: a pictorial inset on maps of North America, a landscape setting for a figurative composition, and a standardized illustration in eighteenth-century geography books.

In 1698 the Parisian cartographer, N. de Fer, adopted the composition as the background for a curious inset on his map of the continent, a motif later incorporated in Herman Moll's map of America, which was printed in London in 1715 (fig. 3). With the Falls of Niagara in the distance, it appears that the beaver are in fact damming the torrential Niagara River. The final appearance of the Hennepin-derived composition on a map was in 1817,[42] long after the Falls had been accurately described and pictured.

In 1700 the official printmaker to the French court, Sebastian Leclerc, utilized the image as the setting for his engraved representation

Fig. 4. Sebastian Leclerc, *Elie enlevé dans un Char de Feu*, 1700 (cat. no. 129). Royal Ontario Museum, Toronto, Canada.

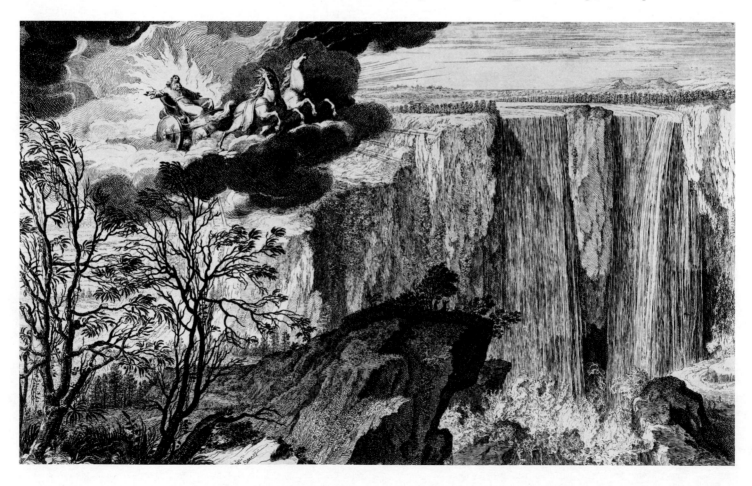

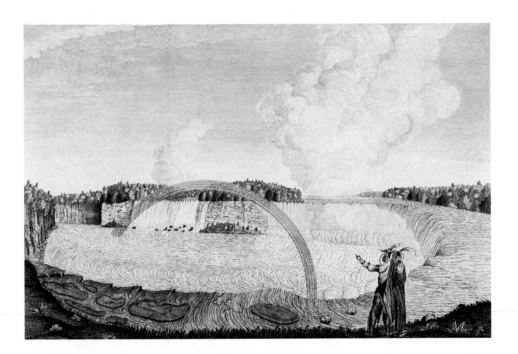

of the prophet Elijah being borne aloft in his fiery chariot (fig. 4). As one
twentieth-century commentator stated, Leclerc wished to "unite in one
plate the greatest natural wonder on earth and the greatest honor vouch-
safed by the Almighty to mortal man."[43] The prophet's fiery ascent is
made all the more wondrous by its juxtaposition with Niagara's watery
plunge. The Hennepin-derived image of the Falls was to be reprinted
ad infinitum in standardized versions throughout the 1700s (see fig. 75).
Gradually, it assumed an iconic status, symbolizing America first as a place
and then as a nation (see fig. 77).

With the conquest of New France in 1760, officers in the victorious
British military forces began to travel to Niagara Falls in ever-increasing
numbers. Some were assigned to Ohio Valley outposts or the nearby forts
guarding the strategically important portage route around the Falls.
Others, however, were simply tourists, fascinated by word-of-mouth
reports and published accounts. Officers in the Royal Artillery and Royal
Engineers had been trained in topographical drawing and watercolor paint-
ing at the Royal Military College at Woolwich and were the earliest visitors
to represent the Falls correctly.[44]

The first artist to have sketched the scene was Lieutenant Thomas
Davies (ca. 1737–1812). During an exploratory tour of the Lake Ontario
shoreline in 1760–61, Davies made drawings, from which he later pro-
duced finished watercolor compositions of the Falls from the Canadian
side. These remarkable works by an amateur artist are both topographic-
ally accurate depictions of the waterfalls and surprisingly successful
attempts to suggest their grandeur. One of the watercolors served as the
basis for the ca. 1768 engraving *An East View of the Great Cataract of Niagara*
(fig. 5),[45] which was the first correct rendering of the local geography and
also the earliest to include Niagara's ever-present rainbow.

Davies's *An East View* is an important work in the history of Niagara
Falls art for the soldier-artist solved the most obstinate of dilemmas: how
to represent the panoramic scene in its entirety while capturing the
uplifting nature of its sublimity. Davies resolved this quandry by selecting
the most comprehensive and impressive of viewpoints—the western or
Canadian verge of the Horseshoe Fall. From this commanding position,
the mile-long stretch of rapids upstream, the individual cataracts, Goat
Island, and the eroded length of the gorge immediately below the Falls

could be represented in an all-inclusive yet provocative fashion. Like Church's *Niagara,* Davies's composition places the viewer at the very brink of the immense, curving waterfall. The sublime encounter with the Horseshoe Fall is suggested by the inherently awesome viewpoint. However, the scene is essentially terror-free: there are no wildly gesticulating figures expressing fear and astonishment. The exalting response to Niagara's vastness so often described by later visitors is evoked by the poetic associations attached to the majestic rainbow and the figures of two Indians in the right foreground. Unlike the Europeans in the 1697 engraving, Davies's aboriginals gaze at the spectacle before them with complete equanimity. In the mid-eighteenth century, a rainbow signified the divinely instituted covenant established between man and God after the Flood. The poetic meanings infused into *An East View* were not only unprecedented but rarely matched by succeeding generations of artists.

Thomas Davies's other two watercolors were clearly intended to be viewed together and thereby constitute a more complete record of the site's character. In *Niagara Falls from Below* (fig. 6), the artist selected a point of view at the edge of the gorge on the Canadian side about a mile downstream from the Horseshoe Fall, a spot where the so-called Indian ladder was located.[46] From this position, all the important features of the landscape upstream could be seen to advantage. Davies's topographical training is evident in the accurate rendering of the configurations and proportions of the two waterfalls and in his handling of geological details. The objectivity of the image is offset by the foreground, designed according to conventions of landscape painting in which arbitrarily placed trees visually frame a vista, in this case the waterfalls. The Indian couples and the pair of redcoats give the composition an arcadian air—a quality distinctly absent from frontier existence.[47]

The pendant view, *Niagara Falls from Above* (fig. 7), has a completely different intent. Instead of an objective transcript, it is a highly imaginative representation of the long vista down the tunnellike gorge from a fanciful vantage point midway along—and almost directly over—the Horseshoe's crescent-shaped brink. In this dramatically composed work, Niagara's awesome grandeur is vividly communicated. The spectator is transported into the picture's fictive space, borne over the terrifying brink of the nearby cataract and carried downriver between the narrow banks of the gorge. The effect is carefully controlled. Trees at either edge of the composition create an oval frame through which the viewer is psychologically propelled by the rapidly receding lines on the surface of the river. In the center of a smaller ovoid formed by the encircling shape of the Horseshoe Fall is a remarkable iconographic emblem. Although common to the locale, the eagle here is readily identifiable as the dove of the Holy Spirit that regularly appears in representations of the life of Christ. The centrality of its placement and its emblematic shape bring greater aesthetic meaning to the picture. The eagle-dove can be interpreted as a unique manifestation of the Spirit of God "moving over the face of the waters" (Genesis I:2), creating order out of chaos. Numerous nineteenth-century visitors echoed that and other biblical phrases in their travel memoirs as they tried to convey the essentially sacred nature of Niagara's sublimity in their personal experiences. Davies's iconographic device suggests the transcendent character of the sublime experience in which man, sensing the presence of Divinity in the grandeur of Creation, is spiritually transfigured and escapes (if only momentarily and imaginatively) the bounds of the material world.[48] What Thomas Davies treated symbolically, Frederic Church would later depict naturalistically.

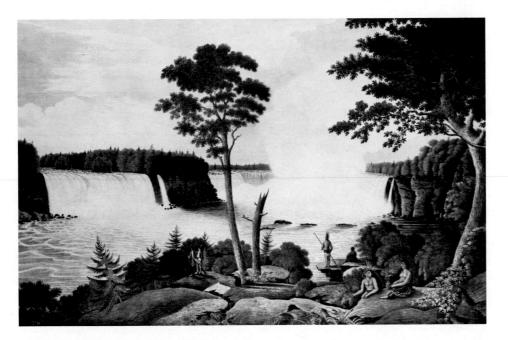

Fig. 6. Thomas Davies, *Niagara Falls from Below*, ca. 1762–68 (cat. no. 68). The New-York Historical Society, New York, New York.

Fig. 7. Thomas Davies, *Niagara Falls from Above*, ca. 1762–68 (cat. no. 69). The New-York Historical Society, New York, New York.

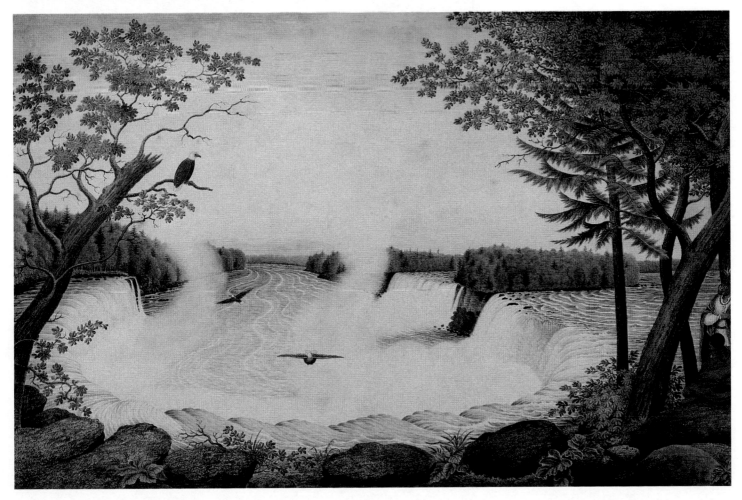

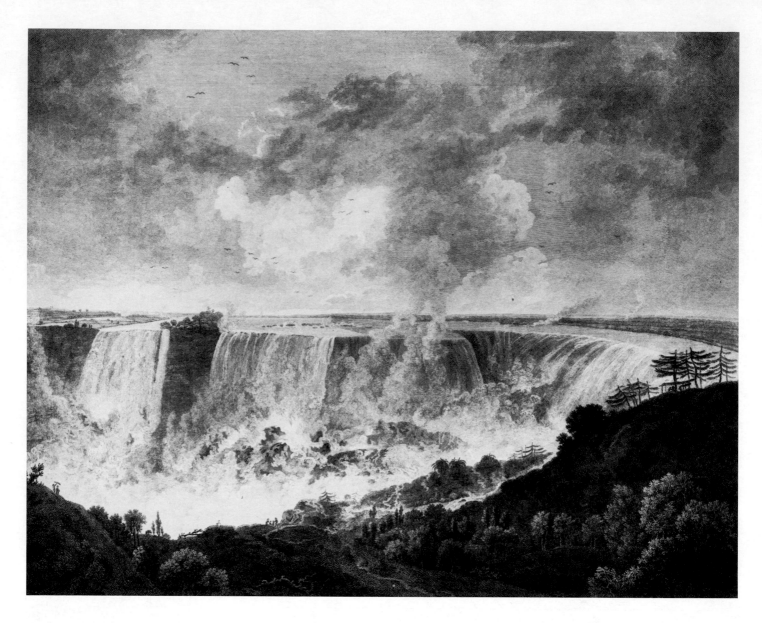

Fig. 8. William Byrne after Richard Wilson, *Cataract of Niagara*, 1774 (cat. no. 39). Public Archives of Canada, Ottawa.

In 1768, Lieutenant William Pierie, a brother officer of Davies stationed at Fort Niagara, sketched the cataracts from a commanding position atop the 100-foot-high upper bank on the Canadian side. From this elevation, overlooking the Horseshoe Fall, the various features of the expansive landscape could be seen to greater advantage than from the edge of the gorge downstream. At some point in the early 1770s, Pierie's on-the-spot drawing found its way into the London studio of Richard Wilson (1714–1782), one of Britain's leading landscape painters. He utilized the soldier-artist's sketch to create *The Falls of Niagara*, a large work exhibited at the Royal Academy in 1774.[49] It was the first oil painting executed by a professional artist and the earliest to be exhibited publicly. In this Pierie-Wilson composition, liberties have been taken: the enlarged Horseshoe Fall dwarfs Goat Island and the American Fall, and the normally squat proportions of the cataracts have been heightened substantially. These changes create an impressive landscape, one that visually evoked the astonishment recorded by contemporary visitors to the site. The inflated scale of the waterfalls, the vastness of their setting (suggested by an uninterrupted horizon line), the wild manner in which the water foams and boils below, and the minuscule scale of the figures stationed on the west bank convey, in rather conventional terms, the fearsomeness of the scene. Although its impact never rivalled that of the 1697 engraving, Wilson's

composition was disseminated through an engraving (fig. 8).

After 1780 pictures of the Falls from the bottom of the gorge on the Canadian side—perhaps prompted by published accounts of fearful adventures amidst the spectacular scenery at the base of the eroded cliff—were in vogue. A description of the perilous descent and the difficult journey over the slippery rocks to the foot of the Horseshoe Fall was commonplace in the journals of visitors. In 1785, the Frenchman Hector St. John de Crevecoeur wrote:

> We were nearly a mile and a half from the foot of the cataract, and the whole way . . . was strewed with these broken pieces of stone, and owing to the great declivity to the river, we were in fear of falling in, as the stones sometimes gave way, and the only way to save ourselves was by lying down, by which we were frequently hurt. The pending rocks above us added much to the horrors of our situation, for knowing those under our feet had fallen at different periods, we could not divest ourselves of apprehension.[50]

At the base of the thundering waterfall, de Crevecoeur encountered "the most awful scene . . . that we had yet seen."[51] A decade later, another Frenchman, La Rochefoucault-Liancourt, asserted that below the west bank "everything seems calculated to strike with terror."[52] By 1800, a view of the Falls from the foot of the gorge was synonymous with the concept of the terrible sublime as defined by Edmund Burke in his landmark treatise, *A Philosophical Enquiry into the Origin of Our Ideas of the Sublime and the Beautiful* (1757).

Burke's treatise operated as a clarifying lens for late eighteenth-century visitors to Niagara Falls, for his widely known definition of the sublime helped infuse order and meaning into the chaotic feelings aroused by the sights and sounds of the cataracts. His initial premise was that the emotions produced by the sublime were "the strongest . . . which the mind is capable of feeling."[53] In his view, a threat to life and limb caused the most intense of human passions—terror. Thus it followed that "whatever is in any sort terrible . . . is a source of the sublime."[54] As visitors were to reiterate time and again in the period before 1830, the Falls of Niagara was the most terrible thing they had ever encountered.

Yet it was not terror itself that was aesthetically pleasurable; it was the sudden remission of fear that caused delight. Once visitors realized that the looming Horseshoe Fall would not literally engulf them and that they could watch its destructive forces in complete safety, their initial terror turned into joyful elation. But Burke's concentration on terror as the motive cause of the sublime and his well-known list of fear-inducing qualities (all of which could be discovered at the Falls) firmly linked Niagara's sublimity with the terrible in the minds of most travelers in the late 1700s and early 1800s.

The earliest known depiction from below was executed about 1787 by Captain James Erskine, a British military man. Erskine's *Niagara Falls from Below* (fig. 9), which contains such mood-evoking devices as a rocky foreground, looming cliffside, and a great dead tree reaching expressively out toward the center of the composition, is clearly indebted to the landscape compositions of Salvator Rosa, at the time judged to be the most sublime of the seventeenth-century landscapists. Instead of the *banditti* who populated Rosa's bleak landscapes, Erskine substituted the more appropriate—but equally effective—Indians.

At the turn of the century the most widely known views from the foot of the west bank were three engravings illustrating the Niagara chapter of Isaac Weld's memoir, *Travels Through the States of North America, and the Provinces of Upper and Lower Canada* . . . (1799), a book undoubtedly

Fig. 9. James Erskine, *The Horse Shoe, Niagara Falls,* ca. 1784 (cat. no. 80). Public Archives of Canada, Ottawa.

familiar to most early nineteenth-century visitors. In two of the works the amateur artist depicted the waterfalls separately, but in *View of the Falls of Niagara* (fig. 10), he widened the angle of vision dramatically to include both cataracts from a point near the bottom of the Indian ladder. The looming rock wall of the western cliffside on the right fictitiously threatens the security of the minute figures in the center; adding to the drama (and partially compensating for the unimposing scale of the distant cataracts) is a theatrically composed cloudscape. Weld's engraving clearly attempts to evoke the delightfully horrible character of the site described in his text as composed of "huge piles of misshapen rocks, with great masses of earth and rocks projecting out from the side of the cliff and overgrown with pines and cedars hanging over your head, apparently ready to crumble down and crush you to atoms."[55]

Not every artist of the period sought to depict the scene from the river's edge below. Some were content with a less exciting location on the upper bank (cat. no. 171) or at the edge of the gorge near the Indian ladder. From this latter spot (called Painter's Point in 1787[56]), the "prospect, [if] less grand [was] more beautiful" than any other.[57] One officer was so taken with the view that he had a wooden studio hauled to the site in order to sketch the Falls in comfort.[58] Captain George Bulteel Fisher also captured this view as the subject of an imposing composition, which was reproduced as an aquatint engraving around 1794 (fig. 11).[59] While the distant cataracts are rendered in a topographically accurate fashion, the fore-

Fig. 10. Isaac Weld, *Travels Through the States of North America, and the Provinces of Upper and Lower Canada, During the Years 1795, 1796, and 1797,* 1799 (cat. no. 212). The New-York Historical Society, New York, New York.

Fig. 11. J. W. Edy after George Bulteel Fisher, *Falls of Niagara,* ca. 1794 (cat. no. 79). Public Archives of Canada, Ottawa.

ground has been arranged in accordance with picturesque conventions: the giant trees framing the waterfalls seem transplanted from a landscape composition by Claude Lorrain; the ragged cedars actually lining the banks of the Niagara Gorge are nowhere in sight; and a figural group—a family of Indians dressed *à l'antique*—have been incorporated in the immediate foreground. The native *pater familias* with a club raised over his shoulder is seen advancing on a coiled rattlesnake, the only threatening note to this otherwise arcadian vision of the sublime Falls.

In the first decade of the nineteenth century, landscapists developed a compositional strategy to cope with Niagara's scenic and affective diversity: the production of a pair of different views of an essentially contrasting aesthetic character. John Vanderlyn (1779–1852), the first academically trained artist to visit the Falls with the intention of reproducing its grandeur,[60] initiated this pictorial solution.

Vanderlyn made the trip in the autumn of 1801, probably at the urging of his patron, Aaron Burr.[61] The young artist traveled north from New York by steamboat and west from Albany by stage and horseback to Buffalo. There he crossed the river and journeyed along the settled British shore to the Falls, where he boarded with the family of Philip George Bender whose farm was directly across from the American Fall. According to his biographer, Robert Gosman, he was initially bewildered by the vast scale of the local landscape. Not only the physical size but the psychological impact of the enormous cataracts confused the artist.[62] Gosman's biography of 1848 reveals the nature of Vanderlyn's quandry: in terms of eighteenth-century aesthetics, Niagara was inherently unpicturesque.[63] There were no mountains in the background; the waterfalls were vast and ungainly in form; the extensive setting was flat and uninteresting; and the gorge into which the river dropped (and from whose high banks the visitor

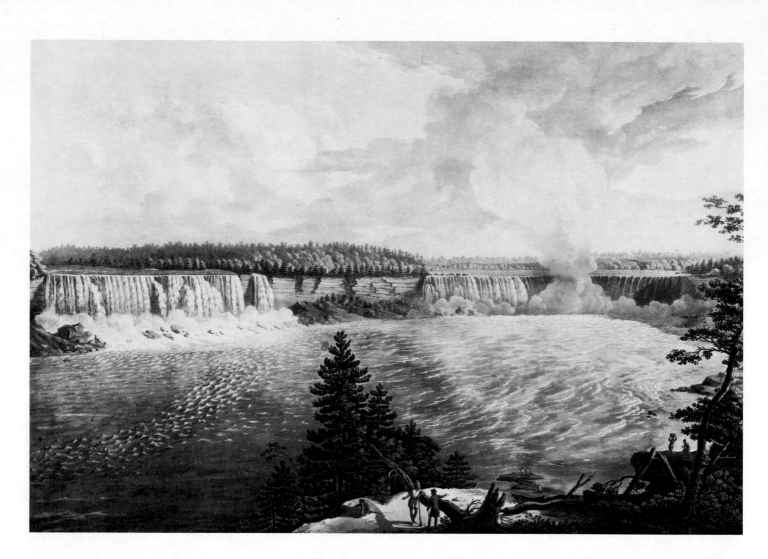

Fig. 12. J. Merigot after John Vanderlyn, *A Distant View of the Falls of Niagara Including Both Branches with the Island, and Adjacent Shores, Taken from the Vicinity of the Indian Ladder*, 1804 (cat. no. 135). Public Archives of Canada, Ottawa.

generally viewed the scene) was little more than a broad, straight-sided trench. Except for the curved profile of the Horseshoe Fall, the larger landscape was composed of straight lines, simplified shapes, and flat planes. The waterfall paintings of such well-known eighteenth-century landscapists as Hubert Robert, Claude-Joseph Vernet, Richard Wilson, and Philip James de Loutherbourg proved unsuitable models for depictions of Niagara. Something new had to be created in order to meet the challenge of the Falls.

During his twelve-day sojourn, Vanderlyn executed a series of outdoor oil studies, two of which are extant (cat. no. 159).[64] The double-view oil study is a semi-scientific record of the liquid formations of the Horseshoe Fall seen from the edge of the gorge. The illogical inset in the upper left underscores the objectivity of the work; obviously, Vanderlyn regarded the canvas as a functional surface, not an inviolate illusory field. In the summer of 1802, he began serious work on his Niagara project.[65] At some point, either at the Falls or back in his New York studio, Vanderlyn determined that the subject could best be presented in a pair of landscapes taken from widely divergent points of view on the Canadian bank. One was to depict both cataracts from afar while the other was to focus solely on the Horseshoe Fall from a relatively close-up position. The first would record what the terrain *looked* like while the second would suggest what the Falls *felt* like.

In late February 1803, the painting of the distant view was completed (cat. no. 160), and Vanderlyn solicited a testimonial as to its "Perfect Correctness."[66] The view of the Horseshoe Fall, however, was not finished by

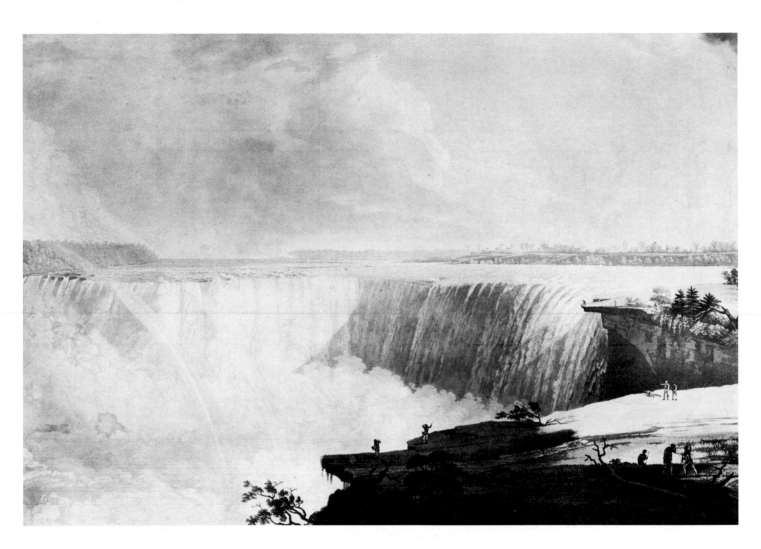

Fig. 13. Frederick C. Lewis after John Vander-
lyn, *A View of the Westerly Branch of the Falls of
Niagara Taken from the Table Rock, Looking Up the
River, Over the Rapids,* 1804 (cat. no. 131). Public
Archives of Canada, Ottawa.

the time the artist returned to France in April. Both works were publicly
exhibited at the Independence Day celebrations held at the American
Embassy in Paris. In September Vanderlyn took the pair of canvases to
London to have them engraved. In August 1804 both plates were com-
pleted and at least 100 pairs of prints pulled.[67]

The engraving, entitled *A Distant View of the Falls of Niagara* (fig. 12),
was based upon the painting of 1803 and its pendant, *A View of the Westerly
Branch of the Falls of Niagara* (fig. 13), was modeled on a lost canvas that
was related to the double-view oil study of 1801.[68] The distant view
depicts the panoramic setting from the edge of the west bank in the vicin-
ity of the Indian ladder. From this location the various components of the
landscape can be seen to advantage. The cataracts, however, are simply too
far off to project their vast size and power. With no mountains in the back-
ground for scale, the waterfalls look like mill dams. *A View of the Westerly
Branch,* however, specifically makes up for this deficiency. In order to
communicate Niagara's awesome sublimity, Vanderlyn chose to concen-
trate on the single motif of the Horseshoe seen from nearby. When exam-
ined together, the two views complement each other. The compositional
strategy of creating a close-up as well as a distant view, initiated by Van-
derlyn, proved to be a popular means of expressing the grandeur of the
Falls and their setting.

A View of the Westerly Branch is the more complex and provocative of
Vanderlyn's compositions. It evokes the sublime in a variety of conven-
tional ways, iconographic and formal. The foreground contains minute fig-
ures, several of which gesticulate expressively; a thunderstorm breaks out

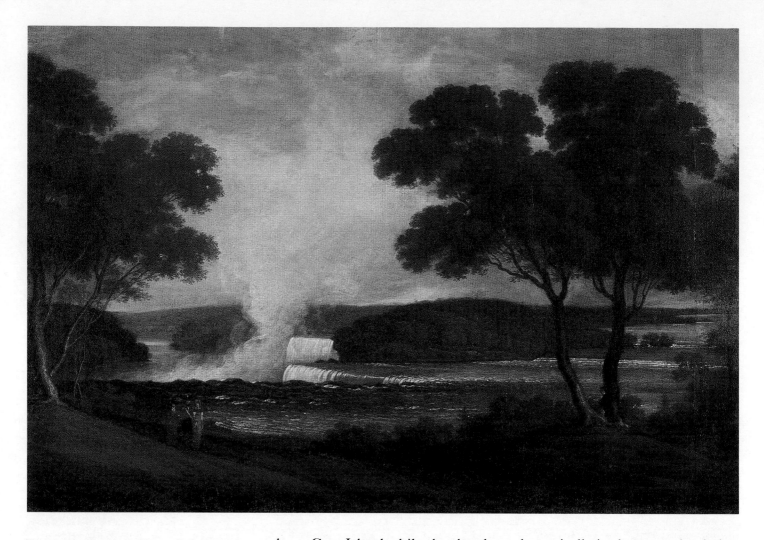

Fig. 14. John Trumbull, *Niagara Falls from an Upper Bank on the British Side*, 1807 (cat. no. 152). Wadsworth Atheneum, Hartford, Connecticut.

above Goat Island while the sky clears dramatically in the west; the dark frontal ledge with its Salvatoresque tree contrasts sharply with the white field of the cataract immediately beyond; and a great rainbow arches across the vapor-filled abyss, redolent with associations of the Deluge. A stormy yet clearing sky above the Horseshoe Fall remained a popular means of filling the upper, unvaried zone with visually interesting shapes while communicating heightened emotion.

Three years after Vanderlyn's trip to the Falls, the Anglo-American poet-ornithologist, Alexander Wilson (1766–1813), set out with two companions on a grand, patriotic journey through the American wilderness. Their destination was Niagara Falls; the whole adventure was celebrated in Wilson's paen to American nature, "The Foresters: a poem, descriptive of a journey to the Falls of Niagara in the autumn of 1804." The lengthy work was serialized in *Port Folio* in 1809–10 (cat. no. 214).[69] The author, aware of the unprecedented nature of his quest, was determined to "roam . . . Columbia's forests through/Where scenes sublime shall meet your wandering view"[70] and present to the reader a sequence of prospects that were the literary equivalent of a moving panorama. The climax of the venture was Niagara Falls, and upon arrival the verse-journey concluded dramatically. The poem was illustrated with a pair of engraved views of the Falls, which, like Vanderlyn's engravings of 1804, contrast an all-inclusive distant view with a narrowly focused close-up of the Horseshoe.

Emphatically panoramic, *A General View of the Falls of Niagara* represents the entire scene as enjoyed from the upper bank, overlooking the Horseshoe. There is an infinite expansiveness to the small-sized work. Unbroken, the horizon line remains the most insistent feature, psychologi-

cally pulling the observer into the boundless space of the western frontier. The four minuscule horsemen in the foreground underscore the immensity of nature's setting. *A View of the Great Pitch*, on the other hand, is entirely different in its psychological impact. Emphatically vertical, it presents a decidedly claustrophobic close-up of the edge of the cataract from below. The sheet of water pitches out toward the spectator, threatening—at least imaginatively—to inundate him. The viewer instinctively recoils from the careening curtain of the torrent that fills the composition and creates a strong vertiginous effect. The truncated, upright view of the Horseshoe spawned a whole class of Niagara imagery—the vertical close-up from below. Small figures emphasize the vast dimensions of the cataract whose size is left to the imagination with only a slice of the whole represented.

While at the site, Wilson watched the gray eagles "sailing sedate in majesty serene"[71] through the rising column of spray and included them in *A General View of the Falls of Niagara*. In his landmark, nine-volume *American Ornithology* (1808–14), he selected that landscape background for his representation of the "adopted *emblem* of our country," the white-headed or bald eagle.[72]

The most prominent artist to visit Niagara Falls in the first decade of the nineteenth century was John Trumbull (1756–1843). In August 1807 Trumbull and his wife spent a week at the Falls, residing on the Canadian side. In mid-September 1808 Trumbull returned to Niagara. A sketchbook preserved at Yale University shows the artist produced at least eight drawings—six during the first visit, and two during the latter.[73] These works reveal that, like Vanderlyn, Trumbull remained on the settled west bank

Fig. 15. John Trumbull, *Niagara Falls from Below the Great Cascade on the British Side*, 1808 (cat. no. 153). Wadsworth Atheneum, Hartford, Connecticut.

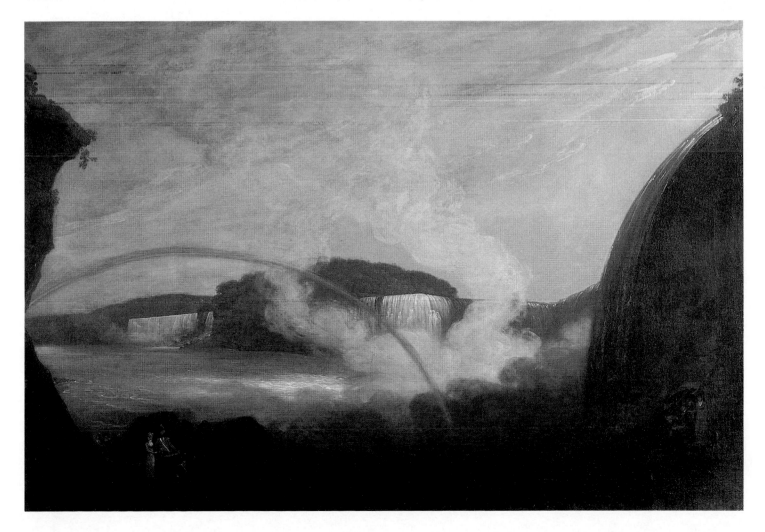

Fig. 16. John Trumbull, *Niagara Falls from Two Miles Below Chippawa*, 1808 (cat. no. 154). The New-York Historical Society, New York, New York.

Fig. 17. John Trumbull, *Niagara Falls from Under Table Rock*, 1808 (cat. no. 155). The New-York Historical Society, New York, New York.

and did not cross to the wilder American shore.

Also like Vanderlyn, whose engravings of the Falls were undoubtedly known to him, John Trumbull regarded Niagara as a commercially exploitable subject and when he returned for a second visit, he decided to go back to England with depictions of the famous scene suitable for the British art market. Writing to Samuel Williams, his English banker, in November 1808, he said, "I shall also bring with me two panoramic Views of the Falls of Niagara, & Surrounding Objects—the scene is magnificent & novel.—I have copied it with all my power, and am not without a hope that it will at once gratify the public curiosity."[74] These two panoramic views are probably the pair of canvases in the Wadsworth Atheneum in Hartford, Connecticut.

Niagara Falls from an Upper Bank on the British Side (fig. 14), dating from about 1807, is based upon a pencil drawing executed during the artist's first visit.[75] As the title suggests, it is an elevated view and was taken from a point on the 100-foot-high ridge overlooking the Horseshoe Fall. The composition is panoramic in scope, if not format, since it incorporates a sweeping vista of the Niagara River from above the upper rapids to the point at which it bends out of sight in the gorge, about two miles below the Falls. Seen from a raised and oblique angle, the profiles of the two cataracts are conjoined naturally into a single and continuous configuration whose undulating form exhibits the qualities of intricacy and variety essential to the aesthetics of the picturesque. Trumbull's chosen vantage point is not only formally picturesque but *affectively* so as well. Since the actual shape and size of the cataracts are partially concealed, this view excited the active curiosity that was integral to the picturesque.

Trumbull's conventional composition was painted according to the precepts of the picturesque as promulgated by William Gilpin, Uvedale Price, and others in the late 1700s. The panoramic view is sectioned off and elegantly framed by tree formations reminiscent of a landscape by Claude. The dark palette, impastoed surfaces, and three receding planes underscore the reliance on artistic traditions rather than reality. Trumbull's picture domesticates Niagara Falls. Nowhere is this more evident than in the figures the artist introduced. To the left, a British redcoat escorts two fashionably dressed female companions across the parklike setting, while on the right, embowered in a niche formed by two tree trunks, is the sketching artist accompanied by his faithful spaniel. Trumbull's presence implies that the subject is indeed suitably artistic and that the representation is in fact authentic. The promenade and the sketcher transform the scene into a social landscape that was in accord with contemporary Anglo-American taste.

Trumbull's second canvas, *Niagara Falls from Below the Great Cascade on the British Side* (fig. 15), was conceived as an aesthetic complement. It is based upon a pencil drawing—the most finished of all the Niagara drawings in the Yale sketchbook—dated September 13, 1808, at 3:00 P.M.[76] Trumbull may have traveled to the Falls a second time specifically to sketch the cataracts from below—which he had failed to do in 1807.

If, according to the aesthetic dictates of the day, *Niagara Falls from an Upper Bank* was categorized as picturesquely beautiful, its pendant must be judged picturesquely sublime. As everyone familiar with contemporary travel accounts was aware, the close-up view of the Horseshoe Fall from below, was the most awesome and terrifying of all:

No words can convey an adequate idea of the awful grandeur of the scene at this place. Your senses are appalled by the sight of the immense body of water that comes pouring down so closely to you from the top of the stupendous precipice . . . you tremble with reverential fear, when you consider that a blast of the whirlwind might sweep you from off the slippery rocks . . . and precipitate you into the dreadful gulph beneath, from which the power of man could not extricate you.[77]

In comparison to Alexander Wilson's *A View of the Great Pitch,* Trumbull's composition from below is highly complex. The angle of vision is not narrowed to concentrate on a section of the Horseshoe, but is widened to include the entire form of the crescent-shaped cataract, the cliff beneath Goat Island, and the distant American Fall. Because of the panoramic scope of the picture, the affective force of viewing the Horseshoe close-up from below is dissipated.

Like its companion piece, *Niagara Falls from Below* is a picturesque production. But this time, its formal design and poetic associations are cast in the mode of picturesque sublimity. The composition is bracketed by the looming rock wall of the gorge to the left and the threatening overhang of Table Rock and edge of the Horseshoe Fall to the right. The sky is dramatic: the long diagonal lines of clouds are streaked with sunset hues. Stretching across the wide "gulph" is a great rainbow, infusing the scene with biblical associations.[78] But even this wilder image reflects niceties of social behavior and remains a civilized locale. In the lower left foreground, a redcoat and a lady display an unusual degree of *sang froid:* neither show any interest in the terror-inspiring spectacle before them; they have eyes only for each other. Underscoring their own inattention is the action of two nearby British soldiers who, clearly under the influence of the sublime, are gesticulating wildly. In the lower right, immediately underneath Table Rock, Trumbull is seen sketching, this time accompanied by his wife and manservant. These figures are at odds with the nature of the site: the artist is seated comfortably on a rock, sketchbook in hand, while his wife, Sarah, stands behind him, her hand resting demurely on his shoulder. Behind both of them stands the servant holding an enormous black umbrella, presumably to shield them from the drenching spray. With the umbrella, the sublime collapses into the ridiculous. No such instrument could shelter anyone from the "blast of the whirlwind" that threatened, in Isaac Weld's words, "to sweep you from off the slippery rocks [into the] dreadful gulph beneath." The presence of the picturesque sketcher lends a wholly inauthentic note to the scene. At the foot of the actual cataract, nature and culture were not to be accommodated. But it is precisely that accommodation which Trumbull attempted to effect in *Niagara Falls from Below.* Through his introduction of familiar motifs and conventional figural poses, he hoped to rationalize nature's wildest forces, to transform the terrifying scenery at the bottom of the Niagara Gorge into an aesthetically controlled landscape.

Before his departure for England in December 1808, Trumbull produced two more ambitious Niagara compositions—oil studies for a proposed circular panorama of the scene, each measuring two-and-one-half feet by fourteen feet. *Niagara Falls Taken from Two Miles Below Chippawa* (fig. 16) is a sweeping representation from a location at the edge of the Canadian bank downstream from the Horseshoe. The second, *Niagara Falls from Under Table Rock* (fig. 17), is an all-embracing view from below. Like the easel paintings, they form a pair, depicting the same scene from different elevations.

While a diplomat in London in the 1790s, Trumbull would have been familiar with the recently devised medium of the 360-degree picture.[79] The Scottish inventor of the panorama, Robert Barker, delighted London audiences in the 1790s with his painstakingly executed circular views of the cities of Edinburgh and London. The highly detailed realism of these topographical and highly illusionistic works imparted a lifelike quality when they were exhibited in the rotundalike Panorama Building in Leicester Square. Standing in the center of the darkened interior at eye level with the horizon, the spectators willingly suspended disbelief and imagined themselves atop a tall building in the midst of the painted scene surrounding them. Trumbull, who lived near the Panorama, could not have failed to notice the popularity of Barker's showcase.

Sometime after 1808, Trumbull showed his panorama studies to Henry Aston Barker, the inventor's son. According to William Dunlap's *History of the Rise and Progress of the Arts of Design in the United States,* the artist wanted to enter into a joint concern with Barker.[80] The Panorama's proprietor, however, rejected the idea and in the process dashed Trumbull's hopes for financial solvency. Alleging that he overheard his old mentor Benjamin West advise Barker not to proceed with his panorama of the Falls, Trumbull held West responsible. West responded that he had urged the plan and Barker had rejected it.[81] But it was the artist himself who was to blame—the studies simply were unsuitable for a circular painting.

Trumbull deliberately distorted the perspective of his attenuated canvases by dramatically pulling the foreground forward and upward at the lateral edges and pushing the distant land forms back toward the center of the composition. In this way he created the impression that the scene was painted on a curved surface. The two studies, however, violated the central principle of a panorama—they did not represent a continuous view from a fixed point. The lifelike illusionism that characterized circular pictures of the period depended upon not only detailed realism but more especially the creation and maintenance of a level, 360-degree horizon line which encircled the spectator. Trumbull's works were two separate views from different positions that could not be conjoined end to end to form a single representation. The only recorded panorama of Niagara Falls to conform to Barker's requirements was the one painted by the indefatigable

Fig. 18. George Heriot, *Travels Through the Canadas . . . ,* 1807 (cat. no. 198). The New-York Historical Society, New York, New York.

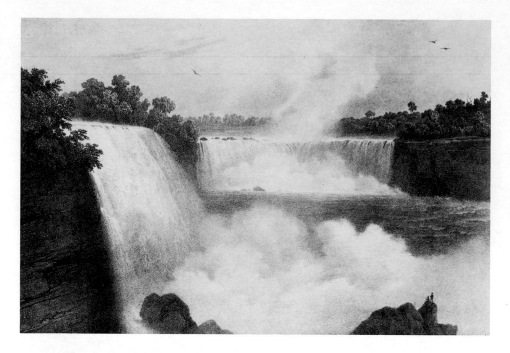

Robert Burford, Henry Aston's successor, and exhibited at the Panorama in 1833 (cat. no. 184).[82]

The picturesque nature of Trumbull's canvases is repeated in a pair of contrasting images of the Falls created by Woolwich-trained George Heriot (1766–1844) in the early 1800s when he visited Niagara as a colonial administrator in British North America. These works subsequently illustrated his memoir, *Travels Through the Canadas.*[83] Like Trumbull's contemporaneous view from the upper bank, Heriot's engraving, *View of the Falls of Niagara from the Bank near Birche's Mills,* is an oblique view of the cataracts from above, looking downstream over the brink of the Horseshoe. Despite the mills at the river's edge, a pastoral note is struck by the herdsman and cattle in the foreground meadow. Sublime associations are reserved for *View of the Falls of Niagara on the Fort Slausser Side* (fig. 18).[84] Although this view from below, which is similar to Trumbull's other canvas, includes both cataracts, it portrays the Falls from a novel and exciting vantage point—the base of the American Fall. It is the earliest known image to represent the scene from this location. "Here nature assumes a majestic and tremendous wildness of form," Heriot had written; "here terror seems to hold his habitation."[85]

The absence of settlements on the American side in the early 1800s explains the paucity of views from the east bank. Yet, the English traveler John Maude, who visited the American side in 1800, believed the oblique angle view of the cataracts from the mainland bank beside the American Fall (the location later known as Prospect Point) was more beautiful than that from the head of the Indian ladder across the gorge because both waterfalls naturally "blended [into] one picture."[86] The widely separated cataracts were indeed visually aligned and presented the visitor with a ready-made pictorial composition. In Heriot's image, the towering nearby form of the American Fall is juxtaposed with the distant sheet of the Horseshoe Fall in an aesthetically satisfying fashion, thus neatly avoiding the awkward combination found in Trumbull's panoramic view from below.

Several engagements, which proved to be the bloodiest confrontations between American and British troops during the War of 1812,[87] laid to waste much of the Niagara region. Settlements and farms along both sides of the river were attacked and burned. In the aftermath of the war, a new era of peace and prosperity was established. Settlers rebuilt their

homes and mills, and those living near the Falls constructed numerous tourist facilities that enabled visitors to reach scenic spots more easily.[88]

Among the first artists to paint Niagara Falls after the war was the American artist-historian William Dunlap (1766–1839), who executed a series of nine on-the-spot watercolors[89] when he visited the site in September 1815 in his capacity as paymaster general of the New York Militia. Another artist to sketch the scene at this time was Jacques Gerard Milbert (1766–1840), a pupil of the renowned French landscape painter of the late 1700s, Pierre-Henri de Valençiennes. Milbert was sent to America by the French government to study the natural history of the eastern states. During his stay from 1815 to 1822, he produced numerous landscapes, many of which were later reproduced as lithographic illustrations in his folio-sized *Itinéraire Pittoresque du Fleuve Hudson et des Parties Latérales* (Paris, 1828–29). Three of the views were of Niagara Falls, a "pittoresque" spot that he visited in 1818. The Frenchman had taken advantage of the newly constructed tourist facilities: *Niagara Falls from the American Side* (fig. 19) was taken from a window midway down the wooden stair tower that was erected in 1818 by Augustus Porter, owner of much of the land on the American side. The view from part way down the bank of the American Fall became one of the most popular and enduring vistas selected by nineteenth-century artists and photographers.

One of the most impressive compositions painted during this period—and certainly one of the most successful evocations of Niagara's terrible sublimity—is George Willis's *Niagara Falls* of 1816 (fig. 20). It is an extremely exciting Salvatoresque production whose dark palette, blasted tree, gesticulating Indian, stormy sky, and rainbow are all typical of the sublime. Willis did not visit the site, however; the source of his inspiration came from Vanderlyn's 1804 engraving, *A View of the Westerly Branch*.

Fig. 20. George Willis, *Niagara Falls,* 1816. Royal Ontario Museum, Toronto, Canada.

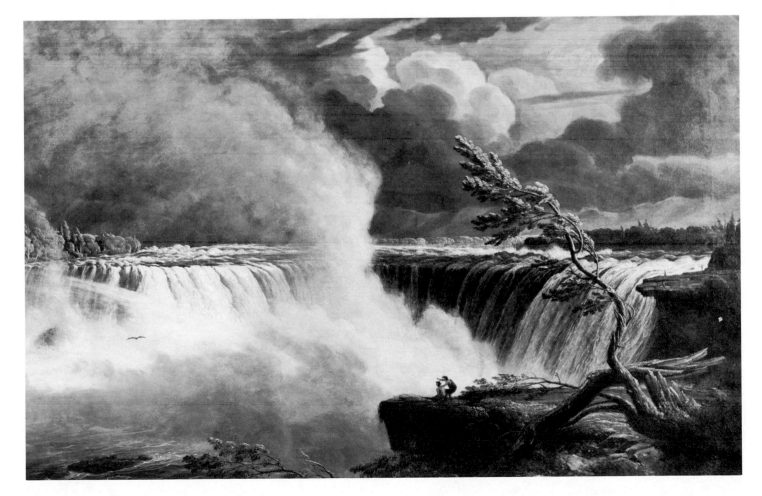

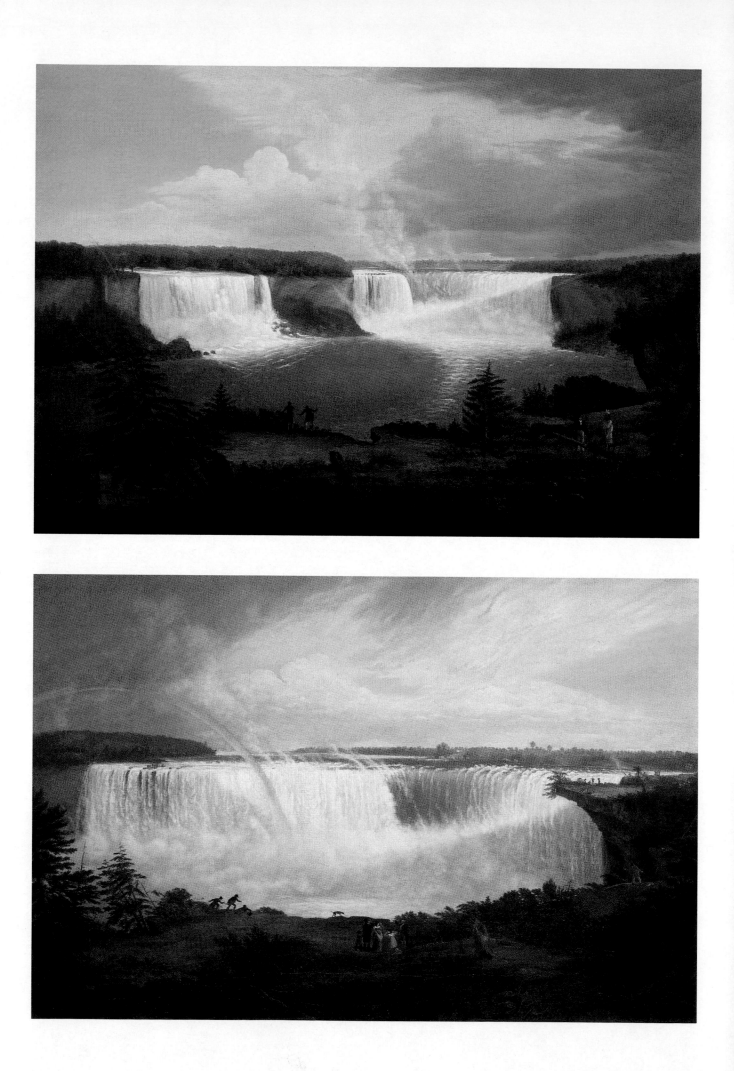

Fig. 23. *Samuel Hooker as Guide*, ca. 1834 (cat. no. 215). Buffalo and Erie County Historical Society, Buffalo, New York.

Fig. 21. Alvan Fisher, *A General View of the Falls of Niagara*, 1820 (cat. no. 81). National Museum of American Art, Smithsonian Institution, Washington, D.C.

Fig. 22. Alvan Fisher, *The Great Horseshoe Fall, Niagara*, 1820 (cat. no. 82). National Museum of American Art, Smithsonian Institution, Washington, D.C.

The most prominent American painter to visit the Falls in the period from 1815 to 1825 was Alvan Fisher (1792–1863), who arrived in July 1820.[90] Despite the number of exciting new vistas available to him on the American shore, Fisher fell back on the example of John Vanderlyn. Fisher's canvases are conventional and picture Niagara from the same locations on the Canadian side. Like Vanderlyn's distant view, Fisher's *A General View of the Falls of Niagara* (fig. 21) weds an accurate representation of the far-off Falls with a picturesque foreground replete with framing devices and anecdotal interest. *The Great Horseshoe Fall, Niagara* (fig. 22), on the other hand, captures the cataract's awesome grandeur by introducing storm clouds, astonished visitors, and a great rainbow.

An unprecedented number of visitors populate Fisher's two Niagaras. In the view of the Horseshoe Fall, twenty-one are arrayed across the foreground. One prominent group in the center reacts with gestures connoting awe and amazement. The man standing with his back to the cataract, addressing the group, is doubtlessly a local guide—perhaps the black top-hatted Samuel Hooker, familiar to tourists in the 1820s and 1830s (fig. 23). The presence of so many visitors indicates that by 1820 the once-remote spot had become a popular attraction.[91]

Fisher painted at least ten Niagaras,[92] most of which were versions of his original pair. Two compositions from below the Canadian bank, however, communicate the grandeur of the Falls in a more idealistic fashion. In *Niagara—The American Falls* of 1821 (cat. no. 83), the gorge appears as a sweeping amphitheater; the sky, clearing in the west, adds to the expansive mood. At the center of the composition, amidst a setting of broken rocks and blasted trees, stands an artist, sketchbook in hand. He is flanked on one side by a companion and on the other, a seated dog. Several additional sketchbooks lie piled among the rocks at his feet. He is a more noble and inspiring figure than Trumbull's artist under the umbrella. Just as he is our surrogate in the painted landscape, so the clean sketchbook page in his hand symbolizes our imagination awaiting the imprint of Niagara's sublimity. Like Fisher's other views, the companion picture, *The Horseshoe Fall from Below* in the Royal Ontario Museum is a conventional production: the Horseshoe Fall is bracketed on the right by an elegantly curved, Claude-like tree while the foreground is composed of Salvatoresque rocks. In the middle of the foreground is a party of three Indians, once the sole inhabitants of the region. Startled by the appearance of a barking dog, they turn to see two tourists approaching their resting place. It is a poignant moment. Fisher has portrayed the passing of an era: just as the tourist has dislodged the Indian from his place at Niagara Falls, so too the settler has displaced the Indian in the larger landscape. As Alvan Fisher's paintings demonstrate, Niagara Falls had entered the age of tourism: no longer a wilderness, it was a safe and increasingly familiar landscape—a fact that conditioned artistic responses in the second quarter of the century.

After 1820, artists captured Niagara's scenic diversity by creating a set of four or more different views. For the most part, these multiple images were conceived as prints, either published as a series or as illustrations in a giftbook. The earliest were the crude etchings by Thomas Hanford Wentworth issued in June 1821[93] and included the first printed view of the Horseshoe from Goat Island. A more sophisticated series was the five lithographs published in London in 1825 after drawings by W. Vivian (cat. nos. 19–23). Another remarkable set was the five etchings after sketches made with the aid of a *camera lucida* by British traveler Basil Hall in 1827 (cat. no. 196).[94]

Among the most handsome Niagara prints of the period were the four

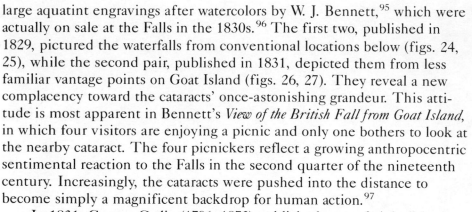

large aquatint engravings after watercolors by W. J. Bennett,[95] which were actually on sale at the Falls in the 1830s.[96] The first two, published in 1829, pictured the waterfalls from conventional locations below (figs. 24, 25), while the second pair, published in 1831, depicted them from less familiar vantage points on Goat Island (figs. 26, 27). They reveal a new complacency toward the cataracts' once-astonishing grandeur. This attitude is most apparent in Bennett's *View of the British Fall from Goat Island,* in which four visitors are enjoying a picnic and only one bothers to look at the nearby cataract. The four picnickers reflect a growing anthropocentric sentimental reaction to the Falls in the second quarter of the nineteenth century. Increasingly, the cataracts were pushed into the distance to become simply a magnificent backdrop for human action.[97]

In 1831, George Catlin (1796–1872) published a set of eight lithographs entitled *Views of Niagara.*[98] Six were views of the Falls and two were maps, one a chart of the Niagara River and the other a descriptive key to the first plate in the series, a remarkable aerial view of the Falls (see fig. 104).[99] This bird's-eye view contains not only all the tourist facilities in place by 1827 but also the various farms, settlements, mills, and roads. The set is a pictorial inducement to tourism: visitors are seen examining the cataracts from all the popular points of view. By following the dotted lines inscribed on the descriptive key, one takes an imaginative pedestrian tour along the well-worn pathways to each scenic outlook. Another set of six Niagara images published abroad in the 1830s—the series of aquatint engravings after watercolor compositions by the English soldier-artist James Pattison Cockburn (cat. nos. 27, 78, 106–109)[100]—helped familiarize European audiences with the iconography of the Falls.

The best-known printed images of the Falls and surroundings produced during the period were the seven steel engravings that appeared in N. P. Willis's immensely popular giftbook, *American Scenery* (1840, cat. no. 213).[101] The prints were made by various engravers after sepia water-

Fig. 24. John Hill after William J. Bennett, *Niagara Falls. Part of the American Falls from the Foot of the Staircase,* 1829 (cat. no. 104). The New-York Historical Society, New York, New York.

Fig. 25. John Hill after William J. Bennett, *Niagara Falls. Part of the British Fall Taken from Under the Table Rock,* 1829 (cat. no. 103). The New-York Historical Society, New York, New York.

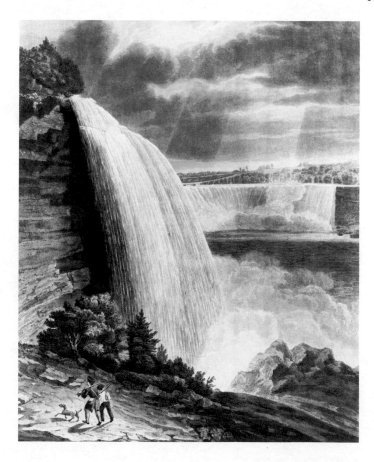

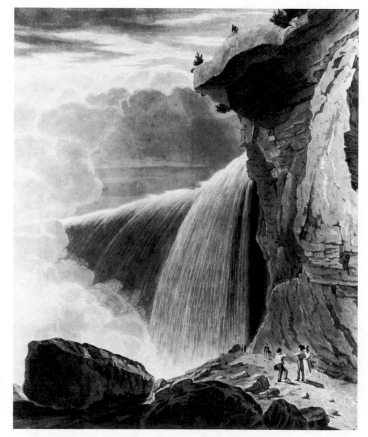

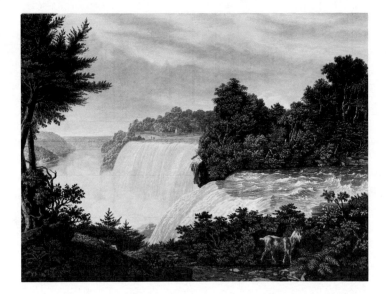

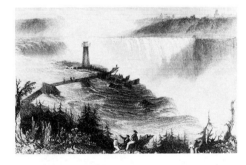

Fig. 26. William J. Bennett, *Niagara Falls. American Fall from Goat Island,* 1831 (cat. no. 24). The New-York Historical Society, New York, New York.

Fig. 27. William J. Bennett, *Niagara Falls. View of the British Fall from Goat Island,* 1831 (cat. no. 25). The New-York Historical Society, New York, New York.

Fig. 28. William H. Bartlett, *The Horseshoe Fall.* Illustration from the book, *American Scenery: or, Land, Lake and River . . .* by Nathaniel P. Willis (cat. no. 213). The New-York Historical Society, New York, New York.

colors executed at the site by the prolific English topographical landscapist William Henry Bartlett (1809–1854).[102] The preciosity of Bartlett's picturesque drawing style militated against successfully communicating Niagara's vast scale and force. Nonetheless, the engravings were the most often copied Niagara compositions of the nineteenth century; only W. J. Bennett's prints came close to equaling their popularity.

Bartlett deliberately shaped forms for expressive purposes. The inanimate form of Terrapin Bridge in his rendering of the Horseshoe Fall (fig. 28) is self-consciously invested with human expressiveness: the extremity appears to lift up in astonishment, just like the gesticulating figure standing on it. The forms of the water also evoke human emotions as the billowing waves appear to rear back in a last vain attempt to resist their fate. What Bartlett portrayed, Willis verbalized. Like other sentimental writers of the day, he invested the river's flow with human feelings: "For three miles, it tosses and resists . . . its unwilling waves fly back . . . and at last touch the glossy curve, convulsed with supernatural horror."[103] Like the artistic conventions of the picturesque, the projection of pathos into the torrent's rush helped reduce Niagara's sublimity to human dimensions.

The convention of depicting the Falls in a set of images taken from various locations was also employed by an English amateur artist, Major Henry Davis (active 1815–52). In a group of four little-known, but highly impressive, color lithographs published in London in 1848 and based upon a series of watercolors dating from 1846 (cat. nos. 70–73), the Montreal-based officer focused on the Horseshoe Fall. The four compositions are among the most romanticized conceptions of Niagara's grandeur. By eliminating most mediating foreground arrangements and reducing his designs to the essentials, Davis dramatically increased the visual excitement and power of his views.

The figures found in his two illustrations of the Horseshoe seen from below inject an associative note. An Indian brave solemnly contemplates the spectacle from the American side. Once a staple of Niagara compositions, the Indian virtually disappeared after 1830. Davis's inclusion of the figure is a deliberate attempt to reinvest the Falls with its original wilderness character. In the companion view from beneath Table Rock, a minuscule figure, overwhelmed by the cataract, clings perilously to the cliff beside the plunging wall of water. Although ideas of danger are forcibly brought to mind, tourists regularly entered the eroded cavern behind the Horseshoe without mishap.

Fig. 29. Henry Davis, *Autumnal Sunset, from Goat Island,* 1846 (cat. no. 72). Royal Ontario Museum, Toronto, Canada.

In *Autumnal Sunset, from Goat Island,* (fig. 29) there are no figures: the great orb of the sinking sun casts a glow over a scene of watery solitude inhabited only by an eagle gliding through the mists. The most impressive of Davis's works, however, is *Horseshoe Fall, from Table Rock* (fig 30). "From this position," he wrote, "the mighty cataract is seen in all its magnificence and splendor." Its motion was eternal: "Ninety millions of tons are estimated to fall into the abyss every hour; for thousands of years have been falling; and doubtless will continue to fall, night and day, for ages."[104] In order to emphasize the timelessness of the river's flow, Davis contrasted its eternity with the transience of a thunderstorm. The bolt of lightning, bursting out of the sky above the upper rapids, brings to mind the symbols of sublime force found in apocalyptic English Romantic landscapes. Seemingly encircled by rising flood waters, the two explorers, fatefully marooned near the brink of the cataract, also recall the popular theme of the Deluge.

Rarely were nineteenth-century views of Niagara Falls as imaginatively composed or poetically suggestive as Davis's works: they represent a world into which no commonplace tourist could ever have set foot. For the most part, artists of the period were content with mundane reality. Such is the case with August Köllner's eight color lithographs of Niagara published in 1848.[105]

Prints of the Falls were also published in pairs after 1825. Among the most prominent examples are compositions by James Hamilton (cat. nos. 93, 94), Robert Havell (cat. nos. 97, 98), and Hippolyte Sebron in 1852.[106] Artists of the period also produced single printed views of the Falls. For the most part, these are either panoramic compositions taken from the edge of the Canadian bank about a mile downstream from the Horseshoe Fall or all-inclusive views from the foot of the American Fall. Outstanding examples of the first type include a large engraving (cat. no. 132) by Captain James Graham and a lithograph (cat. no. 164) by A. de Vaudricourt. The latter was based upon a series of sequential daguerreotypes (see fig. 55) produced by William and Frederick Langenheim of Philadelphia, pioneer photographers of the Falls.[107]

The most all-embracing single view from the edge of the Canadian

bank was Robert Burford's circular panorama of 1833 (fig. 31). Based upon sketches made at the site in the autumn of 1832, it was probably the most realistic representation of the local landscape composed during the second quarter of the century. In the descriptive catalogue, Burford wrote,

> *a Panorama alone offers a scale of magnificent magnitude to exhibit at one view (which is indispensible) the various parts of this wonderful scene, and to convey an adequate idea of the matchless extent, prodigious power, and artful appearance, of this stupendous phenomenon of nature.*[108]

The engraved plan of the lost picture demonstrates the essential problem: no comprehensive view executed in a topographically accurate manner could ever evoke the cataracts' grandeur for they are simply too distant to be impressive features in an extensive composition. Only a close-up depiction adequately communicates their scale and force.

Karl Bodmer's engraved *Niagara Falls* of 1843–44 (cat. no. 166), a panoramic composition based upon a watercolor of 1834,[109] suggests the scene's awesome character. Taken from the foot of the Canadian bank, the angle of vision is dramatically low, almost eye level with the surface of the river. A great eagle, gliding over the river amidst limestone fragments, is the only living presence in this otherwise desolate landscape. In this view, the bird makes one of its last appearances as a symbol of the sublime in a Niagara depiction.

All-inclusive views from the base of the American Fall were the second most popular image for single prints. A familiar example of this type is William Guy Wall's *Niagara Falls from Below* which served as the fron-

Fig. 30. Henry Davis, *Horseshoe Fall from Table Rock*, 1846 (cat. no. 73). Royal Ontario Museum, Toronto, Canada.

tispiece for the second volume of J. H. Hinton's *History and Topography of the United States* when it was published in America in 1834. The land forms have been deliberately adjusted for dramatic effect. In the lower left, Wall reintroduced the motif—an Indian attacking a rattlesnake with a club—that had been a central feature in G. B. Fisher's engraving of about 1794 (see fig. 11). Other conventional means of suggesting the sublime include the gesticulating figures at the foot of the cataract and those in the ferryboat nearing the shore.

Although W. J. Bennett's contemporaneous engraving, *Niagara Falls from the American Side* (fig. 32), is essentially identical to Wall's composition, it is decidedly different in emotional character. Gone are the fearsome Indian and rattler, and instead of expressing awe and amazement, the passengers in Bennett's boat remain quietly seated. Their lack of excitement suggests an essential change in the conception of the sublime that occurred in the 1830s—the elimination of terror as the definitive emotion.[110]

After 1830, increasing numbers of Niagara visitors categorized their response to the Falls as a transcendent emotional uplift. For many, it was a sacred experience, redolent with associations of divinity. In the words of the Reverend F. W. P. Greenwood, Niagara Falls was a "beautiful, holy creation [that was] full of spirit and meaning." If the traveler stood at the end of Terrapin Bridge and gave way to his feelings, the minister declared,

> *he must drop upon his knees, for the grandeur is overpowering. The soul is elevated, and at the same time subdued, as if in an awful presence. Deity is there. The brooding, commanding Spirit is there. "The Lord is upon many waters" . . . "Deep calleth unto deep". . . .*[111]

In Greenwood's view, there was a "natural connection between all sublime and pure sentiment, and the conception of Deity. All grandeur directs us to Him."[112] During the 1830s, it was commonly assumed that God communicated directly with man through natural sublimity and that nowhere was this communion more profound than at Niagara Falls. The English novelist Captain Marryat stated in 1837 that it was "through the elements that the Almighty speaks to man [and] what can inspire more awe of him, more

Fig. 31. Robert Burford, *Description of a View of the Falls of Niagara, Now Exhibiting at the Panorma . . .*, 1833 (cat. no. 184). Brock University Library, St. Catharines, Ontario, Canada.

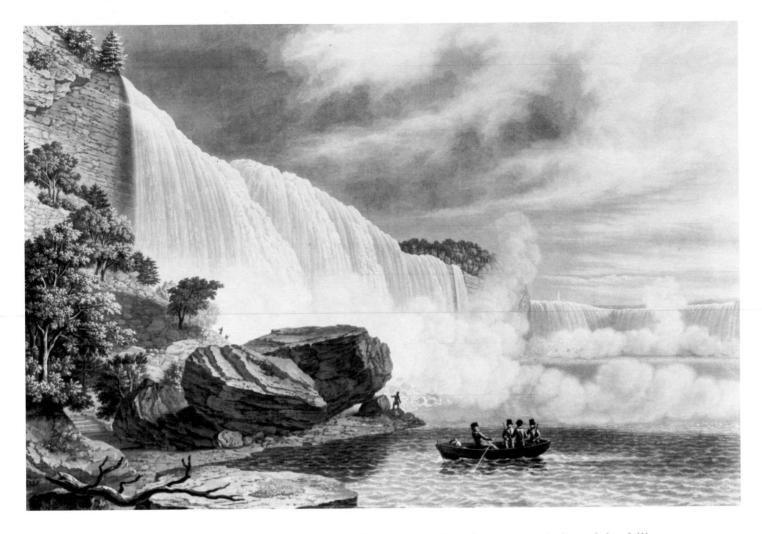

Fig. 32. William J. Bennett, *Niagara Falls from the American Side*, ca. 1835 (cat. no. 26). Royal Ontario Museum, Toronto, Canada.

Overleaf:

Fig. 33. John Vanderlyn (attributed), *Niagara Falls from the Foot of the American Fall*, ca. 1832 (cat. no. 162). Private Collection.

Fig. 34. John Vanderlyn (attributed), *The Horseshoe Fall from Below Table Rock*, ca. 1832 (cat. no. 163). Private Collection.

reverence, and more love than the contemplation of thy falling waters, great Niagara!"[113]

Aside from provoking religious sentiments, the Falls also aroused feelings of peace and calm. During his visit in 1834, Nathaniel Hawthorne noted that the turmoil of the Horseshoe Fall "assumes a sort of calmness. It soothes while it awes the mind."[114] Historian Anna Jameson reported in 1836 that "in the midst of this tremendous velocity of motion and eternity of sound, there [is] a deep, deep repose."[115] Coincident with these novel impressions, there was a new interest in Niagara's beauty, which was distinct from its so-called sublimity. During the 1830s and 1840s, beauty denoted not only an aesthetic category but a moral quality. Elevating feelings of peacefulness and intimations of a divine presence were indicative of Niagara's strong moral influence and hence its beauty. So fixed did this point of view become that Niagara was considered more beautiful than sublime, or awful.[116] As Niagara became less terrifying, beautiful, rather than sublime, seemed a more appropriate term for the Falls.

During the second quarter of the nineteenth century, the production of prints predominated. Nonetheless, painters were active, and several topographical canvases deserve mention. The most spectacular are two large paintings that recently have been attributed to John Vanderlyn. Upright compositions measuring seven feet by five feet, they were produced from studies dating from 1832.[117] Conceived as a complementary pair, they depict the scene from below, near the foot of each cataract (figs. 33, 34). Minute tourists underscore the immensity of the nearby waterfalls while impressive light effects add to the visual excitement inherent in the viewpoints.

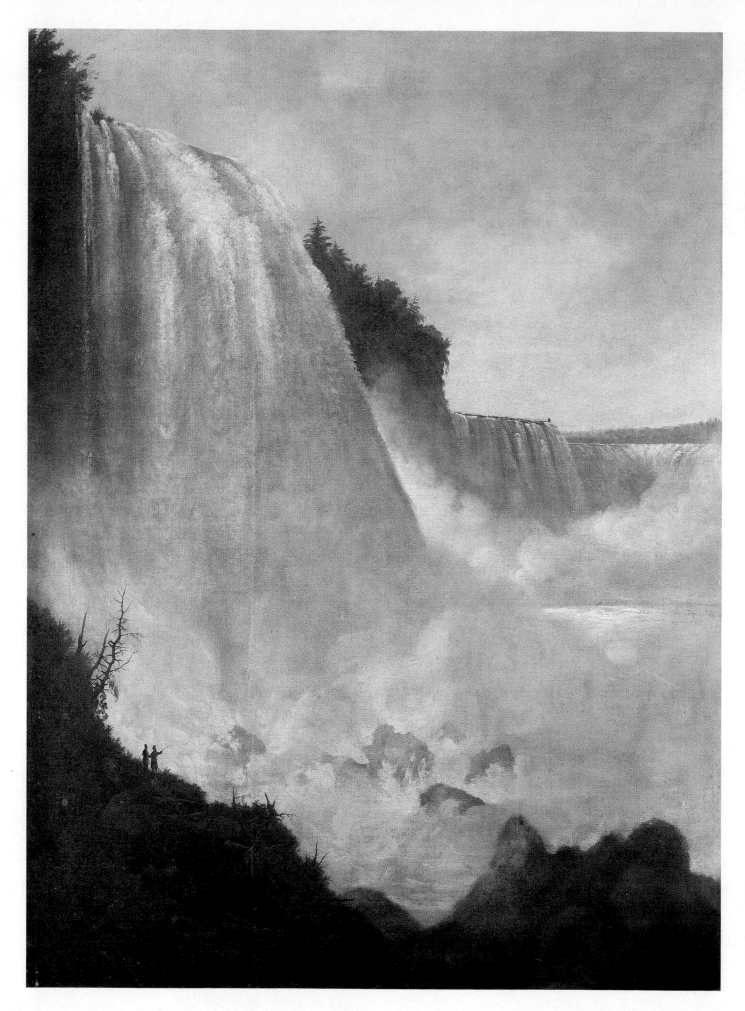

Fig. 35. John Vanderlyn, *General View of the Falls and Rapids of Niagara*, 1840-41. New York State Office of Parks, Recreation and Historic Preservation, Bureau of Historic Sites, Senate House State Historic Site, Palisades Region.

If the two canvases are the largest painted during this period, William Birch's (1755–1834) 1827 miniature representing the American Fall from below (cat. no. 38) is certainly the smallest. It is the most diminutive painting ever produced to attempt to suggest Niagara's vastness. On the reverse of the 2⅝-by-2⅜-inch image, Birch wrote "this wild oblique sketch . . . gives in my opinion a greater idea of its Magnitude than the front view where the distance necessary [sic] loses its immensity."[118] An Indian, blasted tree, and looming rockface infuse the tiny picture with connotations of the terrible sublime.

For the most part, painters followed the general strategies employed by contemporary printmakers—creating pairs or series of divergent views. Rembrandt Peale (1778–1860) followed the latter model, producing three paintings based on watercolor studies made in 1832.[119] The French artist Victor de Grailly (1804–1889) emulated engravers' examples more closely: all his various Niagaras, are simply versions of prints after Bennett, Bartlett, and Robert Havell.[120] An elevated view attributed to Havell (cat. no. 99) is among the relatively few imaginative visions of the scene produced by a topographical landscapist of the period.

Among the most widely seen easel paintings was John Vanderlyn's mammoth-sized *General View of the Falls and Rapids of Niagara* (fig. 35). Completed in Paris in 1840–41, it was first exhibited at the Salon of 1841.[121] According to the artist's testimony, it was based upon "a highly finished sketch painted at the spot in 1826."[122] Seen from the Canadian shore overlooking the rapids upstream, the cataracts are minor and unimpressive features in the larger landscape, dominated by a fancifully arranged foreground. Vanderlyn was well aware of the unspectacular nature of his view but argued defensively:

this distance is necessary for the eye to embrace the whole; and if the spectator is not struck by the magnitude and grandeur of the Cataract, the same disappointment would be felt on witnessing the reality, which requires to be seen and examined close by, to be struck, or made sensible of the greatness or sublimity of the subject.[123]

In Vanderlyn's opinion, the chief virtue of the uninspiring landscape was its "scrupulous correctness [for it] will serve to show after the lapse of a century or more, what changes time has brought about . . . how the Horseshoe Fall has receded."[124] It was to be a geological portrait of the scene as it existed in 1826.

Several painters in the second quarter of the nineteenth century attempted to convey the exalted nature of Niagara's sublimity in a more meaningful fashion. The earliest of these was the Quaker preacher and folk painter, Edward Hicks (1780–1849). His first *Falls of Niagara* (fig. 36), dating from 1825, is based on a reproduction of the Falls in an engraved inset on a map of North America published in Philadelphia in 1822.[125] No doubt Hicks was attracted to the symbolic nature of his model, for like the earlier Hennepin-derived image of the Falls, it too served as a landscape emblem of the continent. In order that his picture be appropriately interpreted in a religious fashion, the artist, a one-time sign painter, carefully lettered eight significant lines from Alexander Wilson's poem "The Foresters" on a painted border surrounding his depiction of the scene. The last pair of rhyming couplets impart to the image the meaning the Quaker preacher intended:

> *This great o'erwhelming work of awful Time*
> *In all its dread magnificence sublime,*
> *Rises on our view, amid crashing roar*
> *That bids us kneel, and Time's great GOD adore.*[126]

The poetic lines function as an interpretive framework by which—and literally *through* which—Niagara Falls assumes religious significance.

Thomas Chambers's *Niagara Falls*, dating from about 1835 (fig. 37), projects an idealism in a naive manner. The composition is based upon Jacques Milbert's lithograph of the view from Porter's stair tower (see fig. 19). Several important alterations have been made, however; the most prominent of which is the figure on a promontory in the center of the foreground. The figure is not a typical tourist in a top hat, but rather a rustic American—a frontiersman in a leather jerkin, broad-brimmed hat, with rifle and powder horn. He resembles Leatherstocking in James Fenimore Cooper's novels and, indeed, the resemblance may have been deliberate.

The linkage of Leatherstocking and American Fall was also evident in a popular play by William Dunlap.[127] *A Trip to Niagara; or Travellers in America* was a farce, played in front of a moving panorama, about English visitors en route to Niagara from Manhattan.[128] The play—and the panorama—concluded at the base of the American Fall where the assembled characters included the aged Leatherstocking, whom the Englishmen had met earlier on their travels. The old frontiersman bitterly lamented the coming of civilization and proposed to escape to the untramelled prairies after his visit to Niagara. But upon looking at the nearby cataract, he happily declared, "this looks like it used to do, they can't spoil this."[129] Chamber's *Niagara Falls* can be interpreted as a symbol of America. The Leatherstocking-like figure is the American Adam.[130] Neither dwarfed by the immensity of the Falls nor terrified by its vast power, he boldly confronts the scene realizing that it is but a mirror of his own restless energies and indomitable spirit.

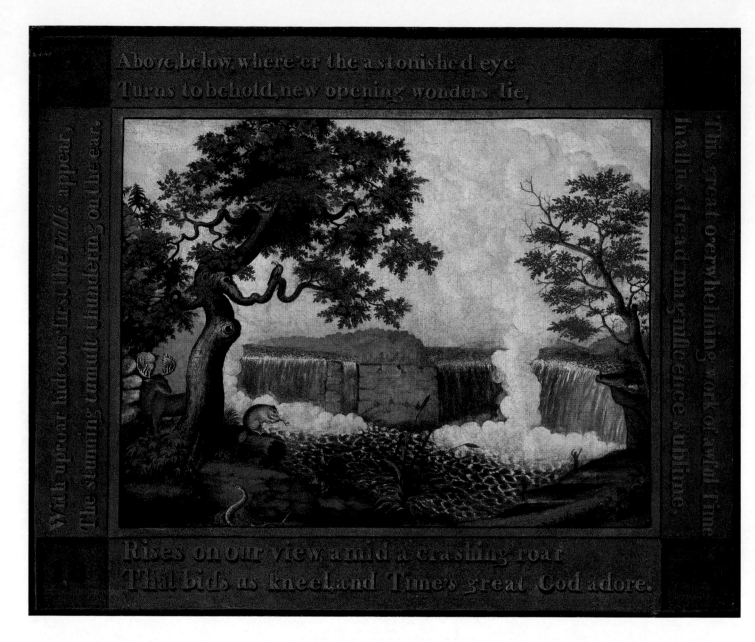

Fig. 36. Edward Hicks, *The Falls of Niagara*, 1825 (cat. no. 102). The Metropolitan Museum of Art, New York, New York.

The one composition that most successfully conveyed Niagara's transcendent meaning in the second quarter of the nineteenth century was Thomas Cole's (1801–1848) *A Distant View of the Falls of Niagara*. Painted in England in 1830, it was engraved by the London publisher of Hinton's *History and Topography of the United States* and served as the frontispiece of the English edition (fig. 38). Later issued as a separate engraving, it was often copied and served a variety of purposes.[131]

Thomas Cole made his initial trip to the Falls on the eve of his first departure for the Old World. As he wrote to his patron Robert Gilmor,

> *I cannot think of going to Europe without having seen them. I wish to take a "last lingering look" at our wild scenery. I shall endeavour to impress its features so strongly on my mind that, in the midst of the fine scenery of other countries their grand and beautiful peculiarities shall not be erased.*[132]

While he wished to obtain an indelible impression of America's natural grandeur, Cole made the trip to sketch various views of the Falls from which he would later create paintings that he proposed to sell in England.

Cole set out from New York City on May 1, 1829, and arrived in Niagara a week later:

Fig. 37. Thomas Chambers, *Niagara Falls,*
ca. 1835 (cat. no. 43). Wadsworth Atheneum,
Hartford, Connecticut.

*I anticipated much, but the grandeur of the falls far exceeds anything I had
been told of them—I am greatly astonished that there have been no great pic-
tures of them—I think the subject a sublime one—but I may fail in the repre-
sentation as others have done before me.*"[133]

His trip coincided with a spell of cold weather. Unable to cross the ice-
choked river to the Canadian shore, Cole was denied the view from Table
Rock. The majority of Cole's twenty-three sketches are from conventional
sites on the eastern side, only one is a unique view. Entitled *Niagara 2
miles off,*[134] it represents the distant scene from a point on the stage road
where travelers arriving from the direction of Lewiston first saw the Falls.
It was the basis for *A Distant View,* one of two Niagaras Cole painted in
London in 1830.[135]

In the composition, Niagara is figuratively as well as literally, distant.
It is a historical portrait of the Falls, an imaginatively reconstructed vision
of a long-lost wilderness. The hotels, mills, and tourist facilities present in
Cole's day have been eliminated. The cataracts and setting appear as they
must have looked to the first European explorer. The only inhabitants of
the painted scene are eagles gliding through the gorge and two Indians

Fig. 38. Fenner Sears & Co. after Thomas Cole, *A Distant View of the Falls of Niagara*, 1831 (cat. no. 147). Private Collection.

who, like those in Thomas Davies's engraving, gaze at the scene calmly, their backs to the viewer.

In May 1829, Cole wrote a seven-stanza poem entitled "Niagara." Written in the voice of an early explorer who stumbles across the scene unaware of its existence, the verse celebrates the sublimity of the Falls.[136] It was Cole's literary strategy, just as it was his artistic one, to recapture the wonder with which man first viewed Niagara's grandeur. The artist-poet was not the first to lament Niagara's loss of innocence, nor was he alone in his desire to recapture the Eden-like atmosphere of the cataracts' sublimity. Nathaniel Hawthorne wrote that the wanderers of old who encountered the cataracts in the midst of the wilderness were blessed. Without preconceived notions to mediate and mar their emotional responses, they experienced the sublime in its purest form. "O, that I had never heard of Niagara until I beheld it," Hawthorne lamented in 1836:

> *But I came thither, haunted with a vision of foam and fury, and dizzy cliffs, and an ocean tumbling out of the sky—a scene, in short, which nature had too much good taste and calm simplicity to realise. My mind had struggled to adapt these false conceptions to the reality, and finding the effort vain, a wretched sense of disappointment weighed me down.*[137]

Cole used a passing thunderstorm over the Falls to symbolize the sublime. In the left-hand portion of the sky, the clouds are black and ominous while on the right, the sun breaks through with a dazzling burst of light to dispel the gloom. The dramatic transition from dark to light signifies the climax of the sublime moment when terror is transformed into peace, when mental tumult gives way to calm and the imagination is "sublimed." The importance of the sunburst, which is indeed central to the meaning of *A Distant View*, was also emphasized in a later oil sketch[138] whose principal feature, a brilliant explosion of yellow-hued light, completely dominates the design.

The interpretation of the sunburst as symbol of a transcendent experience is clearly supported by a passage in Cole's important literary work,

Essay on American Scenery. In this seminal text, he clearly articulated the mind-expanding nature of Niagara's grandeur: "And NIAGARA! that wonder of the world . . . in gazing on it, we feel as though a great void had been filled in our minds, our conceptions expand—we become a part of what we behold!"[139] Just as the sunburst graphically illustrates mental expansion, so the rapt passivity of the Indians in the foreground represents the spiritual union with the supernatural in and through the experience of the sublime. In that transcendental climate they have become a part of what they behold.

By mid-century, the portrayal of the Falls had lapsed into standardization. With few exceptions, views became predictable and repetitive, lacking expressive power and relying upon established responses. In the 1850s, however, a new generation of American artists, members of the so-called second generation of Hudson River School painters, showed a renewed interest in the subject. They proved surprisingly innovative in their attempts to reinvigorate the tradition and create pictures that communicated Niagara's power in a fresh and unusual fashion.

When Frederic Church and his contemporaries visited Niagara Falls in the early 1850s, the site bore little resemblance to Thomas Cole's nostalgic dream of untouched beauty. Factories and hotels crowded the river's edge above the American Fall; on the Canadian side, virtually denuded of trees, a line of commercial buildings stretched from Table Rock north along the gorge.[140] During the summer season, the place swarmed with tourists. Described as the "center of a vortex of travel,"[141] Niagara Falls attracted an estimated 60,000 visitors in 1850.[142] Despite its popularity as America's premier watering place and the fact that it had long been a "hacknied"[143] subject, the nation's leading artists approached the scene with renewed interest.

Church's generation revitalized the practice of illustrating the Falls by developing a series of novel approaches. These included four basic stratagems: depicting standard views, but in an unusual and provocative manner; picturing the cataracts from entirely new points of view; rendering them during mood-heightening moments and seasons (specifically by moonlight and during winter); and finally, using such recently introduced media as the moving panorama and photography. In each case, the desire was to achieve new aesthetic results that would alter preconceived notions of Niagara's scenic character by creating a fresh relationship between viewer and depicted scene.

John F. Kensett (1816–1872) was one of the first to become thoroughly "Niagarized."[144] During his initial visit in August 1851, however, he encountered one of the most persistent problems plaguing sketchers—too many onlookers. "The crowd," he reported, "is a slight obstacle to one's studying—indeed the first annoyance seemed beyond my patience—but I am now getting hardened and don't mind an audience of fifty."[145] The following year, Kensett returned for another lengthy and productive stay, and in 1857 returned to the Falls for a third and final sketching trip.

Kensett produced not only pencil sketches but a large number of *plein air* oil studies. In fact, few landscapists were to match his artistic output at the Falls.[146] The artist's own register reveals that between 1853 and 1856 seven Niagara canvases were sold to prominent collectors.[147] Titles of various recorded works indicate that Kensett painted not only the waterfalls and rapids, but the gorge, suspension bridge, the Whirlpool, and Brock's Monument as well.[148] Several listed works were moonlight views from Goat Island.

Kensett abandoned the conventions of the picturesque in the small Niagaras. Even though he often selected traditional points of view, geolog-

Fig. 39. John F. Kensett, *Niagara Falls*, ca. 1854. United States Department of State, Diplomatic Reception Rooms, Washington, D.C.

ical reality dictated compositional arrangements. As a result, there is a refreshing realism to his pictures. In his works (cat. no. 122) the pictorial rhetoric generally applied to views from below the Canadian bank is absent, allowing the spectator an unusually direct and invigorating response to the actual scene. The oil studies made at the site in 1851 and 1852 were later used as models for larger, studio productions such as the oval canvas of about 1854 (fig. 39) in the State Department. In this worm's-eye view of the distant Horseshoe, the old iconography of the sublime—blasted trees, Indians and storms—has been banished. Instead, it conforms to the mid-century's conception of the sublime as the highest form of morally elevating beauty. Not all of the artist's Niagaras were quiescent illustrations such as this; others were dramatic close-ups (figs. 40, 41).[149]

Fig. 40. John F. Kensett, *Rapids Above Niagara*, ca. 1857 (cat. no. 124). Professor and Mrs. William B. Rhoads.

Jasper Cropsey (1823–1900) first visited the Falls in August 1852 and was deeply impressed by the scenery. "This sublime nature about me," he wrote to his wife Maria, "constantly moves my soul in admiration of its creator."[150] Like Kensett, he sketched in pencil and oil, depicting a wide variety of motifs. One view in particular caught his attention—the vista downriver from a rock twenty-five feet out from the base of Luna Fall. Peter Porter, son of the original owner of Goat Island, pointed it out and informed him that no artist had ever sketched the scene from that promontory.[151] Cropsey executed several studies and upon his return to New York worked up a large canvas, *Niagara Falls* (fig. 42), which he exhibited at the National Academy of Design in 1853. In September 1855 he returned to the Falls and once again sketched the "magnificent scene"[152] from the half-submerged rock. The following year he produced a small oil study of the view[153] and in 1857, while residing in London, he painted *Niagara Falls from the Foot of Goat Island* (see fig 80), which was chromolithographed in England.[154] In 1882, Cropsey made a final rendering of this signature-type Niagara composition.[155] So closely was the view identified with him that no other artist is known to have depicted it.

Fig. 41. John F. Kensett, *Terrapin Tower, Niagara Falls*, 1857 (cat. no. 125). Professor and Mrs. William B. Rhoads.

The viewpoint in Cropsey's *Niagara Falls* is exciting: the spectator is imaginatively placed out in the river. On the right-hand side of the composition, nearby Luna Fall and the American cataract are seen from an oblique angle, the great rocks at their base piled in a picturesque heap. To

the left, high up on the west bank and looking like a great white palace, is the newly enlarged Clifton House hotel. A great rainbow, set amidst veils of mist and spray rebounding from the rocks, spans the center of the composition. Viewers all too familiar with standardized images must have been startled and thrilled to see such a novel representation. In 1860, while still in London, Cropsey painted another unusual view. An upright composition of the Horseshoe Fall, seen from Goat Island (see fig. 103), it reveals the far-off cataract through a screen of foreground trees. In the lower left, seated on a rustic bench at a scenic outlook, is a smartly dressed female tourist. Her male companion, leaning against a tree trunk, bends solicitously toward her. The figures inject a sentimental note; perhaps they are honeymooners. The charming depiction suggests gentler qualities and quieter moods than those normally associated with the scene. One critic termed it a "novel view of that very hacknied subject, Niagara Falls."[156]

Nighttime depictions were another means by which artists of the 1850s offered new visions of the grandeur of the Falls. Paens to the moon's ability to "harmonize, to soften, to spiritualize"[157] the spectacle were especially numerous in the 1850s. One guidebook declared that

> *the pale, mysterious light . . . [sheds a] sweet influence . . . the rivers are turned into "vales of winding light"; the cliffs lose their harshness of outline; the trees, in their picturesque repose, look like the trees of a dream; even sound itself, in sympathy with the scene, falls upon the ear with softer cadence.*[158]

Another writer of the decade reported that the silvery luminescence imparted a "dreamy obscurity in which the imagination best loves to revel."[159]

Before 1850, few artists attempted to portray the scene by moonlight.

Fig. 42. Jasper Cropsey, *Niagara Falls*, 1853 (cat. no. 55). The Newington Cropsey Foundation, Greenwich, Connecticut.

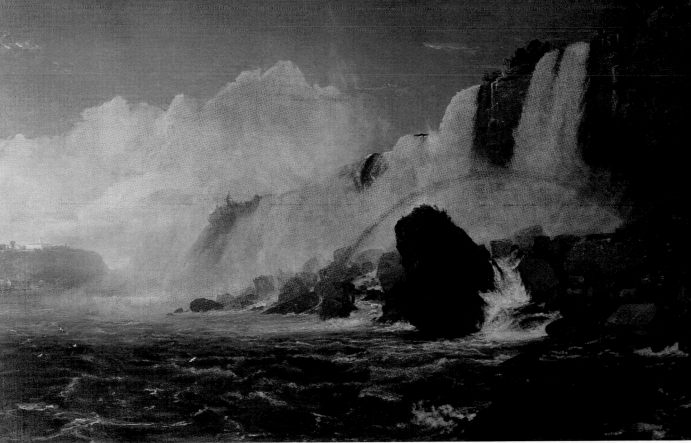

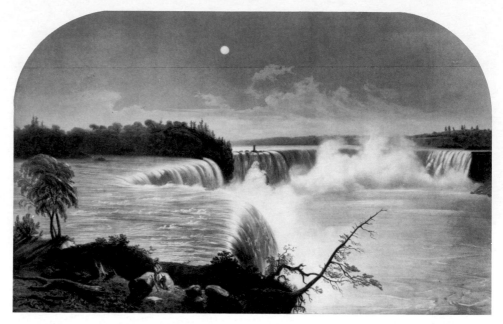

Fig. 43. Edmund Walker after Frederick W. Lock, *Niagara Falls. Summer View of the American and Horseshoe Falls by Moonlight*, 1856 (cat. no. 165). The New York Public Library, New York, New York.

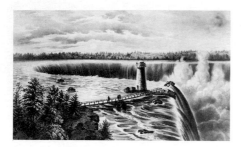

Fig. 44. Currier & Ives, *Niagara from Goat Island*, ca. 1865 (cat. no. 58). Royal Ontario Museum, Toronto, Canada.

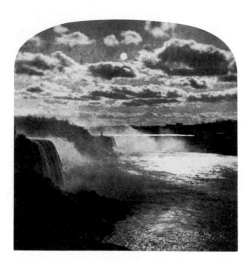

Fig. 45. George Curtis, *Falls from New Suspension Bridge—Moonlight*, ca. 1869–73 (cat. no. 66). Private Collection.

The earliest to represent the "rare union"[160] of sublime and beautiful effects was the English artist, J. R. Coke Smyth. His nighttime view was published as a color lithograph in 1839. It is an unconventional composition: with foreground eliminated, the viewer is suspended over the rushing torrent. To the right, the rising moon casts a long, glittering reflection down the length of the upper rapids and across the lip of the Horseshoe's brink. Its "sweet influence" does much to ameliorate the rhetorical terrors of the depicted scene.

The most affecting mid-century representation of Niagara by moonlight is Frederick Lock's (active 1843–60) *Niagara Falls. Summer View of the American and Horseshoe Falls by Moonlight* (fig. 43). The panoramic view is illuminated by a full moon in a cloudless sky; the river looks like molten silver; and the rising spray takes on a wraithlike character. The cold light imparts a lonely and silent quality to the landscape, and in the immediate foreground a solitary figure gazes thoughtfully at the spectacle before him. His relaxed pose and calm demeanor are outward signs of an inward reverie. Rarely was a setting to be suffused with so much poetic mystery.

The single most celebrated moonlight view—and one of the most famous of all Niagara paintings—was Regis Gignoux's (1816–1882) monumental canvas, *Niagara Falls by Moonlight*, dating from 1859. Although the canvas is lost, it is known today because of a full page engraving published in *Harper's Weekly*.[161] A view of the Horseshoe from the Goat Island side, it was hailed as a "worthy pendant"[162] to Church's daylight view from the opposite shore. The American critic James Jackson Jarves considered Gignoux's painting to be superior to Church's because of the poetic suggestiveness of the lunar reflections. "The mysterious conditions of a clouded moonlight," he wrote in his landmark book, *The Art Idea* (1864), "greatly heightens the effect of the whole scene, and baptizes it with the spirit of the imaginative unreal, making it the opposite of Church's Niagara by Daylight."[163] Gignoux's composition was the direct source for Currier & Ives' *Niagara Falls from Goat Island* (fig. 44). Whereas the painting had been devoid of human activity, the mass-produced print included a series of tourists enjoying the view from Terrapin Bridge.

The most sensational moonlit depiction is Herman Herzog's (1832–1932) vast canvas, *View of Niagara Falls in Moonlight* (fig. 46). In this dramatic depiction taken from the new suspension bridge erected in 1869 across the gorge next to the American Fall, the cold rays of a beclouded

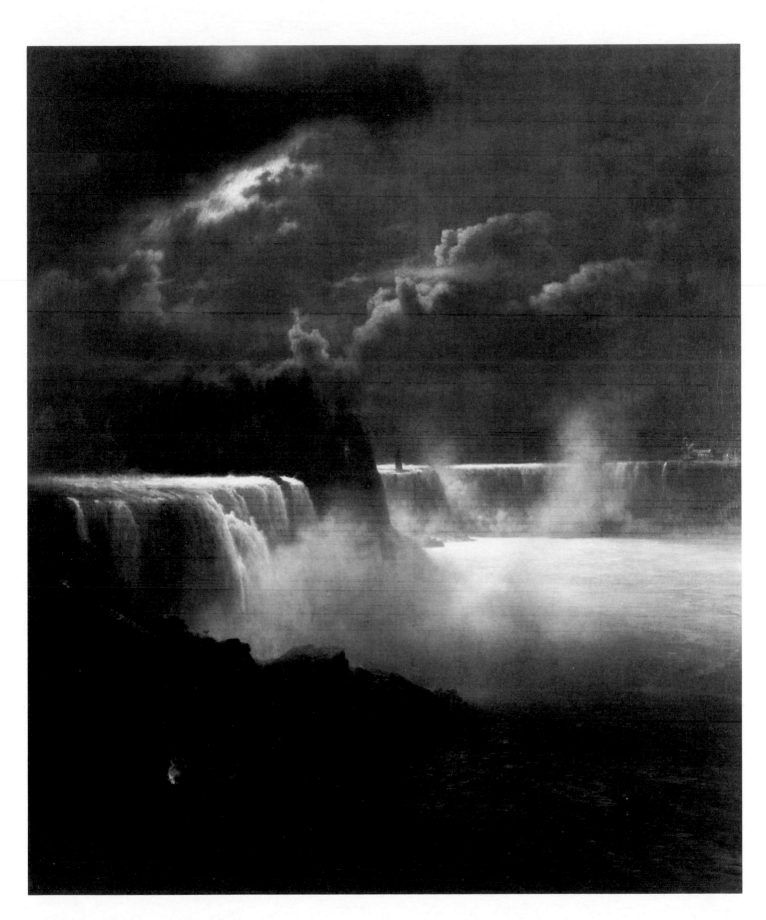

Fig. 46. Herman Herzog, *View of Niagara Falls in Moonlight*, 1872 (cat. no. 101). Museum of Fine Arts, Springfield, Massachusetts.

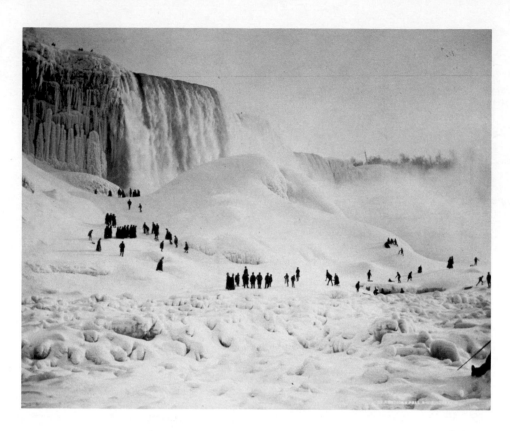

Fig. 47. George Curtis, *American Fall—Ice Mountain,* 1870s (cat. no. 60). Local History Department, Niagara Falls, New York, Public Library.

Fig. 48. Edward Anthony, *Niagara in Winter,* ca. 1860–61 (cat. no. 3). Private Collection.

moon reveal a dreamscape as suggestive as any fervid word-picture of the magical nighttime scene. It is a virtuoso piece of light-painting: the very weight, density, and texture of cloud formations, fields of spray, and falling water are revealed through varying degrees of translucency. The coldness of the moonlight is underscored by the warm tones of a bonfire on the dark shoreline below, a lantern in a ferryboat, and the illuminated windows of Table Rock House in the distance. This nighttime view was a popular one for stereographic photographers of the period (fig. 45).

The view of the cataracts by moonlight was surpassed in "radiant"[164] beauty only by the sight of them in winter daylight. As one writer commented, "the moonlit view is eclipsed only by the winter scenery of the Falls."[165] Between December and March, freezing spray coated trees, rocks, and manmade structures on the nearby shores, turning them into grotesque sculptural forms. Though the cataracts never froze, huge ice cones were slowly formed on the rocks below, partially obscuring them (fig. 47). Ice floes choked the rapids upstream and compacted ice completely covered the river in the gorge. Giant icicles hung down in such massive and intricate groupings at the borders of the waterfalls that they suggested fantastic architectural forms (fig. 48). "He who has not seen Niagara in mid-winter," intoned one mid-century journalist, "has not seen it in all its superbness."[166]

Although few travelers were on hand to witness the winter scenery "in all its glory"[167] during the first half of the century, winter trips to the Falls became fashionable in the 1850s. Throughout the decade, all manner of periodicals published lengthy reports effusively describing the splendors of the ice and snow-covered scene. According to one writer, Niagara's "intrinsic sublimity and beauty experience a literal transfiguration. Nature is idealized. Nothing more beautiful or enchanting can be conceived."[168] Others, however, were struck by the savage look[169] of the Falls in winter and felt the season restored Niagara to its former wilderness.[170]

Wintertime views were rare before the 1850s. The first ambitious canvas to communicate the melancholy character of the Falls in winter was

Gignoux's imposing *Niagara, Table Rock—Winter* (fig. 49). Exhibited at the National Academy of Design in 1847, the composition is the conventional, vertical view seen from below, which was first introduced by Alexander Wilson. Associations of fear and danger are substantially increased by the foreboding sky, shadowed abyss, and fantastic ice formations. Giant eagles swoop through the spray-choked air in front of the granitelike cataract, and three small figures (the foremost, an artist with his portfolio tucked under his arm) are perilously stationed on the icy path beneath the looming overhang of Table Rock. Few nineteenth-century portrayals of Niagara match the Gothic horror of this gloomy, ice-girt depiction.

In all, Gignoux painted four wintertime Niagaras.[171] The most famous, and one of the most popular paintings of the Falls in the mid-century, was *Niagara Falls in Winter* (1858), a sunrise view of the Horseshoe Fall from Goat Island celebrated for its delicate coloration. Its present whereabouts unknown, the canvas was purchased by Williams & Stevens as "a pendant for Church's *Niagara*,"[172] and in July 1859 both paintings were exhibited side by side. In the opinion of the *New York Leader*, the "TWO GREAT PAINTINGS . . . should always be viewed together, for they are counterparts of Niagara."[173] Not all of Gignoux's Niagaras were moonlight or winter views: *Niagara Falls* (cat. no. 91) painted in 1855 is a standard summertime portrayal from the base of the Canadian cliff.[174]

Among the spate of winter views produced in the mid-1850s, two large lithographs—Edwin Whitefield's *View of Niagara Falls* and Frederick Lock's *Winter View of the Horseshoe Fall Taken from the Canadian Side*—were published in 1856. In the lower right of Lock's composition is the figure of an artist, his easel mounted on a snow bank, gazing rapturously at the spectacle. Jasper Cropsey's *Niagara Falls in Winter* of 1868 (fig. 50), on the other hand, is a particularly luminous representation: the brilliant orb of the sun seen above the American Fall irradiates the snow-covered landscape.[175]

Fig. 49. Regis Gignoux, *Niagara, The Table Rock—Winter*, 1847 (cat. no. 90). U.S. Senate Collection, Washington, D.C.

Fig. 50. Jasper Cropsey, *Niagara Falls in Winter*, 1868 (cat. no. 57). The Art Institute of Chicago, Illinois.

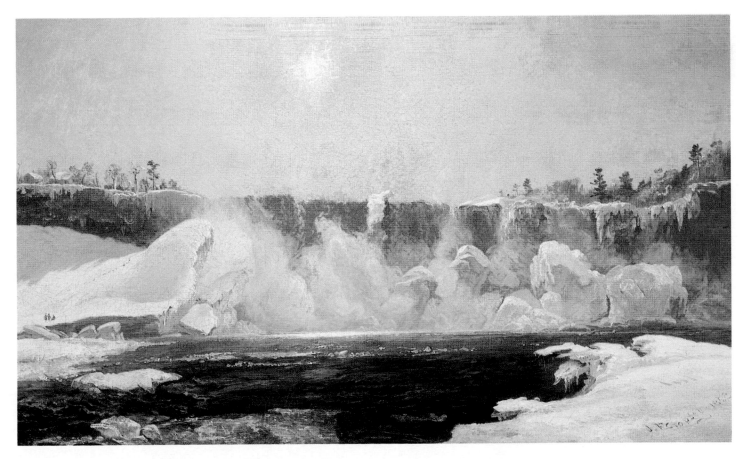

The moving panorama provided the best means of exhibiting Niagara's varied scenery most fully. After all, the scene itself had been described as "an endless diorama of ever-varying wonders . . . demanding, for its complete development, the beholder to take advantage of all possible positions at all hours of the day and evening."[176] The most famous of these productions, devoted in whole or part to the subject of the Falls, was the 1,000-foot canvas roll painted in 1853 by the Cincinnati landscapist, Godfrey N. Frankenstein (1820–1873).[177] In the years immediately preceding Church's *Niagara*, Frankenstein's creation was the most widely viewed and celebrated representation of the scene.

Frankenstein first visited Niagara Falls in 1844 and for the next nine years returned annually to sketch the waterfalls from every angle, at all times of day and season. By 1852, he had completed 200 different canvases. No other artist was to match Frankenstein's dedication or his artistic production, and had Church's canvas not eclipsed the panorama so completely, the Ohioan might well have earned the title of premier painter of the Falls.

The artist selected 100 views from amongst his Niagara paintings and, with the aid of two assistants, reproduced them on a canvas support that measured 9 feet by 1,000 feet. No longer extant, the work was exhibited so often it apparently wore out. Individual scenes are known today from a series of seventeen engravings published in *Harper's Monthly*[178]; a single canvas dated 1848 (fig. 52) was the model for one part. Reviews of the panorama called attention to the variety of scenes, which were arranged in sequence to suggest a walking tour of the site. According to one reporter, "no locality [had] ever been treated in such a numerous series of views."[179] The presentation was interrupted for dramatic purposes for, like a film, the hour-and-one-half long production was composed to avoid boredom. The climax of Frankenstein's so-called Metropolitan Niagara was the final sequence of winter views that were "altogether new and startling."[180] During a lengthy and popular tour of the nation in the mid-1850s, it was hailed as a "great national work . . . the pride of America."[181]

Another important, although disconnected, series of mid-century views were the Niagara canvases painted in 1855–56 by the visiting Danish landscapist, Ferdinand Richardt (1819–1895). Thirty-two different paintings were included in the artist's *Niagara Gallery* exhibition, which was held in New York in November 1856.[182] Hailed as "the most accurate views of Niagara Falls ever painted in this country,"[183] these topographical depictions were taken from numerous points of view, during various times of day. The extant canvases provide a faithful record of the local landscape.

In *Niagara Falls* (fig. 51), fifty-five individuals are carefully represented in the parklike setting of Prospect Point. The very texture of contemporary tourism is conveyed: some figures stand next to the river, others lean against railings, still more relax on benches. In the center foreground, an Indian woman carries a basket of native handicrafts (popular souvenirs of the period), while to the left, a group gathers by the peak-roofed daguerreotypist's studio, waiting to have their photos taken in front of the American Fall. Richardt's mammoth-sized general view from the opposite shore, *Niagara Falls* (fig. 53), likewise records all the tourist facilities: the Maid of the Mist wharf, the ferry slip, and the wooden changing house at the foot of the winding road where passengers donned protective oilskins before boarding the pleasure steamer and where carriages awaited fares. Richardt's canvases represent Niagara exactly as it must have appeared to Frederic Church in 1856.

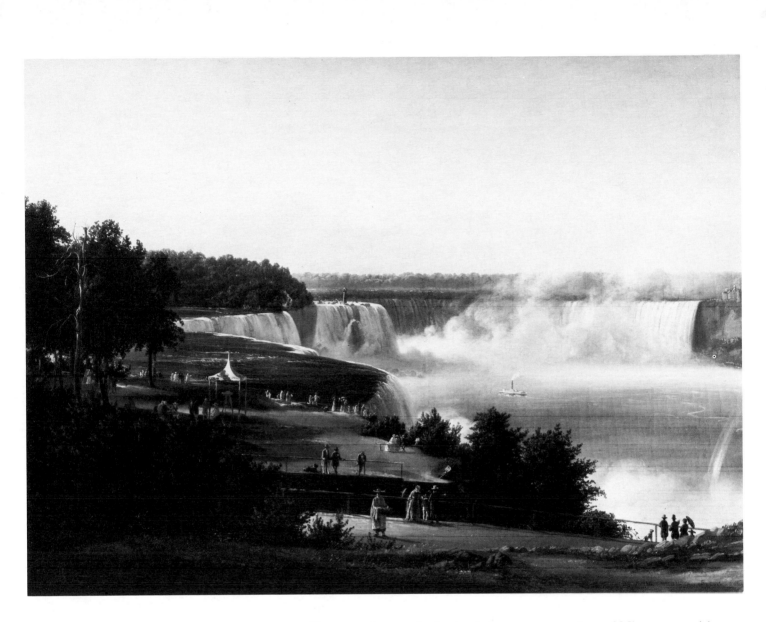

Fig. 51. Ferdinand Richardt, *Niagara*, ca. 1855 (cat. no. 141). The Heckscher Museum, Huntington, New York.

Photography revolutionized the representation of Niagara at mid-century. Just as the Falls had become the most painted, so it was to be the most photographed natural wonder in the last half of the nineteenth century. The earliest known example, taken about 1841, is a view of the Horseshoe from the Canadian bank in front of the Clifton House. A daguerreotype, it was published as an etched illustration (fig. 54) in N. M. P. Lerebours's *Excursions Daguerriennes* (Paris, 1840–44). The earliest ones to survive were the five daguerreotypes that formed the panoramic view of the Falls taken by the Langenheim brothers of Philadelphia (fig. 55).[184] The most widely known early photos were the double-whole plate daguerreotypes that were taken by Jesse L. Whitehurst of Baltimore and exhibited in the American photograph section of the Crystal Palace exhibition in London in 1851.[185]

The first resident "daguerrean artist" at the Falls was Platt D. Babbitt (cat. nos. 6, 7). Established by 1853,[186] Babbitt who had a monopoly to photograph tourists on Prospect Point, set up his camera in a peak-roofed pavilion. Nearly all the photos of visitors in front of the American Fall that date from the mid-1850s were taken by his hand. Apparently, Babbitt's camera was in position all day long and "when a group of visitors stood on the shore to survey the Falls from that point, he took the group—without their knowledge—and showed it to the visitors before they left."[187] In nearly every instance, he made a sale. Not all Niagara photos from the 1850s were snapshots of tourists. Many were aesthetically

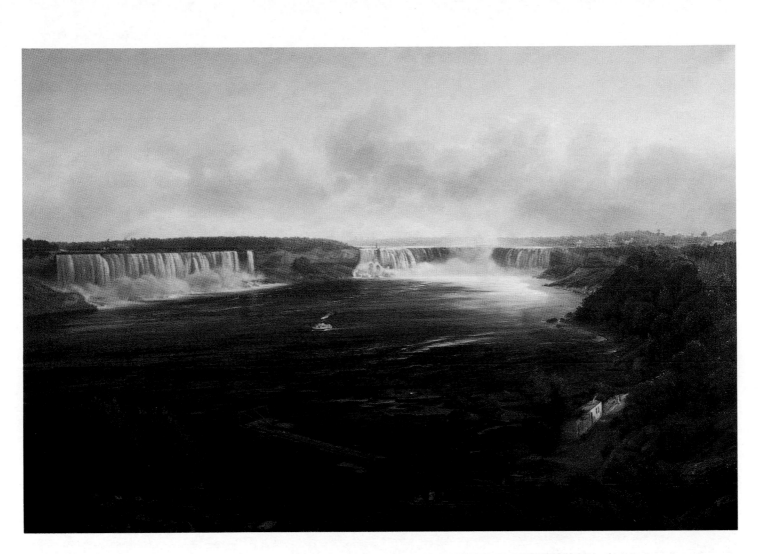

Fig. 53. Ferdinand Richardt, *Niagara Falls*, 1856 (cat. no. 143). United States Department of State, Diplomatic Reception Rooms, Washington, D.C.

composed works: close-ups, winter views, and dramatic angles that communicated the grandeur of the Falls.[188]

Among the most revolutionary photographic technologies perfected in the 1850s (at least in terms of its impact upon the public imagination) was stereoscopic photography. The stereograph was composed of two photos of the same subject taken from slightly different angles. When placed side by side on a cardboard mount in a hand-held optical viewer (known as a stereoscope), the two images fused into one. Since it approximated binocular vision, a three-dimensional image resulted. No other single subject in the world was to be stereographed as frequently as Niagara Falls,[189] and in the last decades of the nineteenth century millions of mass-produced Niagara views were retailed throughout North America, Britain, and Europe. By 1860, there were ten resident photographers producing stereos[190] as well as numerous visiting free-lance cameramen.

Stereographs of Niagara Falls and vicinity can be divided into two basic categories—picturesque and topographical. In the former, photographers sought unusual or evocative vantage points in order to capture the cataracts' scenic grandeur (fig. 56); in the latter, they took straightforward views that document buildings, bridges, tourist facilities, and dare-devil exploits (fig. 57). In the first category, aesthetic precepts comparable to those motivating painters influenced the selection of motif and view.

The appearance of the inexpensive stereograph virtually destroyed the market for prints of the Falls, and large engravings and lithographs virtually disappear after the 1850s. One print to prevail against the rising tide of three-dimensional photos was the magnificent chromolithograph of Church's *Niagara* (cat. no. 146).

Fig. 52. Godfrey N. Frankenstein, *Niagara Falls from Goat Island*, 1848 (ca. no. 86). Anonymous Loan.

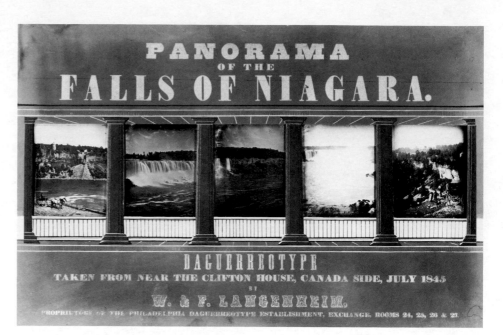

Fig. 55. Frederick and William Langenheim, *Panorama of the Falls of Niagara,* 1845 (cat. no. 126). Gilman Paper Company Collection, New York, New York.

Fig. 54. N. M. P. Lerebours, *Niagara, Chute du Fer à Cheval,* 1841–43 (cat. no. 130). Buffalo and Erie County Historical Society, Buffalo, New York.

Fig. 56. Charles Bierstadt, *Looking Under the Falls Canada Side, Niagara, NY,* late 19th century (cat. no. 35). Private Collection.

Fig. 57. Edward and Henry T. Anthony, *Clifton House,* 1871–74 (cat. no. 4). Private Collection.

Frederic Church reportedly visited Niagara Falls in August 1851,[191] but his first documented sketching trip occurred in March 1856, at the end of an exceptionally severe winter.[192] On-site pencil, gouache, and oil studies reveal that although he pictured the cataracts from various conventional standpoints on the American shore, he was particularly impressed by the view of the Horseshoe and Terrapin Tower from Goat Island at sunset (fig. 58).

Church returned for a second and longer stay in early July 1856 and was back again for yet another sojourn in late August–early September. Unlike most of his contemporaries, he did not select one or more appealing views and prepare finished sketches as models for studio canvases. Instead, as demonstrated by the numerous extant studies, he was interested in details, aspects of the whole.[193] Only a handful of his sketches are self-sufficient works. In 1856, Church painted a small studio canvas of the Horseshoe Fall from the American side (Wadsworth Atheneum). It was his first attempt to represent the cataract's liquid formations in a scientifically accurate fashion, recording how the river, in its downward plunge, undergoes dramatic alterations in density and color. In comparison to the extraordinary illusionism of the final composition, however, it is clear that the artist had yet to learn to mimic nature's action.

The single most important decision that Church faced in his New York studio was the selection of the viewpoint for his proposed large canvas. He was familiar with many of his contemporaries' works and doubtless with the tradition of illustrating the Falls in general. In fact, he had already painted an ambitious composition twelve years earlier. As a student of Thomas Cole, Church produced a large *Niagara Falls* (cat. no. 44) based on his teacher's famous *A Distant View* (see fig. 38).

A small thumbnail drawing in the collection of the Cooper-Hewitt Museum represents the initial idea for *Niagara*'s grand compositional design. A conceptual vision, rather than an actual view, it is an all-embracing representation taken from an astonishing point of view near the very brink of the western edge of the Horseshoe. Late in 1856, Church painted a panoramic oil study based on this design (fig. 59). Measuring twelve inches by thirty-five inches, it appeared to accomplish in a single cohesive image what generations of artists had tried to do in two or more pictures: not only is the local geography accurately recorded but the visi-

Fig. 58. Frederic Church, *Niagara from Goat Island, Winter,* 1856 (cat. no. 45). Cooper-Hewitt Museum, Smithsonian Institution, New York, New York, (1917-4-765A).

tor's own psychological reaction is embodied in the close-up viewpoint. A New York critic reviewed the oil study in Church's studio: "He has succeeded in making the most comprehensive view of the Falls yet achieved, and . . . when transferred to a large canvas and finished, it will be the most satisfactory view of the cataract ever made."[194]

Church, however, was dissatisfied with this pictorial solution and rejected it as a model. He may have determined that it was too comprehensive and lacked both a structural cohesion and psychological focus. For whatever reason, Church decided to reorganize the basic design and in January 1857 painted a new compositional study (fig. 60). While retaining the same panoramic format of the previous work, this second oil sketch concentrated solely on the great sweep of the Horseshoe Fall. The small painting was reviewed in the February issue of *The Crayon:*

> *Mr. Church . . . exhibits a sketch of Niagara Falls, which more fully renders the "might and majesty" of this difficult subject than we ever remember having seen these characteristics on canvas. The point of view is happily chosen, and its impressiveness seems to have been produced by . . . a skillful subordination of accessories; the eye is not diverted, led away, as it were, from the soul of the scene by the diffuse representation of surrounding features.*[195]

Fig. 59. Frederic Church, *Niagara Falls,* 1856 (cat. no. 47). Private Collection.

In this second study, Church undertook a thorough re-vision of the

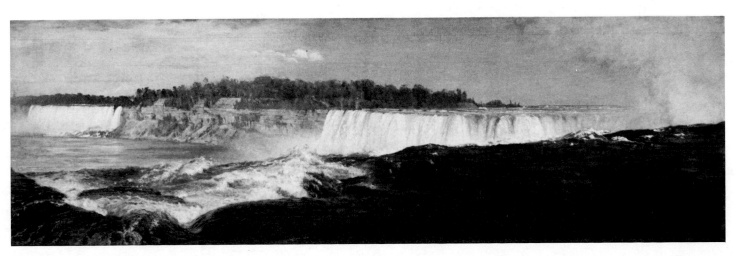

Fig. 60. Frederic Church, Study for *Niagara*, ca. 1857. (cat. no. 50). New York State Office of Parks, Recreation and Historic Preservation, Bureau of Historic Sites, Olana State Historic Sites, Taconic Region.

subject, physically and psychologically. By centering his attention on the single motif of the Horseshoe Fall, he created a more unified design with greater visual force. The giant waterfall takes up fully three-quarters of the composition, giving the work a monumentality and cohesiveness that was lacking in the earlier study. The picture now represented the very essence of the Niagara experience—vast amounts of water in furious motion. No previous painter had dared to depict so little, yet represent so much.

The final canvas was finished in April 1857 (see fig. 1). The panoramic proportions of the study were maintained but the viewpoint was raised slightly and the sky increased in size. In the left foreground, near the brink of the cataract, Church added a broken rainbow and a tree trunk. On the balcony of Terrapin Tower, he painted a female visitor: so minute, she remains almost invisible to all but the most observant. Her scale matches that of an actual visitor standing at the opposite edge of the real Horseshoe.

Like the Falls, *Niagara* induced an experience of the sublime in all who saw it. The psychological experience differed only in degree. Fundamental to the picture's effectiveness was the elimination of a traditional foreground. Without a psychological barrier erected between him and the depicted scene, the spectator is propelled into *Niagara*'s fictive space and discovers himself suspended above the surging waters. It was a daring and highly effective strategy to involve the viewer emotionally. By deliberately dispensing with the conventions of the picturesque, Church created a new type of picture devoid of preconceptions. The terrifying yet exhilarating power of the scene was to be palpably *felt* for the first time. The viewer experienced the sublime before *Niagara* by willingly suspending disbelief. The painting *was* Niagara: the illusion of reality was so complete that it was easy to exclaim, as so many did, "this *is* Niagara, *with the roar left out*!" Central to its illusionism was the replication of the action of moving water —among the most difficult of subjects to represent. "To paint running water is always difficult," noted the London *Times*,

> but when the running water is the expanse of a mighty river . . . hurrying to such a fall, it may well be imagined what labor has been necessary . . . what patient mastery . . . to leave the spectator impressed, as by the astounding reality, with the abstract of motion and sound.[196]

Niagara remains the finest depiction of liquid motion in western art. It is unsurpassed in its realistic representation of hydraulic forces. In an unequaled fashion, Church anatomized the river's flow and recognized that outward appearances were the direct result of invisible energies

occurring beneath the surface. Other painters had looked at the Falls and seen bewildering action; Church, with his mind's eye attuned to the inner life and logic of running water, looked and saw—and painted—the intelligible drama of natural history unfolding before him. No previous landscapist had been as scientific in his approach to painting water. While Turner had understood the nature of hydraulic forces, his marine and river landscapes gave the impression of movement through *texture*. In Church's *Niagara* water, not paint, is suggested.[197]

Its stunning illusionism notwithstanding, *Niagara* is a grand idealization. Not only is the viewpoint imaginary, but the actual shape of the painted cataract conformed to an abstract order that the artist firmly imposed on the entire twenty-four-and-one-half-square-foot surface. Its configuration was altered to fit the arbitrary dimensions of the panoramic canvas (the proportions of which are 1:2). The western profile of the Horseshoe in the immediate foreground was stretched dramatically so that it reached the great reentrant angle which Church placed at the right. This resulted in a surprisingly cohesive and elemental composition that is radically reductive and unadorned because the great curve of the cataract is the simple armature upon which the myriad details are elaborated. Yet that simplicity is deceptive; there is a rigorous system of internal organization that is highly complex. Throughout, the two-dimensional nature of the picture plane is stressed: the composition is comprised of two horizontal bands of sky and water, and there are a series of interlocking formal correspondences above and below the horizon line. At the same time, however, the composition is developed in three dimensions. Insistent spatial recessions pull the imagination deep into illusory distance so that the eye is subconsciously directed not only across the face of the picture but far into its fictive depths. There is a primary point of focus though: as the eye sweeps across the plane and back into space, it comes back to rest on a specific spot—the notch on the lip of the cataract in the center of the painting. It is a point of rest and departure as the imagination makes its continuing journey of discovery.

Niagara is a carefully edited vision of the Horseshoe Fall as seen and felt by a visitor who has achieved the final, resolution phase of the sublime, when feelings of fear have been transformed into uplifting peace. The sense of calm that pervades the picture is largely the result of the order and balance of the compositional arrangement, but it is also poetically expressed in the image of a departed thunderstorm. The cumulus cloud on the horizon and the parted clouds above the waterfall reveal that a storm has recently passed. In its wake the rainbow, with its elevating associations of divine peace, reappears and the whole scene seems to sparkle with a renewed lustre. In the transition from storm to calm, the landscape, like the sublimed imagination, is spiritually transfigured. The cataract's awesome sublimity has been converted into inspiring beauty.

Charles Dickens's response to the close-up view of the Horseshoe from Table Rock is perhaps the closest literary equivalent to Church's *Niagara*.

> *It was not until I came on Table Rock, and looked—Great Heaven, on what a fall of bright-green water!—that it [Niagara's vastness] came upon me in its full might and majesty. Then, when I felt how near to my Creator I was standing, the first effect, and the enduring one—instant and lasting—of the tremendous spectacle, was Peace. Peace of Mind: Tranquillity: Calm Recollections of the Dead: Great Thoughts of Eternal Rest and Happiness: nothing of Gloom or Terror. Niagara was at once stamped upon my heart, an image of Beauty: to remain there, changeless and indelible. . . .*[198]

Church's painting is a satisfying representation of the mid-century's transcendent re-vision of Niagara's aesthetic character. In *Niagara*, as in contemporary meditations on the scene, the beautiful and the sublime have been conflated into a new order of grandeur: the "sublimely beautiful."[199] The recognition of this inspiring mode of beauty was more a religious than an aesthetic act: beauty and sublimity respectively represented divine love and the terrible wrath of God.[200] The juxtaposition of the rainbow and the cataract in reality and in *Niagara* was a revelation that the "sublimity that bears token of God's power" is always accompanied by the "beauty which testifies to his love."[201] In few landscapes of the nineteenth century were divine benevolence and omnipotence displayed so effectively as in Church's painting; in many quarters, *Niagara* was viewed as a religious work of art. One writer considered the picture a revelation of those beatific visions that foreshadow the "unseen beautiful."[202] The painting was a representation of divinity as experienced in and reflected through Nature's Grandest Scene.

Like his contemporaries, Frederic Church interpreted his subject typologically.[203] In the 1850s, a material *type* was an "anticipatory, prophetic model" of something in heaven.[204] It was a natural phenomenon that functioned as a sign or emblem from God, prefiguring the divinely ordained future. Like the Old and New Testaments, the material and spiritual universes were envisioned by Church's generation as analogous, paralleling one another. Like the Bible, natural scenery—or to use a metaphor common to the period, the Book of Nature[205]—was a living text rationally composed by the hand of the Creator for the instruction of mankind. As Asher Durand put it in 1855, nature was "fraught with lessons of high and holy meaning."[206] As the terrestrial world's Grandest Scene, the most magnificent leaf in the "mystic volume"[207] of the Book of Nature, Niagara Falls surpassed all other landmarks in divine significance. As the finest depiction of the Falls, Church's *Niagara* appropriated all of the scene's biblical associations.

In the Romantic age, Niagara Falls was regularly interpreted as a "type of the Eternal,"[208] an earthly manifestation of God's unseen attributes. In 1852, the Reverend Henry Cheever wrote "we look at Niagara and we think of God—his attributes—his infinite power—his eternity—his incomprehensibility—and the unfathomableness of divine truth."[209] The force of the plunging waters was interpreted as analogous to divine wrath, while the beauty of the rainbows was perceived as a sign of His mercy. A popular guidebook of 1838 commented at length on the typological significance of the site, a significance that Church's generation accepted unquestioningly.

> *It seems to be the good pleasure of God, that men shall learn His Omnipotence by evidence addressed to the senses . . . and that there shall be on earth continual illustrations of His mighty power. . . . The floods of Niagara, by the majesty of their power and ceaseless thunderings, proclaim to the eye, and to the ear, and to the heart, the Omnipotence of God. . . . In beholding this deluge of created Omnipotence, the thought, how irresistible is the displeasure of God, rushes upon the soul. It requires but little aid of the imagination to behold in this ceaseless flow of waters, the stream of His indignation, which shall beat upon the wicked, in the gulf below the eternal pit. . . . With these associations, all is dark, terrific and dreadful, till from the midst of this darkness and these thunderings, the bow, brilliant type of mercy, arises, and spreads its broad arch over the agitated waters, proclaiming that the Omnipotence which rolls the stream is associated with mercy as well as justice.*[210]

The Eternal Rainbow of Niagara[211] was also viewed as typical of the

Fig. 61. Frederic Church, Study for *Under Niagara*, 1858 (cat. no. 52). New York State Office of Parks, Recreation and Historic Preservation, Bureau of Historic Sites, Olana State Historic Site, Taconic Region.

covenant established between God and man in the aftermath of the Flood, and visitors to the Falls considered it suggestive of that "emblem of peace"[212] first seen by Noah. In 1843, John Quincy Adams declared the "promise-bow"[213] to be a constant "pledge of God that the destruction from the waters shall not again visit the earth."[214] Standing next to the Sovereign of the World of Floods[215]—or in front of Church's *Niagara*—the nineteenth-century traveler was imaginatively transformed into a modern Noah, a witness to a regenerated earthscape, free from sin.[216]

Niagara was not only a "type of the Eternal" but a prophetic model of the American nation. Church captured not only the absolute spirit of the place but the expansive spirit of his age. Like its subject, the painting was representative of the nation's collective aspirations. According to G. W. Curtis in 1855, Niagara Falls was "the grand, central, characteristic object of American scenery, the majestic symbol of unceasing life and irresistible progress." Its waters were not only an "image of life but of that which makes life valuable—liberty."[217] Curtis imagined the "eternal anthem"[218] of the Falls as an inspirational voice "in the heart of the continent," urging the nation onward: "the trumpet-like cataract . . . like a voice from heaven, [cries] aloud, FORWARD!"[219] Beyond the unbroken horizon line of *Niagara*, the spectator of 1857 sensed the vast space of the continent itself, waiting to be filled.

In the words of the *Home Journal* in 1853, "the spirit of the age, the spirit of the nation should form the soul of the artist."[220] Writing in 1859, the novelist and critic Adam Badeau declared that Church indeed caught the spirit of the times and "embodied it in his 'Niagara.'" It was, he asserted, "the finest picture yet done by an American artist; at least that which is fullest of feeling."[221] It was "a true development of the American

Fig. 62. Frederic Church, *Niagara Falls, from the American Side,* 1867. National Gallery of Scotland, Edinburgh, Scotland.

Fig. 63. Albert Bierstadt, *Home of the Rainbow—Horseshoe Fall, Niagara*, ca. 1869 (cat. no. 28). Mr. and Mrs. George Strichman.

Fig. 64. Albert Bierstadt, *Niagara Falls from the Canadian Side*, ca. 1877 (cat. no. 31). National Gallery of Canada, Ottawa.

mind; the result of democracy, of individuality . . . of the liberty allowed to all."[222] In the "rush of Church's Niagara, . . . the fitful, easy, yet splendid intensity of today"[223] was abundantly expressed. The painting was "the concretion, the result, of the influences of the present world."[224] "In no other way," Badeau concluded, "can one affect the world than . . . in embodying thus its ideas."[225] In crystallizing the aspirations and beliefs of mid-nineteenth-century Americans, Church created a national icon which, like the subject itself, fused "in a single image ideas of American nature, American character, and American destiny."[226] As a votive picture, *Niagara* was a revelation of American Genesis, a promise of spiritual regeneration in the here-and-now. As David Huntington has written, *Niagara* was a "cultural erasure, [an] icon for forgetting the past."[227] Not only was it a composition that owed nothing to artistic conventions, it was a succinct representation of America's "mythical Deluge which washes away the memory of an Old World so that man can live at home in a New World."[228] In front of *Niagara*, seemingly right before the "grand, central, characteristic object of American scenery," the viewer of 1857 felt like a latter-day Noah, a New Man in a New World.

Church's interest in the Falls did not end with the completion of *Niagara*. In August 1858, he returned to the site for a month-long stay. Toward the end of his sojourn, he chartered the *Maid of the Mist* to take him to the very base of the Horseshoe Fall. No artist had dared venture so close, and the captain kept the steamer headed into the current for forty minutes while Church made a rough oil sketch. The small work (fig. 61) was the basis for his next Niagara canvas, *Under Niagara* (whereabouts

Fig. 65. Thomas Moran, *Rapids above Niagara*, 1885 (cat. no. 138). Donald and Kathryn Counts.

unknown). Completed in "a single day of fervid and impetuous toil,"[229] in May 1862, it measured four feet by six feet. It was immediately shipped to London where it was reproduced as a chromolithograph (cat. no. 145). If *Niagara* was a peaceful portrayal of the sublime as transcendence, *Under Niagara* was an exciting evocation of the terrible sublime. The cataract seems to pour out of the sky, almost overwhelming the viewer.

Four years later, Church returned once more to the subject. Commissioned by the New York art dealer Michael Knoedler to paint another grand view of the Falls,[230] the artist reviewed his sketches and selected a detailed drawing of the vista from the vicinity of Prospect Point, which he made during July 1856.[231] The work was finished in March 1867. Entitled *Niagara Falls, from the American Side* (fig. 62),[232] it was among the largest he ever painted: it measures eight feet six inches by seven feet seven inches. Knoedler shipped the painting to London where, like Church's other views of the scene, it was chromolithographed. Exhibited in a commercial gallery, it stunned Britons with its scientific accuracy. One critic commented that "future generations may come to this picture as a splendid page of the world's physical history, a true and faithful record of a great marvel."[233] But *Niagara Falls, from the American Side* is not, like *Niagara*, a symbolic representation of Nature's Grandest Scene, but rather a spectacular depiction of the cataracts' scenic splendor from a viewpoint long considered the most beautiful of all. It was to be the artist's last ambitious portrayal of American scenery, painted on the eve of his first trip to the Old World.[234]

Church's great rival in the 1860s and 1870s, Albert Bierstadt (1830–1902), was also greatly attracted by the subject of Niagara Falls. He first visited the site in the summer of 1869, staying with his famous

photographer-brother Charles who lived and worked in Niagara Falls, and returned on several occasions.[235] Bierstadt painted numerous Niagaras — the exact number is unknown, but there are at least a dozen extant canvases.[236]

Few landscapists after the Civil War were to represent the Falls and their setting so variously. Some pictures were dramatic close-ups; others, distant views (figs. 63, 64); some epic visions; others, unaffected glimpses (cat. nos. 29, 32). Charles Bierstadt's Niagara photographs may well have influenced his brother's paintings. In numerous instances, there is a photographic realism to the ragged cedar trees and broken rocks in the foreground. In other works, the foregrounds have been imaginatively arranged so that features such as fallen trees lead the eye diagonally into the middle distance, approximating the three-dimensional effects achieved with similar devices in stereo views. None of Bierstadt's Niagaras contain extra-aesthetic meanings: they remain visually interesting and often novel views of a much-painted scene.

Thomas Moran (1837–1926), like Bierstadt, another celebrated painter of the natural wonders of the Far West, also painted Niagara Falls.[237] For the most part, his drawings and paintings focused on the enormous energy of the rapids, both above the Falls (fig. 65) and below, in the narrow gorge. In each case, the artist consciously strove to create pictorial effects that bordered on the theatrical. His views of the cataracts also concentrate on the river's vast hydraulic forces. The view of the American Fall from below Goat Island cliff was a favorite (fig. 66). Moran's depictions of Niagara, executed in the 1880s, are the last pictorial images by a leading landscapist in which the rhetoric of the terrible sublime found full and imposing expression.

Fig. 66. Thomas Moran, *Cave of the Winds, Niagara*, ca. 1881 (cat. no. 137). Anonymous Loan.

In the aftermath of the Civil War, culture in America underwent a radical transformation. Out of the wreckage of the older order, a new and far more complex society emerged, one in which artistic values were distinctly different. During the fourth quarter of the nineteenth century, American art abandoned its provincial character and became cosmopolitan.[238] "Art for Art's Sake" replaced Ruskin's "Truth to Nature" as the principal rallying cry as younger artists sought out the avant-garde in such distant art centers as London, Munich, and Paris. Imitation of nature, characteristic of the landscapes of the Hudson River School, was replaced by painterly techniques in which the process of artistic creation mattered as much, if not more, than subject. Moreover, Americans' vision of nature was radically altered. No longer was landscape viewed as the Book of Nature, hallowed by divine grace. With the growing acceptance of the world view of Charles Darwin in the 1870s and 1880s, nature was increasingly secularized.[239] Its previous symbolic significance slowly faded. A new generation perceived Niagara's dazzling rainbows as products of sunlight refracted through moisture, not symbols of God's mercy and love. And the cataracts themselves, once terrestrial signs of divine wrath, were viewed as an extraordinary spectacle of hydraulic power capable of being harnessed for the production of electricity.

After 1870, the number of Niagara paintings declined dramatically. In large measure, this was due to the collapse of the ideology of the sublime and a general shift of interest away from native landscape to new subject matter—the figure, history, and urban scenes.[240] Moreover, by the 1870s, the natural beauty of Niagara's setting had been despoiled by decades of unrestricted commercial and industrial development. With the exception of Goat Island, the immediate neighborhood had become urbanized. Its very accessibility had ensured that Niagara Falls would be overrun by civilization. A visit to the Falls in the 1870s was in many ways an unpleasant

Fig. 67. George Barker, *Niagara Falls*, 1880s (cat. no. 18). Buscaglia-Castellani Art Gallery of Niagara University, Niagara Falls, New York. Dr. and Mrs. Armand J. Castellani Collection

experience for, at every step, the tourist was harassed by organized bands of souvenir hawkers, carriage drivers, guides, and photographers. It was virtually impossible to escape them, and the number of upper- and middle-class tourists to visit the Falls began to decline. For those in search of the sublime and unspoiled natural grandeur, Yosemite, Yellowstone, and other wonders of the Far West beckoned. What Niagara Falls had been to the first quarter of the century, the spectacular scenery of the Rockies was to the last.

But the features of the Falls did not go unrecorded during this period; the fourth quarter of the century proved to be the age of photography at Niagara. Photographers, such as Charles Bierstadt, George E. Curtis, George Barker, and, in the late 1890s, William Henry Jackson,[241] continued the tradition of Church, Bierstadt, and Moran by producing dramatic images in the spectacular mode (fig. 67). Jackson's monumental colored photograph from the vicinity of Prospect Point (fig. 68), reminiscent of Church's *Niagara Falls, from the American Side*, is the final expression of the grandiose rhetoric of the Hudson River School at Niagara Falls.

Several important American artists of the period, however, did paint the Falls. In June 1878, European-trained William Morris Hunt (1824–1879), Boston's leading portraitist, visited Niagara for a vacation. Orginally, he had no intention of sketching the scene, but he was so impressed by the sight of the waterfalls and rapids that he immediately sent back to Boston for his painting materials. During his month-long stay, Hunt exe-

Fig. 68. William H. Jackson, *Niagara Falls from Prospect Point*, ca. 1898–1908 (cat. no. 116). Library of Congress, Washington, D.C.

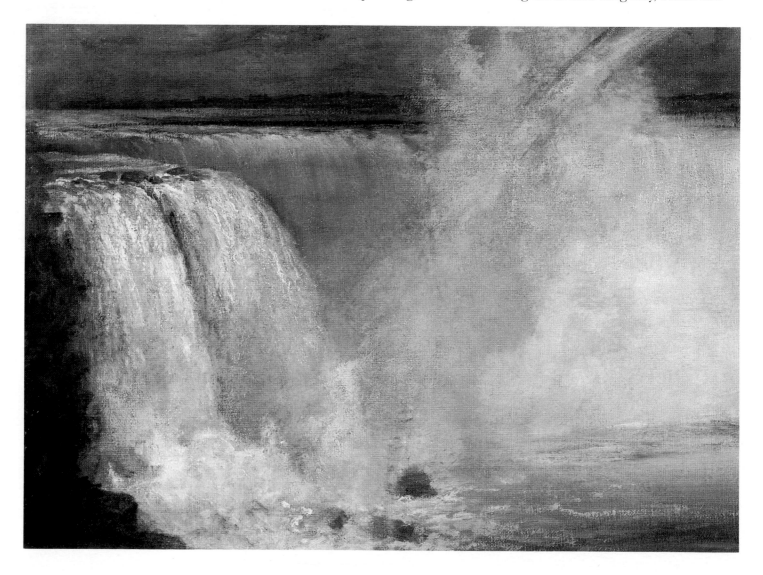

Fig. 70. William Morris Hunt, *Niagara Falls*, 1878 (cat. no. 110). Smith College Museum of Art, Northampton, Massachusetts.

cuted a series of charcoal drawings and pastels as well as several oil paintings, of which *The Rapids, Sister Islands, Niagara* (cat. no. 112) is an example.[242]

Hunt's vision of nature was post-Romantic. He was primarily concerned with representing the interaction of color and light, not evoking the sublime or suggesting the cataracts' symbolic significance. His depictions are self-sufficient exercises in abstract design, bravura brushwork, and subtle coloration. The *American Fall, Niagara* (fig. 69) was his favorite. He referred to the powerfully painted work as the "brown Niagara" because of the somber red-brown sky that contrasts with the vivid emerald hues on the cataract's brink and the opaline tints in the falling water and spray.[243] The picture at Smith College (fig. 70) is the most innovative. It is an almost formless, close-up view of the Horseshoe in which the textured brushwork and delicate colors—not the waterfall—are the real subjects of the painting. Artistic technique, not the identity of the scene, is of paramount importance.

In the same month Hunt was painting at the Falls, he received a commission to decorate two lunettes in the New York State Capitol in Albany. One of the themes he originally intended to treat in his murals was Niagara Falls. Back in his Boston studio he executed two mammoth-sized canvases: one was a version of the "brown Niagara" and the other, an equally large view of the Horseshoe Fall from the Canadian side that is clearly indebted to the design of Church's *Niagara*.[244] In the end, however, he selected more conventional, allegorial subjects for his Albany murals.

Another American artist who painted the Falls after 1875 was George Inness (1825–1894). Like Hunt, Inness arrived without his painting materials but was so impressed by the scene that he was inspired "to get [his] impression of the falls down right away" and rushed to the Buffalo studio of an old friend where he demanded brushes, paints, and canvas.[245] His initial impression in 1881 was ultimately translated into a large studio canvas.[246] It is an unusual work for Inness—a dramatic view of the Horseshoe Fall from the bank of Goat Island that includes an eagle evoking the sublime. A reviewer in 1884 found the painting "stirred the blood and fired the imagination"[247]—an expressiveness the artist's usual views of pastoral scenery deliberately avoided.

In all, Inness painted seven oils and one watercolor of Niagara between 1881 and 1893.[248] The composition that appealed to him the most, and one which he repeated on three occasions, was the view of the American Fall seen face on from the Canadian bank. The large version (fig. 71), like the others, displays a characteristically dematerialized landscape in which there is no solidity to forms. Everything has been dissolved in a lustrous atmosphere. Even the dark smoke from the Bath Island paper mill chimney is blended with the mists from the cataract to veil the landscape. Like the artist's other late landscapes, it is a highly personal vision of nature.[249] The scene no longer contains a collective meaning; Inness' picture is a private, subjective depiction. It is a quiescent view that does not evoke the sublime but instead suggests an exclusive, hermetic experience.

The last American artist to treat the subject of Niagara Falls in depth was John Twachtman (1853–1902). In the early 1890s, he was commissioned by a Buffalo physician, Dr. Charles Cary, to paint the scene. Eventually, he produced a series of fourteen canvases.[250] The first of these was exhibited in 1894, the date traditionally given to all of them, but he is likely to have painted Niagaras from sketches or memory throughout the remainder of the decade.

Fig. 69. William Morris Hunt, *American Fall, Niagara* 1878 (cat. no. 111). The Corcoran Gallery of Art, Washington, D.C.

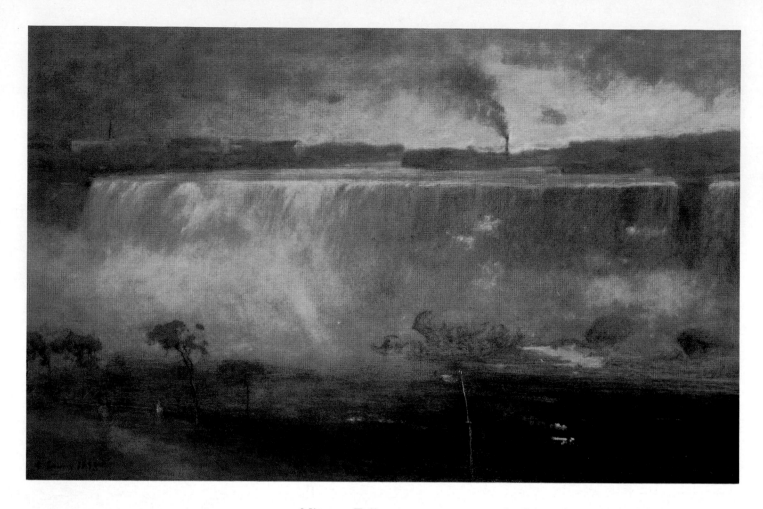

Fig. 71. George Inness, *Niagara Falls*, 1893
(cat. no. 115). Hirshhorn Museum and Sculpture
Garden, Smithsonian Institution, Washington,
D.C.

Fig. 72. John H. Twachtman, *Niagara in Winter*,
ca. 1894 (cat. no. 156). The New Britain
Museum of American Art, Connecticut.

Niagara Falls was a most unusual subject for the impressionist
Twachtman. Normally, he avoided such dramatic and spectacular scenes.
His landscapes generally are intimate glimpses of rural scenery in and
around his Connecticut country home. Often, he repeated the same motif
at different times of day and season, seeking to evoke the variety of quiet
moods aroused by changes in season and atmosphere.

Twachtman's compositions are highly abstract; forms are usually
reduced to flattened shapes with sinuous outlines. Often, there is an Ori-
ental grace to his works; colors are soft and pale, and brushwork is deli-
cate. His Niagaras depict the gorge and Falls from below, traditionally the
most awesome of vantage points. Yet instead of exciting views that suggest
the cataracts' vast size and power, his pictures are intimate, subjective
impressions of color and light. Like Hunt's and Inness' paintings, they are
first and foremost works of art, not views of a celebrated natural wonder.

Twachtman concentrated on a close-up view of the Horseshoe Fall
from below, first illustrated by Alexander Wilson in 1810, which he
painted in summer and winter (figs. 72, 73).[251] In these works, all sugges-
tions of sublimity are absent: the immense wall of thundering water that
had terrified and thrilled generations of tourists has been transformed into
a diaphanous veil of luminous color. Twachtman's delicate representations
offer an elusive conclusion to the artistic encounter with Niagara's gran-
deur begun two centuries before.

Fig. 73. John H. Twachtman, *Niagara Falls*, 1894
(cat. no. 157). National Museum of American
Art, Smithsonian Institution, Washington, D.C.

1. As quoted in Charles Mason Dow, *Anthology and Bibliography of Niagara Falls*, 2 vols. (Albany, N.Y.: J. B. Lyon & Co., 1921), 2:826.

2. Hugh Blair, *Lectures on Rhetoric and Belles Lettres*, 2 vols. (London: W. Strahan, T. Cadell; Edinburgh: W. Creech, 1783), 1:46.

3. Hibernicus, pseud. [De Witt Clinton], *Letters on the Natural History and Internal Resources of the State of New York* (New York: Sold by E. Bliss & E. White, 1822), 209.

4. For indepth studies of literary and artistic responses to Niagara's sublimity see Elizabeth McKinsey, *Niagara Falls: Icon of the American Sublime* (Cambridge and New York: Cambridge University Press, 1985); Elizabeth McKinsey, "The Sublime in America: Niagara Falls as a Naional Icon, 1800-1860" (Ph.D. diss., Harvard University, 1976); and Jeremy Elwell Adamson, "Frederic Edwin Church's 'Niagara': The Sublime as Transcendence" (Ph.D. diss., University of Michigan, 1981).

5. Unidentified nineteenth-century poem quoted in Ralph Greenhill and Thomas D. Mahoney, *Niagara* (Toronto: University of Toronto Press, 1969), 8.

6. See note 191.

7. *New York Times*, May 1, 1857, 8.

8. The original, more specific title was shortened by Church's contemporaries to *Niagara*.

9. *Home Journal*, May 9, 1857, 2.

10. Quoted in *F. E. Church's Painting of Nature's Grandest Scene; The Great Fall, Niagara. Painted by F. E. Church* (New York: Williams, Stevens, Williams & Co., [1857]), 6. Hereafter *F. E. Church, 1857*. This brochure contains excerpts from six reviews of Church's picture published in various American periodicals and newspapers in May 1857.

11. *New York Daily Mirror* (n.d.), quoted in *Cosmopolitan Art Journal* 1 (June 1857): 130.

12. *Albion*, quoted in *F. E. Church, 1857*, 8.

13. *Weekly Traveller*, Ibid., 13.

14. *New York Times* (n.d.), Ibid., 6.

15. *New York Daily Mirror*, quoted in *Cosmopolitan Art Journal* 1 (June 1857): 130.

16. Ibid.

17. *Albion* 35 (May 2, 1857): 213.

18. *New York Daily News* quoted in *F. E. Church, 1857*, 7.

19. *Courier & Enquirer*, Ibid., 7.

20. *Weekly Traveller*, Ibid., 13.

21. *Albion* 35 (May 2, 1857): 213.

22. *New York Daily Mirror*, quoted in *Cosmopolitan Art Journal* 1 (June 1857): 130.

23. *New York Daily News*, quoted in *F. E. Church, 1857*, 7.

24. Ibid.

25. *New York Daily Mirror*, quoted in Cosmopolitan Art Journal 1 (June 1857): 130.

26. *Weekly Traveller*, quoted in *F. E. Church, 1857*, 13.

27. *New York Times*, Ibid., 6.

28. *New York Daily News*, Ibid., 7.

29. John Ruskin, *Modern Painters*, 5 vols. (London, 1843–60). The first two volumes were published in the United States in 1847; volumes 3 and 4 in 1856. For a study of the impact of Ruskin's aesthetics on American culture see Roger B. Stein, *John Ruskin and Aesthetic Thought in America, 1840–1900* (Cambridge, Mass.: Harvard University Press, 1967). Church was an avid reader of Ruskin.

30. Henry Theodore Tuckerman, *Book of the Artists* (New York: G. P. Putnam and Son; London: Sampson Low and Co., 1867), 371.

31. *Spectator*, July 25, 1857, 784.

32. *Art Journal* (London) 19 (1857): 262.

33. *Illustrated London News*, May 8, 1858, 410.

34. *F. E. Church's Celebrated Painting of the Great Fall, Niagara: Returned and on Exhibition* (New York: Williams, Stevens, Williams & Co., 1858). Hereafter *F. E. Church, 1858*. This second brochure contains excerpts from the six American reviews published in the 1857 brochure, a notice in *The Crayon* (September 1857), and excerpts from seven British reviews.

35. *Cosmopolitan Art Journal* 3 (December 1858): 49.

36. Printed cover, *F. E. Church, 1858*.

37. For advertisements and reviews see *Baltimore American* 9 (December 1858): 2; *Baltimore Sun*, December 9, 1858, 2; *National Intelligencer* (Washington, D.C.), December 31, 1858, 1; January 6, 1859, 1; *Richmond Enquirer* (Virginia), January 14, 1859, 2; *Daily Picayune*, (New Orleans), March 23, 1859, 1. It was subsequently exhibited in Boston, December 28, 1859–February 18, 1860. See *Boston Evening Transcript*, December 28, 1858; February 17, 1859. I am indebted to Gerald L. Carr for bringing the Baltimore, Washington, Richmond, and New Orleans reviews to my attention.

38. The full title is *Nouvelle Découverte d'un très grand pays Situé dans l'Amérique, entre le Nouveau Mexique et la Mer Glaciale* (Utrecht: Chez Guillaume Brodelet, 1697). By 1699, it had been published in English, German, Dutch, and Spanish and was reprinted in numerous editions in the early 1700s. There were three illustrations in all: Niagara Falls, a bison, and a map of the territory, drawn and engraved by J. V. Vanien who may also have created the Niagara view.

39. Louis Hennepin, *A New Discovery of a Large Country in America*, ed. Reuben Gold Thwaites, 2 vols. (Chicago: McClung, 1903), 1:54. A reprint of the first English edition, 1698.

40. Ibid. In Hennepin's earlier account of the expedition, *Description de la Louisiane, nouvellement découverte au Sud-Ouest de la Nouvelle France, par ordre du roy* (Paris: Chez la Veuve Sebastien Hure, 1683), the waterfalls had been described as 500 feet high. The 1683 report on Niagara was only two paragraphs long; the 1697 account took up two chapters.

41. Ibid., 54.

42. James Wyld, *The United States* (London, [1817]).

43. Peter Augustus Porter, *Official Guide: Niagara Falls, River, Frontier* (Buffalo: Matthew-Northrup Works, 1901), 119.

44. For a discussion of the drawing instruction at Woolwich see Woolwich, England, *Records of the Royal Military College* (London: Furnival, Parker and Furnival, 1851), 23; Andrew Wilton, *British Watercolours, 1750 to 1850* (Oxford: Phaidon Press, 1977), 12-13. Paul Sandby, was appointed chief drawing master in 1768 and instructed many of the British military officers who sketched the Falls in the late 1700s and early 1800s.

45. The original watercolor, signed and dated 1762, is in a private collection in London. Inscribed "Done on the spot by Thomas Davies, Capt. Royal Artillery," it is reproduced in Robert H. Hubbard, *Thomas Davies in Early Canada* (Ottawa: Oberon Press, 1972), 33. The engraving was one of six in a series entitled *Six Views of North American Waterfalls*, ca. 1768. All are illustrated in Robert H. Hubbard, *Thomas Davies, c. 1737-1812* (Ottawa: National Gallery of Canada, 1972).

46. The "Indian ladder" was the trunk of a large cedar tree whose branches had been lopped off to provide footholds and leaned against the side of the cliff. It is first mentioned in Ralph Izard, "An Account of a Journey to Niagara . . . in 1765," in Dow, *Anthology and Bibliography* 1:65. It was replaced in 1796 by "Mrs. Simcoe's ladder," a wooden ladder put in place to assist the wife of the Governor of Upper Canada to descend the bank.

47. In September 1763, a band of Senecas attacked a British convoy transporting supplies over the portage road killing and scalping eighty redcoats. The incident was known in the annals of Niagara Falls as the "Devil's Hole Massacre."

48. For a provocative study of the sublime as transcendence, see Thomas Weiskel, *The Romantic Sublime: Studies in the Structure and Psychology of Transcendence* (Baltimore and London: The Johns Hopkins University Press, 1976). As transcendence is related to the experience of the grandeur of Niagara Falls, see Adamson, "Church's 'Niagara,'" 411-527.

49. Richard Wilson, *The Falls of Niagara*, ca. 1774, Central Art Gallery, Wolverhampton, England. Royal Academy of Arts, 1774, no. 315. For a list of Niagara pictures, see *300 Years Since Father Hennepin: Niagara Falls in Art, 1678-1978* (Niagara Falls, Ont.: Niagara Falls Heritage Foundation, 1978); for American views, see listing under "Niagara Falls," Inventory of American Painting before 1913, National Museum of American Art, Washington, D.C. Dow's *Anthology and Bibliography*, vol. 2, also lists maps and pictures.

50. Hector St. John de Crevecoeur, "Description of the Falls of Niagara, 1785," in Dow, *Anthology and Bibliography*, 1:72.

51. Ibid., 73.

52. Duc de la Rochefoucault-Liancourt, *Travels Through the United States of North America . . . in 1795, 1796 and 1797* (London, 1799), in Dow, *Anthology and Bibliography* 1:112.

53. Edmund Burke, *A Philosophical Enquiry into the Origins of Our Ideas of the Sublime and the Beautiful*, ed. J. T. Boulton (Notre Dame and London: University of Notre Dame Press, 1968), 39. Early American editions include those published in Philadelphia in 1805 and 1806, and New York in 1829.

54. Ibid.

55. Isaac Weld, *Travels Through the States of North America . . . in the Years 1795, 1796, and 1797*, 2 vols. (London: J. Stockdale, 1799), 1:123-124.

56. "Capt. Enys' Visit to Niagara. Journal of Capt. Enys, 29th Regiment," in Dow, *Anthology and Bibliography*, 1:74. Actually "Painter" was a mispronunciation of Bender, the name of the settler on whose property the scenic outlook was located. In the 1780s, the west bank of the Niagara River was settled by Loyalist members of Butler's Rangers, irregular troops stationed at the mouth of the Niagara River on Lake Ontario. The census of 1783 counted forty-six heads of families on the British side of the Niagara. The American shore was not settled until 1805.

57. Weld., 1:121.

58. Ibid.

59. Fisher's composition was subsequently reproduced as an aquatint engraving in Paris in the early 1800s.

60. Vanderlyn, although the first professionally trained American artist to paint the Falls, was not the earliest American to sketch the scene. The surveyor Andrew Ellicott's *View of the Falls of Niagara* was reproduced as an engraving in the *Columbian Magazine*, 4 (June 1790) and again in the *Massachusetts Magazine*, 2 (July 1790). See Dow, *Anthology and Bibliography*, 1:91. In November 1799, the Connecticut portraitist Ralph Earl (1751–1801) visited the Falls with two others to make studies for a panorama of the scene. See *Carolina* (Charleston, S.C.) *Gazette*, November 14, 1799, 2; *Federal Gazette and Baltimore Daily Advertiser*, November 18, 1799, 3. I am indebted to Merl M. Moore, Jr., for bringing these citations to my attention. See also *New York Daily Advertiser*, March 18, 1800, in Rita Susswein Gottesman, *The Arts and Crafts in New York, 1800–1804* (New York: New-York Historical Society, 1965), 4. Earl's lost work was exhibited in Northampton, Mass., Boston, New Haven, New York, Philadelphia and London. It apparently was not a circular painting, but a canvas measuring fifteen feet by thirty feet.

61. Burr supplied Vanderlyn with a letter of introduction, dated September 18, 1801, to his friend Thomas Morris of Canandaigua, N.Y. Quoted in Matthew Davis, *Memoirs of Aaron Burr*, 2 vols. (New York: Harper and Brothers, 1836–37), 2:153. In July 1801, Burr's daughter, Theodosia, and her husband, Joseph Alston, visited Niagara Falls on their wedding tour—perhaps the first honeymooners to do so. See Dorothy Valentine Smith, "An 'Intercourse of the Heart': Some Little-Known Letters of Theodosia Burr," *New-York Historical Society Quarterly*, 37 (January 1953): 49.

62. A typescript of Robert Gosman's unpublished "Biographical Sketch of John Vanderlyn, Artist" (1848) is preserved in the New-York Historical Society. The chapter on the Niagara visit (misdated 1802) is reprinted in Frank H. Severance, "Studies of the Niagara Frontier," *Buffalo Historical Society Publications*, 15 (1911): 164–69. Gosman misspells Bender's name "Burden."

63. The majority of late eighteenth- and early nineteenth-century artists visiting the Falls were familiar with the aesthetics of the picturesque as disseminated in the writings of the English author, William Gilpin. Gilpin developed the concept of the picturesque through a systematic comparison of natural scenery to the idealized compositions of the seventeenth-century landscapists, Claude Lorrain, Nicholas Poussin, Gaspard Dughet, and Salvator Rosa. By "picturesque," he simply meant that type of scenery "capable of being illustrated in painting." *In Three Essays: On Picturesque Beauty; On Picturesque Travel; and On Sketching Landscape* (London: Blamire, 1792) Gilpin provided a formula for creating artistic landscapes. Compositions were to be made up of three receding planes: a background of variegated mountain profiles; a middle distance of rolling land formations, containing the chief object of interest; and the foreground, "the foundation of the whole picture," was to be dark-toned and contain features such as rocks, trees and vegetation whose surfaces and silhouettes were rough and varied. For a general study of Gilpin and the picturesque, see Carl Paul Barbier, *William Gilpin: His Drawings, Teaching and Theory of the Picturesque* (Oxford: Clarendon Press, 1963). The classic study of the picturesque remains Christopher Hussey, *The Picturesque, Studies in a Point of View* (London and New York: Putnam, 1927).

64. Both works, in the collection of the Senate House Museum, Kingston, N.Y., traditionally have been dated ca. 1827, the year Vanderlyn reportedly made his second trip to the Falls. See Kenneth C. Lindsay, *The Works of John Vanderlyn* (Binghampton: State University of New York Art Gallery, 1970), 57. Technically, however, they are closely related to the artist's thinly painted works of 1800-03.

65. John Vanderlyn to Aaron Burr, March 25, 1802. Pennsylvania Historical Society.

66. Lindsay has dated the canvas about 1827 or 1837, the date of Vanderlyn's last visit to Niagara. However, like the two oil studies, it is much more thinly painted and higher toned than the pictures of the 1820s and 1830s. Moreover, had it been painted at the later dates, Vanderlyn would probably have introduced the man-made facilities erected near the Falls. The testimonial, dated February 28, 1803, was prepared by Edward Thornton, British Chargé d'Affaires at Washington who himself had visited Niagara in 1799. Typescript in the Senate House Museum, Kingston, N.Y.

67. Aaron Burr to John Vanderlyn, April 22, 1805, Pennsylvania Historical Society. Sales of the prints were a disaster. Not only was the subscription list lost but so were the plates. John Vanderlyn to Roger Strong, February 24, 1812, Senate House Museum.

68. Lindsay has argued that the undated canvas in the exhibition (cat. no. 161) is the original model. See Kenneth C. Lindsay, "John Vanderlyn in Retrospect," *American Art Journal* 7 (January 1975): 83-85. Comparison with the engraving of 1804, reveals, however, that it lacks the necessary detail to have been the engraver's model. It is likely a copyist's production or a later, unrecorded version by the artist. For a more complete discussion of Vanderlyn's Niagaras, see Adamson, "Church's 'Niagara'" 89-98.

69. The 2,219-line poem was published in nine consecutive numbers of the *Port Folio*, from June 1809 to March 1810. It was later reprinted in its entirety without the engraved views in Alexander Wilson, *The Foresters: A Poem, Descriptive of a Pedestrian Tour to the Falls of Niagara* (Newton, Pa.: S. Sigfried & J. Wilson, 1818).

70. Ibid., 5.

71. Ibid., 76.

72. Alexander Wilson, *American Ornithology; or, the Natural History of the Birds of North America*, 3 vols. (Philadelphia: Bradford and Inskeep, 1811), plate xxxvi.

73. The sketchbook, covering the years 1804–08, is entitled *More Recent Sketches* and is in the Beinecke Library, Yale University. For a discussion of John Trumbull at Niagara Falls, see Bryan Wolf, "Revolution in the Landscape: John Trumbull and Picturesque Painting," in *John Trumbull: The Hand and Spirit of a Painter* (New Haven: Yale University Art Gallery, 1982), 225–30.

74. John Trumbull to Samuel Williams, November 11, 1808, Beinecke Library, Yale University. Quoted in Wolf, 225.

75. *More Recent Sketches*, [sketch #16]. The drawing, made on two pages, is inscribed as taken from "Forsyth's," the property overlooking the Horseshoe from the upper bank owned by the Forsyth family since the mid-1780s.

76. Ibid., [sketch #29].

77. Weld, *Travels . . . 1795, 1796, and 1797*, 1:128.

78. For a discussion of the biblical significance of the rainbow in landscape painting, see George P. Landow, "The Rainbow: A Problematic Image," in U.C. Knoepflmacher and G. B. Tennyson, eds., *Nature and the Victorian Imagination* (Berkeley and Los Angeles: University of California Press, 1977), 341-69.

79. For a history of the circular panorama picture, see "The Panorama: With Memoirs of its Inventor, Robert Barker, and his son, the late Henry Aston Barker," *Art Journal* (London), n.s. vol. III (February 1857), 46–47; Germain Bapst, *Essai sur l'histoire des Panoramas et des Dioramas* (Paris, 1891); Lee Parry, "Landscape Theater in America," *Art in America*, 59 (November-December 1971): 52-62; Richard Altick, *The Shows of London* (Cambridge, Mass., and London: Harvard University Press, 1978).

80. William Dunlap, *A History of the Rise and Progress of the Arts of Design in the United States*, 3 vols. (1834; repr. New York: Dover Publications, 1969), 2:51.

81. Ibid., 52.

82. See note 108.

83. George Heriot, *Travels Through the Canadas: Containing a Description of the Picturesque Scenery on Some of the Rivers and Lakes*, 2 vols. (London: Richard Phillips, 1807). Heriot was among the most gifted military-trained landscapists to sketch in Canada in the early nineteenth century. He had been instructed at Woolwich by Paul Sandby. For information on Heriot, see Gerald Finley, *George Heriot, Painter of the Canadas* (Kingston, Ont.: Agnes Etherington Art Centre, Queen's University, 1978).

84. From 1760-1820, the American Fall was commonly called the Fort Schlosser Fall after the German mercenary officer in the British army, Col. John J. Schlosser, who rebuilt the palisaded fortification at the head of the portage trail after it had been burnt by the retreating French forces in 1759. When the British were forced to withdraw from the eastern side of the river in 1796, the name of the small settlement that later grew up around the abandoned fort was Schlosser or Schlosser Landing. The name was variously misspelled; "Schloper" or, in Heriot's case, "Slausser." The Horseshoe Fall was also known as the British or Canadian Fall.

85. Heriot, *Travels Through the Canadas*, 1: 171.

86. John Maude, *A Visit to the Falls of Niagara in 1800* (London: Longman, Rees, Orme, Brown and Green, 1826), 147.

87. For a description of the events of the War of 1812 on the Niagara frontier, see Donald Braider, *The Niagara* (New York, Chicago, San Francisco: Rinehart and Winston, 1972), 165–86.

88. An ice-resistant timber bridge to Goat Island was constructed in 1818. It spanned the rapids in two stages, using Bath (now Green) Island as an intermediary point. An enclosed stair tower, erected next to the American Fall in 1818, allowed visitors to reach the foot of the cataract in safety. The same year, a similar facility was constructed near Table Rock on the Canadian side and ferry service using rowboats was instituted across the river from a point below the American Fall.

89. The watercolors are in the Addison Gallery of American Art, Phillips Academy, Andover, Mass. They are described in William Dunlap, *Diary of William Dunlap*, 3 vols. (New York: New-York Historical Society, 1930), 1:xxiv–xxv.

90. In 1820, Fisher had been commissioned by a Salem (Massachusetts) patron, Judge Daniel Appleton White, to paint the Falls. A letter to White containing a descriptive key to the various landmarks in his pair of canvases is in the National Museum of American Art. Photographs of nineteen drawings made by Fisher during his visit to the Falls in 1820 are in the curatorial files, NMAA.

91. By 1820, travelers could be housed comfortably on the American shore in the Eagle Tavern near the river (later enlarged as the Cataract House hotel); on the Canadian shore, they could be accommodated in greater luxury at John Brown's newly erected Ontario House on the upper bank overlooking the rapids upstream from the Horseshoe Fall. A British tourist in 1820 reported that "upwards of one hundred folio pages [of a guest register] had been written with names within the last five months." James Flint, *Letters from America* (Edinburgh: W. & C. Tait; London: Longman, Hurst, Rees, Orme and Browne, 1822), 294. William Forsyth's grand Pavilion Hotel overlooking the Horseshoe was constructed in 1822 and could house and feed one hundred guests.

92. For a list of recorded Niagaras by Alvan Fisher, see *Inventory of American Painting Before 1913*, NMAA.

93. The printed wrapper of the set, entitled *Five Engravings of Niagara Falls* (Oswego, 1821), states that "the *whole* [series], when taken together, will exhibit delineations from all those different points in which the Falls are advantageously seen." Example in the Canadiana Department, Royal Ontario Museum.

94. Basil Hall, *Forty Etchings, from Sketches Made with the Camera Lucida, in North America, in 1827 and 1828* (Edinburgh: Cadell & Co., 1829). A camera lucida was a lightweight mechanical instrument that reflected an image through a prism onto a sheet of paper allowing an artist to trace outlines accurately.

95. Two of the original watercolors are in the collection of the New-York Historical Society.

96. Maximilian Prince Wied-Neuwied, *Travels in the Interior of North America* (London: Ackermann & Co., 1843), 496. The prints are identified by Maximilian's citation of the publisher, Henry Megarey of New York.

97. See the essays in this catalogue by John Sears, *Doing Niagara Falls in the Nineteenth Century* and Elizabeth McKinsey, *An American Icon.*

98. George Catlin, *Views of Niagara, Drawn on Stone and Colored from Nature by George Catlin* (New York: Carvill, 1831). On the cover of the set in the Clements Library, University of Michigan, is the inscription: "From the difficulty of coloring the views a very limited number has been struck off & they will be no where to be found in the print stores. Geo: Catlin."

99. In the imprint, the aerial view was described as "taken from Mr. Catlin's *MODEL*, which was made from a careful survey." The three-dimensional model of the Falls and environs was completed in 1829 and based upon the survey conducted in 1827. See William Leete Stone, "From New York to Niagara. Journal of a Tour. . . .," *Buffalo Historical Society, Publications,* 14 (1910): 245. The model formed part of Catlin's "Indian Gallery" when it was shown in London in 1848. It was also exhibited at the Crystal Palace Exhibition in 1851. See Adamson, "Church's 'Niagara,'" 144.

100. The series was first published in London by Ackermann & Co. in 1833. A restrike edition was published in 1857.

101. Nathaniel Parker Willis, *American Scenery; or, Land, Lake and River: Illustrations of Transatlantic Nature* (London: George Virtue; New York: R. Martin, 1840).

102. Bartlett prepared sepia watercolor sketches at the Falls in October 1836. He also collaborated with Willis on *Canadian Scenery Illustrated*, 2 vols. (London: George Virtue, 1842), which also included several Niagara views. For a study of Bartlett, see Alexander M. Ross, *William Henry Bartlett: Artist, Author & Traveller* (Toronto: University of Toronto Press, 1973).

103. Willis, *American Scenery*, 49. Terrapin Bridge was a 300-foot timber construction built out along the Terrapin Rocks on the eastern verge of the Horseshoe Fall in 1829. It extended ten feet out beyond the brink of the cataract. Terrapin Tower, the most famous of all man-made facilities at the Falls, was a 45-foot high lighthouse-like observatory with a viewing balcony reached by an inside spiral stair. Constructed in 1833 near the end of Terrapin Bridge it was a rival attraction to Table Rock, the one-quarter acre limestone ledge that projected 60 feet out from the Canadian bank beside the Horseshoe Fall and collapsed into the gorge in June 1850. The tower was demolished in 1873.

104. Henry Davis, *Views of the Falls of Niagara, Painted on the Spot in the Autumn of 1846* (London: Thomas M'Lean, 1848).

105. Augustus Köllner, *Views of American Cities* (New York and Paris: Goupil & Vibert, 1848-51).

106. Hippolyte Sebron, *Niagara Falls, General View;* and *Niagara Falls, The Horseshoe Fall,* aquatint engravings by Salathé (Paris: Goupil & Co., 1852).

107. Beaumont Newhall, *The Daguerreotype in America* (New York: Duell, Stone and Pearce, 1961), 50. See also Robert Taft, *Photography and the American Scene: A Social History, 1839–1889* (New York: Dover Publications, 1964), 93.

108. Robert Burford, *Description of a View of the Falls of Niagara, Now Exhibiting at the Panorama, Leicester Square* (London: T. Brettell, 1833), 4. Burford's panorama was subsequently exhibited in New York. Burford sketched the Falls in the autumn of 1832.

109. The watercolor is reproduced, among other places, in W. H. Goetzmann and W. J. Orr, eds., *Karl Bodmer's America* (Omaha: Joslyn Art Museum and University of Nebraska Press, 1984), 344.

110. A.G.I., "An Examination of Burke's Theory of the Sublime," *Knickerbocker Magazine,* 2 (August 1833): 113-19. In this critical analysis of Burke's treatise, the American author categorically rejects the notion of terror. For a study of changes in the concept of the sublime in the 1830s, see Adamson, "Church's 'Niagara,'" 466ff; Barbara Novak, "Sound and Silence: Changing Concepts of the Sublime," in *Nature and Culture, American Landscape and Painting, 1825–1875* (New York: Oxford University Press, 1980), 34–46.

111. Francis William Pitt Greenwood, *Miscellaneous Writings* (Boston: Charles C. Little and James Brown, 1846), 307, 294, 304.

112. Ibid., 286.

113. Frederick Marryat, *A Diary in America,* 2 vols. (1839; repr. New York: Alfred Knopf, 1962), 90.

114. Nathaniel Hawthorne, "My Visit to Niagara," in *The Complete Works of Nathaniel Hawthorne,* 22 vols. (Boston: Houghton, Mifflin, 1900), 17: 251.

115. Anna Brownell Jameson, *Winter Studies and Summer Rambles in Canada,* 2 vols. (London: Saunders and Otney, 1838), 1:51.

116. For comments on Niagara's beauty, see Greenwood, 297; Jameson, *Winter Studies,* 1:66; James Fenimore Cooper, *Oak Openings; or, The Bee-Hunter,* 2 vols. (New York: Burgess, Stringer, 1848), 2:217; and especially James Dixon, *Personal Narrative of a Tour Through a Part of the United States and Canada* (New York: Lane and Scott, 1849), 241.

117. John Davis Hatch, "John Vanderlyn's Views of Niagara," University of Delaware Symposium—"American Paintings Before 1900: New Perspectives," April 12, 1985, has attributed the unsigned works to John Vanderlyn. The date can be established by the presence of a second enclosed staircase built down the Canadian bank in the summer of 1832 and the absence of Terrapin Tower (not constructed until 1833) in the view from below the Horseshoe Fall. The only artist, who had the skills to work on such a large scale, known to have visited the site in 1832 was the English panoramist, Robert Burford.

118. There are two miniatures of the same view by Birch. One is in collection of the Pennsylvania Academy of the Fine Arts, the other in the National Museum of American Art. The example at PAFA is inscribed on the reverse; according to the inscription, the view was based on a sketch by [Hugh] Reinagle, a Philadelphia scene painter who had exhibited Niagara pictures in 1819.

119. Peale's canvases are in the following collections: (formerly) Lyman Allyn Museum, New London, Conn.; Lowe Art Museum, Coral Gables, Fla.; Lee B. Anderson, New York.

120. Two of de Grailly's pictures after Bennett's views from Goat Island are in the Lyman Allyn Museum, a third, after Havell's view from the Chinese Pagoda (an observatory that stood in Point View Gardens from 1845–53) was formerly with Vose Galleries, Boston.

121. Paris, *Salon* (1841), no. 1933. The picture was titled *Vue prise sur la rivière du Niagara dans le haut Canada, à l'endroit de la Cataracte.* To give it topical interest, it was subtitled "cette vue embrasse le lieu on a été incendié le bateau à vapeur *la Caroline.*" The burning of the American steamboat *Caroline* by British commandos on the night of December 29, 1837, was one of the most celebrated incidents in the aftermath of the failed republican rebellion in Upper Canada. To forestall incursions across the border by rebels and their American sympathizers, British troops were stationed at the Falls from late 1837 through 1841. During these years, the redcoats added new interest to a Niagara visit. American tourists were delighted with military drills and moonlight band concerts. Many of the regular soldiers, however, deserted to the U.S.

122. Text of a proposed handbill offering the picture for sale, n.d., Senate House Museum. Traditionally, the date 1827 has been given to Vanderlyn's second trip to the Falls. "I was there in 1837," he later wrote, "about ten years after the sketches [sic] of this view was made." John Vanderlyn to John Rand, June 4, 1843. SHM.

123. Ibid.

124. Ibid.

125. Henry S. Tanner, *A Map of North America* (Philadelphia, 1822). The inset, which conjoins the Falls with another natural wonder, the Natural Bridge in Virginia, is reproduced in James Ayres, "Edward Hicks and His Sources," *Antiques,* 109 (February 1976): 366. Hicks and two companions had visited the Falls in 1819 while on a preaching tour of western New York and Ontario. A later Niagara painting (ca. 1835) is in the collection of the Abby Aldrich Rockefeller Folk Art Museum, Williamsburg, Va.

126. Wilson, 75. Hicks would have been familiar with Wilson's poem since it had been published in book form in his hometown of Newton, Pennsylvania, in 1818.

127. William Dunlap, *A Trip to Niagara; or, Travellers in America. A Farce in Three Acts* (New York: E. B. Clayton, 1830). See Parry, 57, 61, note 10, for more information on Dunlap's panorama.

128. For the most part, the individual scenes in the panorama were based upon William Guy Wall's *Hudson River Portfolio* (New York: Henry I. Magarey, 1828). The source for the Niagara backdrop is unknown.

129. Dunlap, *A Trip to Niagara*, 52.

130. For a study of Cooper's Leatherstocking character as an American Adam, see R. W. B. Lewis, *The American Adam: Innocence, Tragedy and Tradition in the Nineteenth Century* (Chicago and London: University of Chicago Press, 1955), 98-105.

131. Cole's composition appeared on an Adams & Co. pink, transfer-printed Staffordshire platter, ca. 1835 (example in the Wadsworth Atheneum) and as an inset on a map of *Canada West*, published by J. & F. Tallis, Edinburgh, ca. 1850. The painting is in the collection of The Art Institute of Chicago.

132. Thomas Cole to Robert Gilmor, April 26, 1829. Quoted in Louis Legrand Noble, *The Life and Works of Thomas Cole*, ed. Elliott S. Vesell (1853; repr. Cambridge, Mass.: Harvard University Press, Belknap Press, 1964), 72.

133. Thomas Cole, Sketchbook #3, 143, Detroit Institute of Arts. Quoted in Henry H. Glassie, "Thomas Cole and Niagara Falls," *New-York Historical Society Quarterly*, 58 (April 1974): 93. See also Henry H. Glassie, "Reevaluation of a Thomas Cole Painting," *Museum Studies 8* (Chicago: Art Institute of Chicago, 1976), 96-108, for information on Cole's picture.

134. Thomas Cole, Sketchbook #3, 126. The sketchbook contains twenty-one drawings of Niagara Falls scenery.

135. The other Niagara painting was a "large" view of the Horseshoe Fall from Goat Island (whereabouts unknown), which Cole later declared to be his "first and best"; Glassie, "Thomas Cole and Niagara Falls," 95.

136. The poem is published in Marshall B. Tym, ed., *Thomas Cole's Poetry* (York, Pa.: Liberty Cap Books, 1973), 50-51. For an excellent discussion of Cole's literary and artistic responses, see McKinsey, "The Sublime in America," 254-63, 270-74.

137. Hawthorne, *The Complete Works*, 17:248.

138. Thomas Cole, *A Distant View of the Falls of Niagara*, n.d., oil on panel, 10½ x 13¾ in., McMurray Collection, Trinity College, Hartford. Reproduced in Howard Merritt, *Thomas Cole* (Rochester: Memorial Art Gallery of the University of Rochester, 1969), 70. Merritt dates it about 1829, but it was painted on the reverse of an Italian scene painted in the 1830s.

139. Thomas Cole, "Essay on American Scenery," in John W. McCoubrey, ed., *American Art, 1700-1960. Sources and Documents* (Englewood Cliffs, N.J.: Prentice-Hall, 1965), 98-110.

140. See essay in this catalogue, Alfred Runte, *The Role of Niagara in America's Scenic Preservation* for a discussion of the despoliation of the cataracts' setting.

141. George William Curtis, *Lotus-Eating: A Summer Book* (New York: Harper & Brothers, 1852), 175.

142. Fredericka Bremer, *The Homes of the New World*, 2 vols. (London: Hall, Virtue and Co., 1853), 2:588.

143. Charles Joseph Latrobe, *The Rambler in North America, 1832-33*, 2 vols. (1836; repr. New York: Johnson Reprint Corporation, 1970), 1:74.

144. The term was coined by Kensett's friend, the editor of *Harper's Monthly*, G. W. Curtis, in *Lotus-Eating*, 1852, 81.

145. John F. Kensett to Frederick Kensett, August 24, 1851. John F. Kensett Papers, Archives of American Art, Smithsonian Institution, Washington, D.C.

146. Twenty-eight Niagara paintings, sketch size and larger, were in the artist's possession at his death in 1872. These were auctioned at Kensett's estate sale in March 1873. See *The Collection of over Five Hundred Paintings and Studies by the Late John F. Kensett* (1873; repr. New York: Olana Gallery, 1977). A total of thirty-six Niagaras by Kensett can be documented.

147. "Register of Paintings Sold," Kensett Papers.

148. The double-decked railroad suspension bridge was designed and built by John Roebling, engineer of the Brooklyn Bridge. It was completed in 1855 and replaced an earlier suspension bridge constructed in 1848. The bridge was located two miles below the Falls. Brock's Monument is a memorial column on the edge of the Niagara escarpment seven miles downstream commemorating the British hero of the Battle of Queenston Heights (1813). A Doric column erected in 1824 was destroyed in 1840 and rebuilt in 1853 in Corinthian style.

149. Several were published in vignette form in Curtis' *Lotus-Eating*.

150. Jasper Cropsey to Maria Cropsey, August 22, 1852. Newington Cropsey Foundation, Greenwich, Ct. During this visit, Cropsey sketched with Kensett.

151. Jasper Cropsey to J. W. Kitchell, November 1, 1897. MacMurray College Library, Jacksonville, Il.

152. Ibid.

153. Jasper Cropsey, *Niagara Falls from the Foot of Goat Island*, 1856, oil on canvas, 10 x 16 in., private collection, Cleveland. The work is reproduced in *Jasper F. Cropsey, 1823-1900* (Washington, D.C.: National Collection of Fine Arts, 1970), 80.

154. Soon after his arrival in London in 1856, Cropsey was commissioned by the Anglo-French printmaking firm, Gambart & Co., to produce a series of American landscapes. Among the sixteen compositions published under the title *American Scenery* were two Niagara views: *Niagara Falls: The American Falls from Biddle's Staircase* (based on fig. 80) and *Niagara Falls: From Prospect Point*. Examples in the Karolik Collection, Museum of Fine Arts, Boston.

155. Jasper F. Cropsey, *Niagara Falls from the Foot of Goat Island*, 1882, oil on canvas, 28⅜ x 52 in., Norton Art Gallery, Shreveport, La.

156. *New York Daily Tribune*, January 31, 1861, 7. The painting became the cornerstone of the Brooklyn Museum's American Collection.

157. *Tunis' Topographical and Pictorial Guide to Niagara* (Niagara Falls, N.Y.: W. E. Tunis, 1855), 39.

158. *The Falls of Niagara: Being a Complete Guide to . . . the Great Cataract* (London, Edinburgh & New York: T. Nelson & Sons; Toronto: James Campbell, 1858), 39.

159. S. A. Lattimore, "Niagara Falls from the American Shore," *Ladies Repository* (September 1852): 343

160. Frederick Fitzgerald De Roos, *Personal Narrative of Travels in the United States and Canada in 1826* (London: William Harrison Ainsworth, 1827), 160.

161. *Harper's Weekly*, July 9, 1859, 437.

162. *New York Times*, February 7, 1859, 4.

163. James Jackson Jarves, *The Art-Idea* (New York: Hurd & Houghton, 1864), 194.

164. *Tunis' Topographical and Pictorial Guide*, 54.

165. S. A. Lattimore, "Niagara Falls from the American Shore," 343.

166. *National Intelligencer*, January 24, 1854, n.p.

167. Ibid.

168. *Tunis' Topographical and Pictorial Guide*, 55.

169. "Winter Scenes of Niagara Falls, " *Frank Leslie's Illustrated Newspaper*, March 22, 1856, 233.

170. "Niagara in Winter," *Harper's Monthly*, 10 (February 1855): 411.

171. See Adamson, "Church's 'Niagara,'" 250-51.

172. *Cosmopolitan Art Journal*, 2 (September 1858): 210.

173. *New York Leader*, July 9, 1859, 6.

174. For comments on the picture, see *The Crayon*, 1 (April 25, 1855): 268.

175. The painting is based on an undated drawing in the Newington Cropsey Foundation.

176. *American Monthly Magazine*, n.s. 5 (June 1838): 533.

177. For a thorough account of Frankenstein's panorama, see Joseph Earl Arrington, "Godfrey N. Frankenstein's Moving Panorama of Niagara Falls," *New York History*, 49 (April 1968): 169-99. The earliest Niagara scenery literally to move was a tableau, entitled *The Cataract of Niagara Falls in North America*, that was featured during the second season of Philip James de Loutherbourg's animated peep-show, the *Eidophusikon* (1782). For this and other theatrical spectacles of the Falls, see Adamson, "Church's 'Niagara,'" 258-60.

178. A. H. Guernsey, "Niagara," *Harper's Monthly*, 7 (August 1853): 289-305. Other views by Frankenstein were reproduced in Frederick H. Johnson, *A Guide for Every Visitor to Niagara Falls* (Rochester: D. M. Dewey, [1852]).

179. *National Democrat*, July 22, 1853. Quoted in Arrington, *New York History*, 49: 180.

180. *Literary World*, 13 (July 23, 1853): 589.

181. *News*, (Savannah, Ga.), June 5, 1854. Quoted in Arrington, *New York History*, 49: 186. Another moving panorama of the 1850s contained a sequence of Niagara views. Produced by Washington Friend (ca. 1820–after 1886) and based on watercolor compositions made during a 5,000-mile sketching tour of North America in 1848–50, the panorama premiered in Quebec and traveled to Montreal, Boston, and New York before being shipped to London. The work was reviewed in the *Art Journal* (London), 5 (May 1854): 153. For a description, see [Washington Friend], *Guide to Mr Washington Friend's Great American Tour of Five Thousand Miles in Canada and the United States* (Nottingham, England: Stafford & Co., 1857). Friend's panoramic view of the scene (cat. no. 87) was probably one of the Niagara views in the panorama.

182. See [Ferdinand Richardt] *Catalogue of the Celebrated Niagara Gallery* (New York: Henry H. Leeds & Co., 1857). The works were reviewed in *The Crayon*, 4 (January 1857): 28.

183. *New York Evening Post*, February 18, 1857, 3.

184. William and Frederick Langenheim first photographed the Falls in the summer of 1845. See Newhall, *Daguerreotype*, 50; Anthony Bannon, *The Taking of Niagara. A History of the Falls in Photography* (Buffalo: Media Study, 1982), 14. The set of sequential daguerreotypes taken from in front of the Clifton House hotel (fig. 55) are the earliest extant photographs of the scene. The photographic panorama was lithographed by A. Vaudricourt and was included as a fold-out illustration in a Niagara guidebook, J. de Tivoli, *A Guide to the Falls of Niagara . . . with splendid lithographic view by A. Vaudricourt* (New York: Burgess, Stringer and Co., [1846]).

185. Taft, 95. Whitehurst's photographs were reviewed in *Tallis' Description of the Crystal Palace, and the Exhibition of the World's Industry in 1851* (London and New York: John Tallis, [1852]), 136.

186. See Bannon, 14. For a delightful account of Babbitt's activities and the problems encountered by photographers at the Falls in the 1850s, see John Werge, *The Evolution of Photography . . . and Personal Reminiscences Extending Over Forty Years* (London: Piper & Carter, 1890), 50–51; 140-58.

187. Werge, *Evolution of Photography*, 51.

188. See for example the whole-plate daguerreotypes attributed to Southworth and Hawes (ca. 1855) in the International Museum of Photography, George Eastman House, Rochester, N.Y.

189. William C. Darrah, *The World of Stereographs* (Gettysburg: The Author, 1977), 70.

190. Bannon, 16.

191. Isabella Judson, *Cyrus Field, His Life and Work* (New York: Harper and Brothers, 1896), 41. In the early summer of 1851, Church accompanied his friend Cyrus Field on a trip to Natural Bridge, Virginia, and Mammoth Cave, Kentucky. When Field and his wife traveled on to Cairo, Illinois, Church went to Niagara Falls where the Fields joined him in August.

192. "Winter Scenes at Niagara Falls," describes the conditions at the site on March 15, 1856.

193. Most of Church's Niagara studies are in the Cooper-Hewitt Museum, New York. Several drawings are reproduced in David Huntington, *The Landscapes of Frederic Edwin Church: Vision of an American Era* (New York: Braziller, 1966) and *Frederic Edwin Church* (Washington, D.C.: National Collection of Fine Arts, 1966). For a short study of Church's *Niagara*, see Jeremy Adamson, "In Detail: Frederic Church and *Niagara*," *Portfolio*, 3 (November/December 1981): 53–59.

194. *Home Journal*, January 3, 1857, n.p.

195. *The Crayon*, 4 (February 1857): 54.

196. *Times* (London), August 7, 1857, 12. Quoted in *F. E. Church, 1858*, 1.

197. For a more complete analysis of the painting of water in *Niagara*, see Adamson, "Church's 'Niagara,'" 372–94.

198. Charles Dickens, *American Notes and Pictures from Italy* (1842; repr., London: Macmillan, 1893), 173.

199. Dixon, *Personal Narrative*, 115.

200. See W. J. Stillman, "The Use and Nature of Beauty," *The Crayon*, 3 (June 1856): 161–63. In *Modern Painters*, vol. 1, Ruskin had declared that sublimity was not separate from but an aspect of beauty. Because of its morally elevating effect, it was the "highest beauty."

201. Stillman, *The Crayon* 3 (June 1856): 161.

202. "The Fine Arts," *Emerson's United States Magazine*, 4 (June 1857), 629.

203. For a study of Frederic Church's art and its relationship to typology, see David Huntington, "Church and Luminism: Light for America's Elect," in John Wilmerding, et al., *American Light: The Luminist Movement, 1850–1875* (Washington, D.C.: National Gallery of Art, 1980), 155–90. For a typological investigation of *Niagara*, see David Huntington, "Frederic Church's *Niagara*: Nature and the Nation's Type," *Texas Studies in Literature and Language*, 25 (Spring 1983): 100-38.

204. Ursula Brumm, *American Thought and Religious Typology*, trans. John Hoagland (New Brunswick, N.J.: Rutgers University Press, 1970), 22.

205. E. L. Magoon, "Scenery and Mind," in *Homebook of the Picturesque* (New York: G. P. Putnam, 1852), 5. In this widely read essay, the Rev. Magoon outlined the era's conception of the moral influence of nature: "The book of nature, which is the art of God, as Revelations is the word of His divinity, unfolds its innumerable leaves. . . ." For a study of American landscape and typology, see James Collins Moore, *The Storm and the Harvest: The Image of Nature in Mid-Nineteenth Century American Landscape Painting* (Ann Arbor: University Microfilms, 1975), 91-106. For a discussion of the "book of nature" and nationalist intentions of mid-nineteenth century American landscapists, see Barbara Novak, "Introduction: The Nationalist Garden and the Holy Book," in *Nature and Culture*, 3-17.

206. Asher B. Durand, "Letters on Landscape Painting," letter 2, *The Crayon*, 1 (January 17, 1855): 34. Quoted in McCoubrey, 111.

207. [E. L. Magoon] "A Chapter on Niagara," *American Monthly Magazine*, n.s., 5 (June 1838): 530. Magoon's authorship of this unsigned essay is established by the fact that many of the sentiments expressed are repeated verbatim in "Scenery and Mind."

208. *Pictorial Guide to the Falls of Niagara: A Manual for Visitors* (Buffalo: Salisbury and Clapp, 1842), 23. For a discussion of Niagara Falls as a "type of the Eternal," see Adamson, "Church's 'Niagara,'" 527–40.

209. Henry T. Cheever, *Voices of Nature to Her Foster Child, the Soul of Man: A Series of Analogies Between the Natural and Spiritual Worlds* (New York: Charles Scribner, 1852), 18. Cheever's book is an excellent example of mid-nineteenth century attitudes toward natural theology.

210. Horatio Adams Parsons, *The Book of Niagara Falls* (Buffalo: Oliver G. Steele, 1838), 332-33. The most extended meditation on the typological meaning of Niagara's rainbow is the "brief sermon" on the subject in Abel Thomas, *Autobiography: Including Recollections of Persons, Incidents and Places* (Boston: Usher, 1852), 211-13.

211. Hawthorne, *The Complete Works*, 17:246

212. Louis Gaylord Clark, ed. *The Literary Remains of the Late Willis Gaylord Clark*, 4th ed. (New York: Stringer and Townshend, 1851), 159.

213. H. D. M. "The Falls of Niagara" in Dow, *Anthology and Bibliography*, 2:734.

214. Quoted in Dow, *Anthology and Bibliography* 1:234.

215. James Silk Buckingham, "Hymn to Niagara" in Dow, *Anthology and Bibliography*, 2: 723.

216. See Huntington, *The Landscapes of Frederic Edwin Church*, 3; Adamson, "Church's 'Niagara,'" 549–55. A Major Mordechai M. Noah did, in fact, earn the title of "Modern Noah." In 1825, he established the City of Ararat on Grand Island in the upper Niagara River where he hoped "all the Jews that had not been deluged by the prevailing waters of Christianity, might assemble and dwell together in this city of the ark. . . ." Burke, *Descriptive Guide*, 10. The city never materialized.

217. George William Curtis, "Niagara Falls," in Charles A. Dana, ed., *The United States Illustrated in Views of City and Country . . .*, 2 vols. (New York: Hermann J. Meyer, 1855), 1:13.

218. Thomas Grinfield, "Hymn on Niagara" in Dow, *Anthology and Bibliography*, 2:727.

219. Curtis, "Niagara Falls" in Dana's *United States Illustrated*, 18.

220. Quoted in Huntington, *The Landscapes of Frederic Edwin Church*, 37.

221. Adam Badeau, *The Vagabond* (New York: Rudd and Carleton, 1859), 124. Quoted in Huntington, *The Landscapes of Frederic Edwin Church*, 67.

222. Ibid.

223. [Adam Badeau] "The Representative Art," *Atlantic Monthly*, (June 1860): 689. Badeau's authorship was attributed by William Coyle in his edition of John Frankenstein, *American Art: Its Awful Altitude. A Satire* (1864; repr. Bowling Green, Ohio: Bowling Green University Press, 1972), 128, note 84.

224. Ibid., 687.

225. Ibid.

226. McKinsey, "The Sublime in America," 136.

227. Huntington, *The Landscapes of Frederic Edwin Church*, 59.

228. Ibid., 71.

229. *New York Times*, December 8, 1862, 4. For other reviews of *Under Niagara*, see *Albion*, 40 (December 13, 1862): 59; *Boston Transcript*, February 19, 1963, n.p.

230. "Niagara Falls, from the American Side, 1867," *A Closer Look at Painters and Painting 1* (Edinburgh: National Gallery of Scotland, 1980), n.p.

231. Dated July 1856, it is in the Cooper-Hewitt Museum. In the same collection is a sepia photograph of the same view to which Church added pigment to evaluate the final effect of his large painting.

232. Originally, the painting was to be a part of the American display in the Fine Arts Department of the Exposition Universelle held in Paris in 1867. The American selection Committee (which included Knoedler) decided, however, not to include newly commissioned works. See Carol Troyen, "Innocents Abroad: American Painters at the 1867 Exposition Universelle, Paris," *American Art Journal*, 26 (Autumn 1984): 5. Instead, the committee selected Church's *Niagara* (1857). It proved one of the most popular pictures on display and was awarded a second class medal by an international jury of artists.

233. "Mr. Church's New Picture of Niagara," *The Saturday Review* (London), n.d. Quoted in *Littell's Living Age*, 97 (May 15, 1868): 443. Various English reviews were reprinted in a brochure, *The New Niagara, by Frederic E. Church* (Boston: Williams & Everett, 1868). See also, *Illustrated London News*, March 7, 1868, 238.

234. The painting was purchased at auction in 1887 by John S. Kennedy, a Scottish-born, New York businessman, who donated the work to the National Gallery of Scotland that year. See *The Weekly Scotsman*, April 30, 1887, for comments on the picture and gift. It has not been seen in America since that date.

235. Bierstadt and his wife visited the Falls in August 1869; he apparently returned in 1877 and was at the site again in 1881 and 1882. His final recorded trip was in 1892 when he attended a family wedding. See Bierstadt Papers, Archives of American Art, Washington, D.C.

236. For a partial list of Bierstadt's Niagaras consult *Inventory of American Painting Before 1913.*

237. In June 1881, Thomas Moran traveled with his family to Niagara Falls to fulfill a commission for a dozen drawings to illustrate George Munro Grant, ed., *Picturesque Canada,* 2 vols, (Toronto: Belden Brothers, 1882). Nine views by Moran and one by his artist-wife, Mary Nimmo Moran, were engraved. Two of the original drawings are in the Thomas Gilcrease Museum, Tulsa, Oklahoma. See also, Thurman Wilkins, *Thomas Moran, Artist of the Mountains* (Norman, Okla.: University of Oklahoma Press, 1966), 145–46.

238. Richard J. Boyle, "The Second Half of the Nineteenth Century," in John Wilmerding, ed., *The Genius of American Painting* (New York: William Morrow and Company, 1973), 140-89.

239. David Huntington, "American Art Between the World's Fairs, 1876–1893," in *Quest for Unity: American Art Between the World's Fairs, 1876–1893* (Detroit: Detroit Institute of Arts, 1983), 11.

240. For a discussion of changes in American art after 1876, see *Quest for Unity,* an exhibition catalogue that outlines the growth of aestheticism between the world's fairs of 1876 and 1893.

241. William Henry Jackson is best known for his photographs of the Far West of the 1860s and 1870s. In the late 1890s he became part owner of the Detroit Publishing Company and between 1898 and 1908 took most of the views of the Falls retailed as colored photo prints. See Bannon, 14. The commercial views were usually colored by a lithographic printing process that Jackson's partner secured from its Swiss inventor.

242. For discussions of Hunt's work at Niagara Falls, see Helen Knowlton, *Art-Life of William Morris Hunt* (Boston: Little, Brown & Co., 1899), 123; see Martha Shannon, *Boston Days of William Morris Hunt* (Boston: Marshall Jones Co., 1923), 133–34; Marchal E. Landgren, *The Late Landscapes of William Morris Hunt* (College Park, Md.: University of Maryland Art Gallery, 1976), 34; and *William Morris Hunt, A Memorial Exhibition* (Boston: Museum of Fine Arts, 1978), 79, 84.

243. Landgren, *Late Landscapes,* 34.

244. William Morris Hunt, *Niagara,* 1878, oil on canvas, 62½ x 100 in., Museum of Fine Arts, Boston; *Niagara Falls,* 1878, oil on canvas, 62⅝ × 99½ in., Williams College, Museum of Art.

245. George Inness, Jr., *Life, Art, and Letters of George Inness* (1917; repr. New York: Da Capo Press, 1969), 178.

246. George Inness, *Niagara Falls,* 1884, oil on canvas, 48 x 72 in., Museum of Fine Arts, Boston.

247. *New York Daily Tribune,* January 13, 1884, 4.

248. See Roy Ireland, Jr., *The Works of George Inness* (Austin and London: University of Texas Press, 1965), 243–45, 282, 327, 386.

249. For a study of Inness' landscape art and the influence of Swedenborgian spiritualism, see Nicolai Cikovsky, Jr., *George Inness* (New York, Washington, London: Praeger Publishers, 1971).

250. *American Impressionist and Realist Paintings and Drawings from the Collection of Mr. and Mrs. Raymond J. Horowitz* (New York: Metropolitan Museum of Art, 1973), 68. Cary was the husband of Evelyn R. Cary who produced the image of the "Spirit of Niagara" for the poster for the Pan-American Exposition held in Buffalo in 1901 (cat. no. 89). See K. Porter Aichele, "The 'Spirit of Niagara': Success or Failure?" *Art Journal,* 44 (Spring 1984): 46–49.

251. A winter view is also in the collection of the Parrish Art Museum, Southampton, N.Y., *Horseshoe Falls, Niagara,* (ca. 1894), oil on canvas, 30¼ x 25⅜ in.

Fig. 74. Unidentified after P. Stampa, *An Emblem of America*, 1809 (cat. no. 173). Mrs. Robert B. Stephens.

by Elizabeth McKinsey

An American Icon

When settlement began in the American colonies in Jamestown and Plymouth, Niagara Falls was already known to Europeans. Readers of Samuel de Champlain's *Voyages* (1604) learned that Indians going upstream from Lake Ontario "pass a fall, somewhat high and with but little water flowing over. Here they carry their canoes overland about a quarter of a league, in order to pass the fall, afterwards entering another lake." The 1632 edition added a map that included "Falls at the extremity of [Lake Ontario], very high, where many fish come down and are stunned."[1] The Falls are neither named nor described—Champlain did not visit the cataract, and it would be nearly a half century more before Father Louis Hennepin would write the first eyewitness European account—but Niagara lore had already begun to take shape. Remote and exotic (deep in Indian territory), associated with anecdotes (carrying canoes), astonishing (it stunned fishes and would stun many visitors), it was already a tall tale ("very high"). It seemed to epitomize the exotic wondrousness that the New World represented to Europeans.

Champlain's brief mention was quoted throughout the seventeenth century, and most subsequent maps of the New World included some reference to "Onguiara Sault" or to the portage around it. After Hennepin's *A New Discovery of a Vast Country in America* published the first engraving of the cataract in 1697 (see fig. 2), the image was adapted again and again for prints disseminated all over Europe. This "prodigious frightful fall" was considered, "of its kind, . . . the greatest phenomenon in nature."[2] Although most early explorers to the Falls sought to present factual, scientific accounts, their reports invariably broke out of measured, rational prose into exclamations of amazement at Niagara, larger and more tumultuous a waterfall than they had ever imagined.

Hennepin stretched the truth drastically, of course, in estimating the height of the Falls at 500 or 600 feet, but even at its actual height of about 160 feet, its volume of water was so astounding and its wilderness setting so remote that Europeans seemed capable of believing anything reported about it. François Gendron, a doctor accompanying the Jesuits, never saw the cataract, but repeated (1644–45) Indian claims that magical "petrified spray" could be found at its base. "Rebounding from the foot of certain large rocks in that place," the water "forms a stone, or rather a petrified salt, of a yellowish color and of admirable virtue for the curing of sores, fistules, and malign ulcers."[3] When Oliver Goldsmith described Niagara more than a century later in his *History of the Earth and Animated Nature* as "the greatest, and the most astonishing . . . of all the cataracts in the world," his superlatives were reasonable enough. But he concluded by saying, "It may easily be conceived, that such a cataract quite destroys the navigation of the stream; and yet some Indian canoes, as it is said, have been known to venture down it with safety."[4] This he reported

without any trace of irony; it seems he believed it.

Champlain's map mentioned the great numbers of dead fish found at the base of the Falls; subsequent writers created their own fish stories. An "infinite Number of Fish take great Delight to spawn here," according to *The Four Kings of Canada* account of 1710. In 1721 Paul Dudley reported hearing of an eighty-six pound trout caught at the Falls, which he was "rather inclined to believe, on the general rule, that fish are according to the waters."[5]

Benjamin Franklin found the extravagance of so many such stories worthy of parody. In London in 1765, he wrote his own fish story, spoofing English newspaper reports of America; he cited

> the Account, said to be from Quebec, in the Papers of last Week, that the Inhabitants of Canada are making Preparations for a Cod and Whale Fishery this Summer in the Upper Lakes. Ignorant People may object that the Upper Lakes are fresh, and that Cod and Whale are Salt-water Fish; But let them know, Sir, that Cod, like other Fish, when attacked by their Enemies, fly into any Water where they think they can be safest; that Whales, when they have a mind to eat Cod, pursue them wherever they fly; and that the grand Leap of the Whale in that Chace up the Fall of Niagara is esteemed by all who have seen it, as one of the finest Spectacles in Nature![6]

Such a satire suggests how credulous the English were about a place that did seem incredible.

Of course, neither cod nor whales were found at the Falls, but other exotic flora and fauna were, which were incorporated into pictures and verbal accounts of Niagara to reinforce its uniqueness. Hennepin pointed out the tall pines that surrounded the cataract and that are so prominent in the print (fig. 75) accompanying Peter Kalm's letter in the *Gentleman's Magazine* (1751). He also remarked upon the rattlesnakes that would be so terrifying to subsequent visitors to the Falls. Eighteenth-century accounts filled out the picture with majestic bald eagles soaring above the abyss and exotic Indians surrounding it.

Fig. 75. Unidentified, *A View of the Fall of Niagara* from *Gentleman's Magazine*, February 1751 (cat. no. 204). The New-York Historical Society, New York, New York.

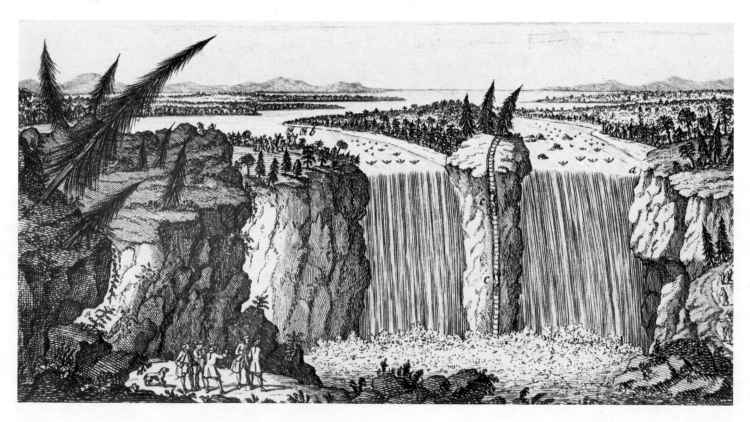

Indians were great natural curiosities in London and they played an especially prominent role in eighteenth-century engravings of Niagara. Even the many prints derived from the Hennepin view, which showed only astonished Europeans gesticulating beside the Falls, almost invariably included aborigines. For example, one engraving (1783) by an artist named Metz depicts an Indian guide gesturing toward the cataract, "showing" it to his European companions. Even more striking is the solitary native American in the etching by H. Fuessli (fig. 76); dressed in full exotic regalia, he is an exact replica of the Indian best known in London at the time—the one in the foreground of Benjamin West's sensational *The Death of General Wolfe* (1770).[7] All three images by Thomas Davies, too, include Indians (see figs. 5–7). In his obvious attempt to create realistic depictions of the scene (and correct the gross errors of the Hennepin view), Indians were of course a realistic documentary touch. But more important, they were a symbol of the New World and helped reinforce the Americanness and wondrousness of Niagara when included in its pictures. In Davies's *An East View of the Great Cataract of Niagara*, the two emphatically exotic Indians in the foreground are strongly connected to the scene iconographically; the rainbow, drawn so heavily that it is more like the edge of a plate than an illusion of light and water, spans the entire cataract and ends just at the feet of the Indians, a bridge uniting them to this unique wonder of nature.

Fig. 76. Heinrich Fuessli, *Vue du Cataract de Niagara, au Pais des Iroquois*, ca. 1776 (cat. no. 88). Royal Ontario Museum, Toronto, Canada.

These are peaceful, even contemplative Indians, but the weapons many of them carry (the spear in Davies's *Niagara Falls from Below*, the gun in Fuessli's print) remind the viewer that they had once been actual enemies in the French and Indian War. Hence they also symbolize the wildness and real dangers of the place. In literature Oliver Goldsmith joins the Indian and Niagara in *The Traveller, or a Prospect of Society* (1764), not only to locate an isolated exile but also to epitomize the dangers of the American wilderness. Describing the tragedy of land enclosure in Great Britain, the poet laments the consequent forced emigration of so many.

> *Forc'd from their homes, a melancholy train,*
> *To traverse climes beyond the western main;*
> *Where wild Oswego spreads her swamps around,*
> *And Niagara stuns with thund'ring sound.*
> *Even now, perhaps, as there some pilgrim strays*
> *Through tangled forest, and through dangerous ways;*
> *Where beasts with man divided empire claim,*
> *And the brown Indian marks with murderous aim;*
> *There, while above the giddy tempest flies,*
> *And all around distressful yells arise,*
> *The pensive exile, bending with his woe,*
> *To stop too fearful, and too faint to go,*
> *Casts a long look where England's glories shine,*
> *And bids his bosom sympathize with mine.*[8]

The poet binds the wandering refugee to himself and therefore to civilization, England, and safety through sympathy and sets off this group against the alien matrix of Niagara, the tangled forest full of wild beasts, and the Indian.

The other image most often associated with Niagara's dangers was the rattlesnake. First noted by Hennepin, this fearful reptile inhabited the area in great numbers until after 1800 and made the descent to the base of the Falls especially perilous. Most eighteenth-century adventurers to that lower region of the cataract mentioned the snakes in their travel accounts, no doubt to augment their readers' respect for their bravery in making the

descent. Edy's engraving after George Fisher's *Falls of Niagara* shows men confronting a prodigious rattler in the foreground (see fig. 11).

Finally, the eagle, which flourished in the area around the Falls until the nineteenth century, was strongly associated with the cataract. Thomas Davies's majestic specimen dominating his *Niagara Falls from Above* (see fig. 7) is the most prominent example in the graphic arts; written accounts, too, abound in soaring eagles. Writers seemed particularly intrigued by reports that birds, usually eagles, became enchanted by the rainbows or the spray of the Falls and were drawn into the falling water and drowned. As one visitor explained,

> *It is said also that birds which fly over the fall are drawn into it in spite of themselves, by the force of the air. I am not sure of this fact, which, however, is not lacking in probability, since there is often seen there a rainbow which seems strongly to attract the birds who direct their flight into it, where they become confused and drenched, lacking strength to ascend.*[9]

The Kalm print (see fig. 75) shows such birds schematically flying in lines toward the brink of the Falls. Their enchantment would seem to be a metaphor for human fascination with the Falls.

Grandiose of themselves, the Indian, rattlesnake, majestic pines, and eagles underlined the grandeur of Niagara. When depicted together they not only emphasized the exotic New World location of the cataract, but they also reinforced its sublimity. Unique American features, they were also powerful symbols of the awe they inspired; emblems of American nature, they were also symbols of the sublime.

When the Colonies declared their independence, then, and sought to establish a new sense of national identity, Americans looked in large part to their most unique resource, the American landscape, and these natural symbols took on new nationalistic meaning. The image in the exhibition that most obviously illustrates this development is the mezzotint *An Emblem of America*, after a print published by P. Stampa in London in 1800 (fig. 77). One of four allegorical depictions of the four continents (a very popular genre in seventeenth- and eighteenth-century Europe), the image also served as a memorial for George Washington who had died the previous year. A female figure, Columbia, obviously prosperous and happy, leans on Washington's gravestone, a sign of her dependence on and gratitude to the founder of the nation, while she holds a United States flag with an eagle superimposed on it. And there in the background is the familiar image of Niagara Falls adapted from the Hennepin print. With wild pine trees beside it and two natives in front, the Falls represents the American land where Columbia will act out her destiny. Not just a unique natural curiosity, it is now a symbol for a unique polity.

The other foreground figure bears examination. A little Indian boy, also leaning against Washington's gravestone, looks like the putto or cherub from classical painting and may be an attempt to elevate the print to higher art. But he also suggests several possible meanings. Does he too offer homage to Washington and so represent a hopeful (and doomed) feeling that the American Indian can be absorbed into a functional civic relationship with the American government? Or do the odd look of terror and perhaps awe and resignation in his eye and his gesture towards Columbia mean that he acknowledges subjugation? It seems significant that he is so small, a relatively helpless child, and Columbia so large and powerful; the modern viewer cannot miss the irony of the implied mother-child relationship in the image. Yet this is hindsight; in 1800 natural and national impulses seemed congruent.

Fig. 77. Unidentified, *An Emblem of America*, 1800 (cat. no. 172). Print Collection, The New York Public Library, New York, New York.

The predominant mood here is optimism. By simultaneously presenting the grave, the vigorous young female, and the child, the artist objectifies the idea of time passing into futurity; individuals die but life goes on. Columbia's centrality and amplitude imply fertility and hopes for posterity. Niagara Falls, otherwise a seemingly timeless image of God's everlasting power or a window backward on vast ages of geologic history, here takes on the nation's futurity and represents the natural arena where the United States will achieve prosperity.

In a number of vernacular adaptations of this print, including fig. 74, the female figure is usually humanized and modernized, transformed from a classical goddess to a buxom girl carrying a liberty cap. The patriotic iconographical elements reappear: the flag with an eagle superimposed (and in at least one version, a rattlesnake on the canton[10]), Washington's tomb, and Niagara Falls in the background. Niagara's function as national symbol in these prints is underlined by the fact that the rattlesnake, the eagle, and the pine tree, long associated with the Falls, had achieved official symbolic status during the War for Independence. The rattlesnake, which symbolized vigilance because it has no eyelids, served as a warning Don't Tread on Me on patriot flags; the pine tree also appeared on revolutionary flags to represent strength and long life; and the eagle was designated the national bird in 1784. Although Niagara never received official recognition as America's preeminent natural wonder, it was an obvious unofficial emblem of the new nation.

John James Barralet's *Science Unveiling the Beauties of Nature to the Genius of America* (1814) includes Niagara Falls in a similar allegorical complex of images (fig. 78). A seated female, America, with liberty cap and

pole is surrounded by a compendium of plants and animals unique to the New World: the familiar eagle, rattlesnake, and beaver, as well as a moose, sunflower, and an array of gourds, alluding to the active enterprise of botanists, zoologists, and ornithologists in America. An Indian woman and her papoose indicate the beginnings of interest in ethnology or anthropology, and Niagara Falls, presiding in the background, symbolizes the geological revelations of the new continent. In the foreground, Science, whose wings indicate her sublime, deific powers, unveils a four-breasted beauty, representing the abundance of Nature. Edward Hicks's *The Falls of Niagara* (see fig. 36), with its similar array of birds and beasts, is a nonallegorical image of the same ideas of national uniqueness and promise.

Writers, too, appropriated Niagara for nationalistic purposes. The most popular Niagara poem during this period, Alexander Wilson's "The Foresters: A Poem; Descriptive of a Pedestrian Journey to the Falls of Niagara, In the Autumn of 1804," presents its subject (and indeed itself) as a patriotic enterprise.

> *Come roam with me Columbia's forests through,*
> *Where scenes sublime shall meet your wandering view;*
> *Deep shades magnificent, immensely spread,*
> *Lakes, sky-encircled, vast as ocean's bed,*
> *Lone hermit streams that wind through savage woods,*
> *Enormous cataracts swoln with thundering floods;*
> *The settler's farm with blazing fires o'erspread,*
> *The hunter's cabin and the Indian's shed,*
> *The log-built hamlet, deep in wilds embraced,*
> *The awful silence of th' unpeopled waste:*
> *These are the scenes the Muse shall now explore,*
> *Scenes new to song, and paths untrod before.*[11]

It is fitting that the goal of the journey should be Niagara Falls, America's most sublime scene.

Wilson wrote his poem in the early nineteenth century during a great surge of literary and artistic nationalism. American artists were exhorted to use American materials to create a new American art. "Do not our vast rivers, vast beyond the conception of the European, rolling over immeasurable Space," asked the orator opening the Pennsylvania Academy of the Fine Arts in 1810, "with the hills and mountains, the bleak wastes and luxuriant meadows through which they force their way, afford the most sublime and beautiful objects for the pencil of Landscape?"[12] Why should Americans look to Europe for inspiration, "while their own country can boast of more attractive" and inspiring scenery? "What is more sublime," asked one writer in 1807,

> *than the Highlands of the North River: what more awfully tremendous than the cataract of Niagara: what more romantick than the vale of Lebanon: what can surpass the solemn and majestick gloom of the distant mountains, the pensive and soothing silence of the groves, the pastoral simplicity of the cottagers, or the wild luxuriancy of the meadow?*[13]

As Thomas Cole, who is credited with beginning the Hudson River tradition of American landscape painting, asserted,

> *the painter of American scenery has, indeed, privileges superior to any other. All nature here is new to art. No Tivolis, Ternis, Mont Blancs, Plinlimmons, hackneyed and worn by the daily pencils of hundreds; but primeval forests, virgin lakes and waterfalls, feasting his eye with new delights, . . . hallowed . . . for his own favored pencil.*[14]

Moreover, as DeWitt Clinton implied, in his 1816 address at the infant American Academy of Fine Arts, American art with American subjects would not only be unique and original, but better than European.

Can there be a country in the world better calculated than ours to exercise and to exalt the imagination—to call into activity the creative powers of the mind, and to afford just views of the beautiful, the wonderful, and the sublime?[15]

Early American artists such as Vanderlyn or Trumbull, then, who went to Niagara to paint its likeness (see figs. 12, 14), had patriotic as well as commercial motives, and viewers of their paintings understood them as national icons.

Fig. 79. Robert W. Weir, *Sa-go-ye-wat-ha (Red Jacket)*, 1828. The New-York Historical Society, New York, New York.

If American nature was grander and more sublime than that in the Old World, and if it would inspire new, even greater art and literature, it would also nurture a new American character. In contact with "oceans, mountains, rivers, cataracts, wild woods, fragrant prairies, and melodious winds, . . . the mind swells into something of the colossal grandeur it admires." Thus at Niagara, "the soul, expanded and sublimed, is imbued with a spirit of divinity, and appears, as it were, associated with the Deity himself."[16] The natural sublime would produce a corresponding moral sublimity.

Accordingly, many of the writers on the War of 1812 attributed American valor to the influence of American nature. Richard Emmons, for example, in his epic *The Fredoniad, or Independence Preserved* (1827), compared the Americans' efforts at the Battle of Niagara to Michael's combat on the plains of Heaven in Milton's great *Paradise Lost*, but the very type of American valor was "The Isle, that separates Niagara's flood, / Scowling defiance."[17] John Neal, in *The Battle of Niagara* (1818), implied that our soldiers were inspired to special bravery in the proximity of the cataract, and Joseph Rodman Drake made the connection quite explicit in his poem "Niagara" (1836).

The green sunny glade, and the smooth flowing fountain,
Brighten the home of the coward and slave;
The flood and the forest, the rock and the mountain,
Rear on their bosoms the free and the brave.

Niagara, he announced in stirring martial rhythms, will produce for America young heroes of "bold bearing, / Pride in each aspect and strength in each form, / Hearts of warm impulse and souls of high daring," ready for any threat to the homeland. He concluded his patriotic anthem with an apostrophe to Niagara.

Then pour thy broad wave like a flood from the heavens,
Each son that thou rearest, in the battle's wild shock,
When the death-speaking note of the trumpet is given,
Will charge like thy torrent or stand like thy rock.
Let his roof be the cloud and the rock be his pillow,
Let him strike the rough mountain, or toss on the foam,
He will strike fast and well on the field or the billow,
In triumph and glory for God and his home![18]

At least one Indian chief seemed proof of this theory. Sa-go-ye-wat-ha, or Red Jacket, was an aged Seneca leader at the end of a long career of resistance to and negotiation with whites when Robert Walter Weir painted his portrait in 1828 (fig. 79). Assuming a low perspective,

placing his subject in a dignified, classical pose, and clothing him in full traditional regalia, Weir created a noble, heroic image. The stark, sublime background (Niagara Falls to his right, a streak of lightning in the sky, rugged rocks beside him, a snake curled around them), Red Jacket's very high forehead (a sure sign of sublime oratorical powers according to the then popular pseudoscience of phrenology), and the medallion around his neck (presented to him in 1792 by George Washington, it depicts the two of them concluding a treaty) all underline his sublimity of character.

George Washington plays a prominent role in another work of art of about the same period that links the grandeur of Niagara Falls with the morally sublime qualities of a hero. *The Spy* (1821) by James Fenimore Cooper, known as the first truly American historical novel, reaches its climax at the Falls. A story of the American Revolution, its title character and true hero is a patriot peddler, Harvey Birch, who is both spy and counterspy. The locals believe him to be working for the British and so ostracize him, but his true employer is none other than General Washington, who is disguised as the heroic, somewhat mysterious character Harper. No one in the book ever realizes that Harper is Washington, but the reader is never deceived.

One passage in particular, when Harper pauses to remark on nature, reveals Cooper's conviction that the American land is sign and support of the American hero. In a marvelous evocation of the moment after a storm passes, just before twilight, he describes

> *a glorious ray of sunshine lighting the opposite wood. The foliage glittered with the checkered beauties of the October leaf, reflecting back from the moistened boughs the richest lustre of an American autumn. . . .*
>
> *"What a magnificent scene!" said Harper, in a low tone; "how grand! how awfully sublime!—may such a quiet speedily await the struggle in which my country is engaged, and such a glorious evening follow the day of her adversity!"*
>
> *Frances . . . saw him standing bare-headed, erect, and with eyes lifted to Heaven. There was no longer the quiet which had seemed their characteristic, but they were lighted into something like enthusiasm, and a slight flush passed over his features.*[19]

In this moment Washington recognizes the fusion of natural sublimity and national promise; his aesthetic sense and patriotism are subsumed in a form of worship. As he pauses in reverence, God and nature reciprocate, inspiring in him the enthusiasm of sublimity and by implication infusing him with courage and stamina to carry on his heroic endeavor.

The relationship between the American hero and American nature is made even more explicit and more democratic in the final chapters of the book. The major plot ends in the next to last chapter in a final interview between Harper and Birch in which the general offers to pay the spy for his indispensable, heroic services. Birch refuses, however, much to the patrician's surprise; he professes only patriotic motivation. At this, Washington—and the reader—realizes Birch's true moral heroism. We have watched him expand emotionally and even physically while the general first speaks to him, in a description reminiscent of Washington's sunset:

> *During this address, Harvey gradually raised his head from his bosom, until it reached the highest point of elevation; a faint tinge gathered in his cheeks, and, as the officer concluded, it was diffused over his whole countenance in a deep glow, while he stood proudly swelling with his emotion.*[20]

Now, refusing the gold, he assumes his full moral stature as the heroic equal of Washington, both by association and by the general's own acknowledgment: "That Providence destines this country to some great and glorious fate I must believe, while I witness the patriotism that pervades the bosoms of her lowest citizens." In fact, Birch's moral credit seems even greater than his commander's, for it must go unacknowledged before the world; political imperatives dictate that the spy's patriotism must never be revealed, while Washington would be nearly deified as his country's savior. "I am known as the leader of armies," he reminds the spy, "but you must descend into the grave with the reputation of a foe to your native land."

Not until thirty-three years later, in the final chapter, is Birch's true character revealed as he receives his virtual apotheosis. The action in this epilogue occurs in 1814 during the next war with Britain, overlooking Niagara Falls. At one level it is simply a device for Cooper to tie all his loose ends together—two young American officers turn out to be the sons of the principal characters in the body of the novel, and their conversation reveals that all have lived happily and prosperously "ever after." But at a more important level, this is Cooper's credo on the heroic American in his natural setting. His rhetoric in describing the young officers imbues them with the power and beauty of the cataract they gaze upon, and when Harvey Birch happens upon them (convenient coincidence!) and recognizes them as their fathers' sons, he exclaims, "'Tis like our native land! improving with time—God has blessed both."[21]

The most heroic association with nature, however, Cooper reserves for Birch in the grand climax of the book. The British suddenly attack, and one of the casualties is Harvey Birch, fallen in some unidentified courageous act. The young captain finds him with a saintly countenance, a tin box clutched to his breast. Inside is a note from Washington, written decades earlier, attesting to Birch's unsurpassed and unrequited patriotism, a fitting eulogy for the fallen hero who has "died as he had lived, devoted to his country, and a martyr to her liberties." While Washington was associated with a glorious sunset, the spy finds his grave at Niagara Falls, the most appropriate resting place for the American hero.

Andrew Jackson's election to the presidency in 1828 seemed to validate such a democratic vision of American heroism; the literature of Jacksonian America abounds with similar associations between Niagara and democratic characters. One example from the popular literature is a lank Vermonter named Forbearance Smith, nicknamed Job, in *Inklings of Adventure* (1836) by N. P. Willis. "The angular outline of his gaunt figure, stretching up from Table Rock in strong relief against the white body of the spray," is linked with the power of the Falls.[22] He proves himself worthy of the association on his excursion to the base of the cataract. A beautiful lady companion is suddenly stranded when a rocky ledge crumbles, but Job throws himself across the abyss as a human bridge for the young lady (and then waits patiently for the guide to return with a rope to retrieve him!); it is an incredible act of heroism. And in fact, Job is a comic character, finally a player in a tall tale whom neither Willis nor the reader takes quite seriously.

But parody is possible here simply because the assumption that American character would be as grand as the landscape (Niagara) was so widespread. During the 1830s and 1840s such popular faith soared to its heights; it was part and parcel of the political belief in America's future that became known as Manifest Destiny. It seemed fulfilled in such great statesmen as Daniel Webster and John Calhoun. Not surprisingly, they were described again and again by analogy to Niagara Falls. Calhoun, for

example, was "the cataract, the political Niagara of America . . . dashing and sweeping on, bidding all created things give way, and bearing down, in his resistless course, all who have the temerity to oppose his onward career."[23] Webster's forehead was thought to look like Niagara and his intellect was as awesome; "the difference between his head and those of common men" was the same as that which "exists between the giant of waters and minor cascades." Emerson extolled "the natural grandeur of his face and manners" and said that "he alone of all men does not disappoint the eye & ear, but is a fit figure in the landscape." Talking with him was like going behind Niagara Falls.[24]

This period marks the high point, also, of faith in the grandeur and power of American artistic inspiration. When Melville first read Hawthorne he thought of the sublimity of the American continent. "The smell of young beeches and hemlocks is upon him; your own broad prairies are in his soul; and if you travel away inland into his deep and noble nature, you will hear the far roar of his Niagara."[25] Whitman would be even more specific, in his 1855 preface to *Leaves of Grass*, about the sources of the American poet's inspiration. He is to be as large as the American land:

> *He incarnates its geography and natural life and rivers and lakes. Mississippi with annual freshets and changing chutes, Missouri and Columbia and Ohio and Saint Lawrence with the Falls [that is, Niagara—Whitman places it in the larger water system] and beautiful masculine Hudson, do not embouchure where they spend themselves more than they embouchure into him.*[26]

American poetry would be a natural outpouring, as powerful and sublime as Niagara itself.

Before the painter Thomas Cole embarked on an extended study tour to England, Italy, and France in 1829, he decided to take a quick trip to Niagara Falls. "I cannot think of going to Europe without having seen them," he wrote to his patron.[27] After he was in London he painted a number of paintings of the Falls and published a widely disseminated engraving of it (see fig. 38). That Cole read a very explicitly nationalistic meaning into the Falls is clear from a poem he wrote on the spot during his 1829 visit. After noting the glorious rainbow ("a far excelling iris"), with all its implied symbolism of God's blessing and promise, he remarked the "ages untold" during which the Falls thundered unheard in the wilderness, unheard

> *Until an enterprise sublime unbarred*
> *The mighty portals of the golden west*
> *And midst its teeming fulness thou wast found*
> *Majestic in the wilderness enthroned.*[28]

For Margaret Fuller, too, Niagara served as the portal of the West; it was at the Falls that she made her first stop on her pilgrimage to the western frontier in 1843, and it is with the Falls that she begins her book, *Summer on the Lakes* (1844), about the journey. Both book and journey proved to be double explorations: moving backward in time from Boston gentility toward the frontier and aboriginal Indian culture to the roots of the American land and society, she also projects forward through rapid settlement toward a shining, prosperous future.[29] This was the decade of Manifest Destiny, when American public faith in its future ran high. Former President John Quincy Adams, visiting Niagara in the same year as Fuller, was left speechless by overwhelming feelings of sublimity at the power of the

waterfall and the beauty of the rainbow, "a pledge from God to mankind." The reference is biblical, of course, but he interprets it as particularly American as well; in a speech on the spot he reminds his countrymen that "You have what no other nation on earth has. At your very door there is a mighty cataract—one of the most wonderful works of God."[30] As James Fenimore Cooper said in his late novel *The Oak Openings*, "the celebrated cataract of Niagara [is a] signal instance of the hand of the Creator," a signal specifically of his special favor for America.[31]

Perhaps the most resounding declaration of nationalism read into Niagara is in a sermon given at the Falls by the famous sailor-preacher, Father Edward T. Taylor, from the seamen's bethel in Boston. "After you have seen Niagara," he intoned,

> *all that you may say is but an echo. It remains Niagara, and will roll and tumble and foam and play and sport till the last trumpet shall sound. It will remain Niagara whether you are friends or foes. So with this country. It is the greatest God ever gave to man; for Adam never had the enjoyment of it; and, if he had he could not have managed it. It is our own. God reserved it for us, and there is not the shadow of it in all the world besides.*[32]

Such use of Niagara as an emblem for the power of the United States was commonplace in the decades before the Civil War. Its vast gushing waters were read as a symbol of liberty; its rainbow, a sign of unique destiny. It was therefore the perfect image for Henry Wadsworth Longfellow's character, Mr. Hathaway, in the novel *Kavanaugh* (1849), when he expounds the need for a national literature (in classic terms, harking back to the beginning of the century and forward to Whitman):

> *"We want a national literature commensurate with our mountains and rivers—commensurate with Niagara, and the Alleghanies, and the Great Lakes!*
>
> *"We want a national epic that shall correspond to the size of the country; that shall be to all other epics what Banvard's Panorama of the Mississippi is to all other paintings—the largest in the world!*
>
> *"We want a national drama in which scope enough shall be given to our gigantic ideas, and to the unparalleled activity and progress of our people!*
>
> *"In a word, we want a national literature altogether shaggy and unshorn, that shall shake the earth, like a herd of buffaloes thundering over the prairies!"*

To achieve such a goal, Mr. Hathaway proposes a new national literary magazine, to be called, appropriately enough in his terms, *The Niagara*.[33]

Another character, Mr. Churchill, however, disagrees with Hathaway and insists that "A man will not necessarily be a great poet because he lives near a great mountain. Nor, being a poet, will he necessarily write better poems than another, because he lives nearer Niagara." And when he hears that the new magazine is to be called *The Niagara*, he undermines Hathaway's patriotic faith with his ironic response: "Why, that is the name of our fire-engine! Why not call it *The Extinguisher?*" Hathaway responds politely, "That is also a good name; but I prefer *The Niagara*, as more national."[34] Hathaway voices the predominant belief in American destiny, political and cultural, and Niagara's role in it, but Longfellow has also introduced doubts about it; why should Niagara conjure golden images of the future any more than it should utilitarian images of water for fighting fires or generating power? And how are we to be sure that such a magazine would not do more to extinguish good literature than to promote it? Or that Niagara-inspired literature would be greater than any other? Of course Longfellow is careful to put such doubts into a comic character's

mouth (a character who himself has never produced the great romance he keeps promising), but the debate reveals a tension underlying the national faith.

Most Americans who breathed doubts about Niagara's patriotic meaning, however, did so in more limited ways. The most common, but usually glossed over, problem they saw was that the Horseshoe Fall, larger and grander by all standards, was not in the United States at all, but in Canada. As one poetic scribbler in the *Table Rock Album* confessed, "My pride was humbled, & my boast was small/*For England's King has got the fiercest Fall!*"[35] Not surprisingly, British visitors such as Fanny Trollope delighted in such a comparison, but even late in the century, Americans such as William Dean Howells could complain that

> *my patriotism has always felt the hurt of the fact that our great national cataract is best viewed from a foreign shore. There can be no denying, at least in a confidence like the present, that the Canadian Fall, if not more majestic, is certainly more massive, than the American. I used to watch its mighty wall of waters with a jealousy almost as green as themselves, and then try to believe that the knotted tumble of our Fall was finer.*[36]

The most ingenious solution to this problem appeared in an anonymous piece in the *Knickerbocker Magazine* in 1843. Without denying that the British Fall was indeed superior, this writer nevertheless predicted a change in the future.

> *One idea impressed me strongly, while enjoying this triumph of Nature's eccentricities; that the Canada Fall was to the American as Great Britain to the United States. Both of the same majestic pattern, equally lofty, created by the same stream, and side by side; but the former more powerful, more irresistible, more overwhelming; while the latter possesses another kind of beauty, less angry, less furious, less threatening, but yet grand and magnificent, and, take away the other fall, incomparable.*

But Britain's government and character had begun to decay, while America was still "the figure of aspiring, expanding youth." "The Canadian Fall," the writer continues, "can gain nothing by the wearings of time. It can have no larger proportion, no higher ledge; but on the other hand, some shifting rock, some rupture in the bed of the river above, may direct the larger share into the American channel, and the relative character of the

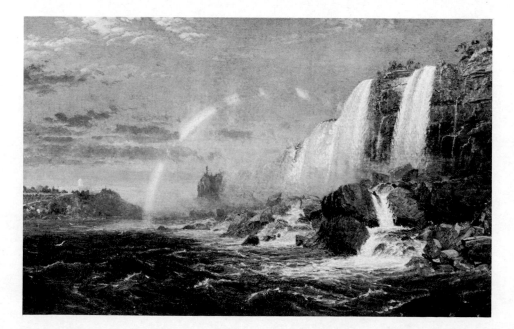

Fig. 80. Jasper Cropsey, *Niagara Falls from the Foot of Goat Island*, 1857 (cat. no. 56). Museum of Fine Arts, Boston, Massachusetts.

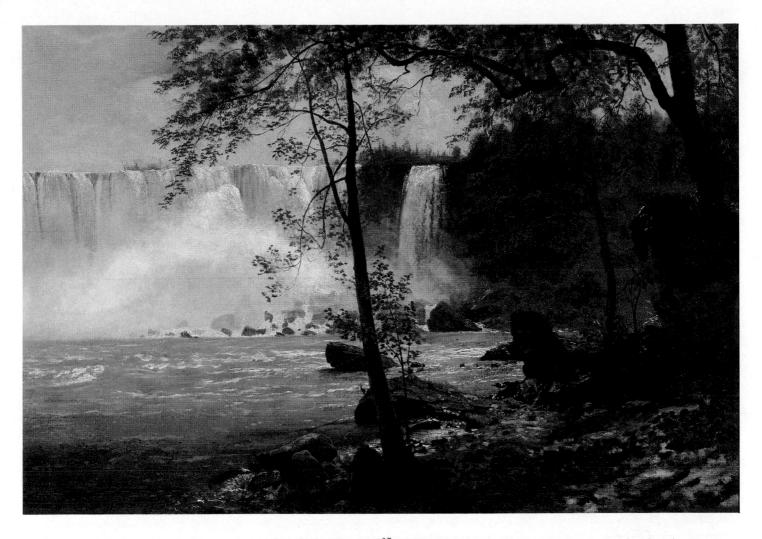

Fig. 81. Albert Bierstadt, *Niagara Falls*, ca. 1880 (cat. no. 32). Sewell C. Biggs Collection.

two be reversed."[37] Although his prediction has proven absolutely wrong geologically (the American Fall is now littered with rocky debris at its base while the Horseshoe Fall still falls in a single powerful bound), his patriotism would have seemed to many Americans to be borne out by the next century of political history.

Only occasionally do we hear a dissonant note in the swell of nationalistic hymns to Niagara. Most striking is "The Fugitive Slave's Apostrophe to Niagara" of 1841, a critique of American government rather than a panegyric. Here, as a literal obstacle between the slave and freedom in Canada, the cataract is revealed to represent only "BASTARD FREEDOM." The tumult of the Falls symbolizes the "maddening passions in the bondman's breast"; his voice joins with Niagara's thunder to shout a curse on slavery and a call for retribution that reads, to the retrospective eye, like a fiery prophecy of the Civil War. At the same time, however, the slave narrator reads the cataract's true meaning as the type of the human spirit, whether black or white, "chainless and strong forever." While this poem condemns slavery and the America that harbors it, then, it still embodies the same values of liberty and power in the Falls as do the more uncritical patriotic paeans.[38]

The visual images of the 1840s and 1850s seem entirely positive. Replete with rainbows, with all their connotations of God's special promise and protection (e.g., pictures by Cropsey and Church; fig. 80); suffused with almost mystical clear light (Kensett's and Bierstadt's paintings; fig. 81); emphasizing the power and the grandeur of the Falls or its tremendous variety and beauty, most of the paintings show visitors contemplating the Falls, climbing up or down or out to various vantage points,

Fig. 82. George Inness, *Niagara Falls*, 1884
(cat. no. 113). The Montclair Art Museum, New
Jersey.

Fig. 83. John H. Twachtman, *Niagara Falls*,
ca. 1894 (cat. no. 158). Mr. and Mrs. Raymond
Horowitz.

absorbing it or "doing" it in the latest tourist modes. But they rarely show a darker side. If a thunderstorm is depicted, it has yielded to a beneficent sunshine, as in Frederic Church's great *Niagara* (see fig. 1). The flood is over, the rainbow has appeared, and one is reminded of the clearing sunset that Harper (that is, George Washington) witnessed in Cooper's novel *The Spy* and read as so full of national promise.

Church's massive canvas was the culmination of all these images. Exhibited in New York in 1857, it was lionized. Thousands paid their twenty-five cents and stood in line to see it. Reviewers hailed it as the first painting to do the impossible; "the eye that could command the hand has seen [the cataract] at last" and the Falls in all its variety of effect and feeling was finally captured on canvas. Critics were "for the first time, satisfied that even this awful reality is not beyond the range of human imitation." Said another, "Mr. Church came and saw and conquered."[39] When the picture was exhibited at the Universal Exposition in Paris in 1867, it was known simply as *The Niagara*. As such, it represented not only the most grandiose scene on the American continent but the triumph of a mature American art. When W. W. Corcoran bought it for $12,500 in 1876 for his new art gallery, he paid the highest price yet to be commanded by an American painting. Depicting the vast vitality of American nature, and by implication of the American nation, the picture had itself become an American icon.

After the Civil War, however, with its unprecedented carnage, and the disillusionment of the failure of Reconstruction and the orgy of capitalist expansion and corruption that followed, faith in a divinely ordained national destiny could not remain so unequivocal. As Americans conquered the land, spanned it with railroads, harnessed its rivers for industry, and fed its forests to the voracious iron horses, they could no longer "read" nature as a sublime and sacred trust. Writers turned from grand, epic explorations of nature and national destiny, such as that in Melville's *Moby-Dick*, to more circumscribed, realistic, or comic treatments of everyday life in cities or small towns, as in the fiction of William Dean Howells or Mark Twain. And painters who began their careers after the war eschewed the large public pictures to which Church and his contemporaries had devoted their energies, "withdrawing their allegiance from the Hudson River, the Falls of Niagara, the Rocky Mountains . . . to seek the humbler intimacy that Nature permits to us."[40] No longer conveying any particular meaning attached to nature, whether patriotic or deific or whatever, they were often not even concerned with nature at all but merely with the process of painting itself. Hence the pictures of Niagara painted late in the century by George Inness (fig. 82) or William Morris Hunt or John Henry Twachtman (fig. 83) are marvelous tour-de-forces of color and painterly technique, but they are not at all concerned with conveying the contours of the scene, much less any meaning it might hold. They are impressionistic, personal visions.

If there was no longer any meaning inherent in the cataract, then it could mean anything to anybody. A vivid illustration of this realization is in an engraving published in *Harper's Weekly* in 1873 called *Niagara Seen with Different Eyes* (fig. 84). The numerous figures arrayed around the Falls—a sailor, a businessman, a poet, an artist, a honeymooning couple (with the "timid brideling's" eyes averted), John Bull, an Indian—suggest every possible response. The accompanying poem enumerates, "Eyes of practical possession, eyes of wonder, eyes of pleasure,/Eyes of fancy deep

and dreamy, eyes of toil and eyes of leisure."[41] The meaning one might read is a function of one's own attitude and condition. Any single meaning would seem to be merely arbitrary.

Post-Civil War literature about Niagara Falls leads to the same conclusion. In his novel *Esther* (1884), Henry Adams turns the honeymoon convention on its head by taking his heroine to the Falls to decide *not* to marry in order to maintain her independent selfhood, and he offers several directly contradictory interpretations of the cataract's significance. The artist character sees its mythic resonance and thinks of Zeus, while the skeptical scientist compares it to a "big, rollicking Newfoundland dog." Esther's best friend, Catherine, sees the Falls as a "woman, and she is as self-conscious this morning as if she were at church. Look at the coquetry of the pretty curve where the water falls over, and the lace on the skirt where it breaks into foam! Only a woman could do that and look so pretty when she might just as easily be hideous." The title character, however, insists that "it is not a woman! It is a man! No woman ever had a voice like that!"[42] We can choose any interpretation we like, it would seem.

In a sketch on "Niagara" (ca. 1871), Mark Twain parodies earlier conventions for viewing the Falls and undermines the extravagant claims made for its significance. The heroic association with Indians, he shows, has deteriorated into commercial exploitation by museum proprietors and souvenir vendors (fig. 85); moreover, he exposes even the remaining token Indians as frauds perpetrated against tourists—they are not Indians at all but mercenary Irish immigrants. Recalling eighteenth-century fish stories, he asserts that Niagara's "opportunities for fishing are not surpassed in the country."

> *Because, in other localities, certain places in the streams are much better than others; but at Niagara one place is just as good as another, for the reason that the fish do not bite anywhere, and so there is no use in your walking five miles to fish, when you can depend on being just as unsuccessful nearer home. The advantages of this state of things have never heretofore been properly placed before the public.*[43]

In another humorous sketch "The First Authentic Mention of Niagara Falls: Extracts from Adam's Diary" (1893), Mark Twain specifically inverts earlier meanings of promise and prosperity read in the Falls. Focusing not on the rainbow but on an obvious, but previously ignored, metaphoric interpretation of the waterfall itself, he plays on the pun of the Falls and the Fall of Man. Placing the Garden of Eden at Niagara, he shows the original honeymoon to have been "no honeymoon." Adam is continually annoyed with Eve. "This new creature with the long hair is a good deal in the way. It is always hanging around and following me about. I don't like this; I am not used to company. I wish it would stay with the other animals." But it is Eve who instinctively names things correctly: "she continues to fasten names on to things that don't need them and don't come when they are called by them, which is a matter of no consequence to her, she is such a numskull, anyway."[44] On the second day recorded, Adam writes, "Been examining the great waterfall. It is the finest thing on the estate, I think. The new creature calls it Niagara Falls— why, I am sure I do not know. Says it *looks* like Niagara Falls. That is not a reason, it is mere waywardness and imbecility. I get no chance to name anything myself." Several days later he laments,

> *The naming goes recklessly on, in spite of anything I can do. I had a very good name for the estate, and it was musical and pretty—GARDEN-OF-EDEN. Privately, I continue to call it that, but not any longer publicly. The new crea-*

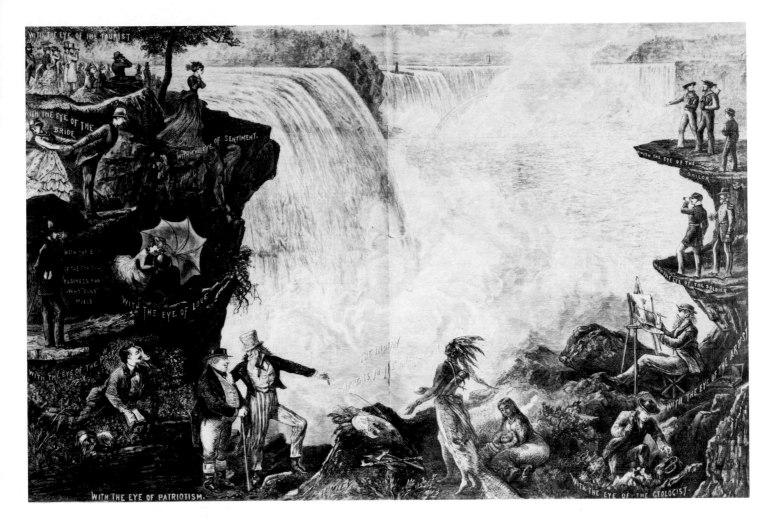

Fig. 84. Arthur Lumley, *Niagara Seen with Different Eyes* from *Harper's Weekly*, August 9, 1873. Staples & Charles, Washington, D.C.

Fig. 85. Unidentified, *Goat Island Bridge*, late 19th century (cat. no. 180). Private Collection.

ture says it is all woods and rocks and scenery, and therefore has no resemblance to a garden. Says it looks like a park, and does not look like anything but a park. Consequently, without consulting me it has been new named—NIAGARA FALLS PARK. This is sufficiently high-handed, it seems to me. And already there is a sign up: KEEP OFF THE GRASS.
My life is not as happy as it was.[45]

By mocking the stereotypical image everyone carries of Niagara ("it *looks* like Niagara Falls"), the commercial hype that surrounds it ("the first authentic mention"), and the extent to which it has been domesticated into scenery, as well as the honeymoon convention, Twain indicates its loss of power. The Fall of the Falls foreshadows the eating of the apple that Adam then goes on to describe.

If the creation of the park at Niagara marked the Fall of American nature for Twain, it was meant to redeem it by its supporters. A magnet for tourists from the earliest years of the century, the cataract was by the 1860s surrounded by hawkers, guides, museums, stairways, vantage points, hotels, refreshment stands, photographers, carriages, and curiosities—all for a price (see fig. 51). It was in sore need of redemption. Even the writer in *Picturesque America* (1874), a lavish giftbook that sought to demonstrate that America's "wildest and most beautiful scenery" was more various and charming than that of the Old World, and so tended to cast a picturesque haze over the scenes described, found nothing to praise in Niagara's surroundings. "The villages that now crowd about its vicinity have no recommendations on the score of fine taste. . . . Niagara, it must be confessed, resembles a superb diamond set in lead. The stone is perfect, but the setting is lamentably vile and destitute of beauty." Human rapacity had all but destroyed America's greatest natural wonder. "In no

quarter of the world is the traveller fleeced as at these falls; he cannot take a single glance at any object of interest without having to pay dearly for it."[46]

Henry James deprecated the "horribly vulgar shops and booths and catchpenny artifices" surrounding the Falls and compared them to "one of those sordid foregrounds which Turner liked to use, and which may be effective as a foil." But he insisted on the incomparable beauty of the waterfall itself. "The perfect taste of it is the great characteristic. It is thoroughly artistic and, as the phrase is, thought out. . . . The genius who invented it was certainly the first author of the idea that order, proportion and symmetry are the conditions of perfect beauty." As his title *Portraits of Places* suggests, it seems that James is describing a picture rather than a real place. It is a masterpiece, set off and protected by James's language as if it is a painting in a museum.[47]

James here does in prose what Frederick Law Olmsted and his colleagues sought to do in fact: to preserve Niagara's wonders for those who could appreciate them. Or as James himself put it, we should "isolate it as much as possible and expose it to no ignoble contact." Using the example of the Yosemite Valley and Yellowstone National Park, set aside as public preserves in 1864 and 1872 respectively, the New York State Legislature finally created the Niagara Falls State Reservation in 1885.

There were some like Twain who disdained the picturesque regulation of the park and the human molding of the scene into scenery, and some might be disturbed at the profound shift in balance between wilderness and civilization on the American continent from the beginning of the nineteenth century to the end. From "Nature's Nation," a polity whose special destiny seemed guaranteed by its vast untouched natural wonders, had grown an urban, industrial, capitalist nation that had run rampant over the continent, using natural resources rapaciously and saving only the most grandiose remnants of nature at the last minute.[48]

Yet the great icon of American nature *was* saved from further destruction and private exploitation. To some degree at least, its surroundings were even restored by tearing down buildings and replanting trees and shrubs. And, whatever its limitations, the park preserved Niagara as a national symbol. In the surge of nationalism at the end of the nineteenth century, poets again addressed Niagara as a "national emblem!" One poem from 1889 by Douglas Sladen, celebrating the United States' rise to become a world power, concludes with these lines:

> *America Niagarized the world.*
> *Europe, a hundred years agone, beheld*
> *An avalanche, like pent-up Erie, hurled*
> *Through barriers, to which the rocks of eld*
> *Seemed toy things—leaping into godlike space,*
> *A sign and wonder to the human race.*[49]

A few years later, Benjamin Copeland was even more Utopian when he addressed Niagara, saying, "With power unrivalled thy proud flood shall speed/The New World's progress toward Time's perfect day."[50] Surely none today would claim that Time's perfect day has arrived, but such hopes persist, at least in our political rhetoric. And if most Americans tend to take the Falls for granted, it still attracts its hundred thousand honeymooners each year, and international visitors still regard Niagara as an essential American sight to see, a national icon to be experienced.

1. Samuel de Champlain, *Voyages,* trans. Charles Pomeroy Otis (Boston, 1880; repr., New York: Burt Franklin, 1966), 271, 301.

2. Louis Hennepin, *A New Discovery of a Vast Country in America* (London, 1698; repr., New York: Kraus, 1972), 318: Hector St. John de Crèvecoeur, "Description of the Falls of Niagara," 1785, in *Magazine of American History 2* (October 1878): 612.

3. As quoted in Charles Mason Dow, ed. *Anthology and Bibliography of Niagara Falls,* 2 vols. (Albany: J. B. Lyon & Co., 1921), 1:20. The "magic stones" were white calcite.

4. Oliver Goldsmith, *A History of the Earth and Animated Nature* (1774; repr., New York, 1825), 65.

5. *The Four Kings of Canada,* excerpted in Frank H. Severance, *Studies of the Niagara Frontier,* Buffalo Historical Society Publications, vol. 15 (Buffalo: Buffalo Historical Society, 1911), 317; Dudley, "Account from Mons. Borassaw," in Severance, *Niagara Frontier,* 319.

6. Benjamin Franklin, *The Papers of Benjamin Franklin,* ed. Leonard W. Labaree (New Haven: Yale University Press, 1968), 12:134–35. This was printed as a letter from "A Traveller," dated May 20, 1765, in *The Public Advertiser,* May 22, 1765.

7. Benjamin West, *The Death of General Wolfe,* 1770, oil on canvas, National Gallery of Canada, Ottawa.

8. Oliver Goldsmith, *The Traveller, or a Prospect of Society* (1764), *Collected Works of Oliver Goldsmith,* ed. Arthur Friedman (Oxford: Clarendon, 1966), 4:267–68.

9. J. C. Bonnefons, in Severance, *Niagara Frontier,* 339.

10. Unknown artist, *America,* ca. 1801, aquatint engraving, Mastai Collection.

11. Alexander Wilson, "The Foresters: A Poem Descriptive of a Pedestrian Journey to the Falls of Niagara, in the Autumn of 1804," *Port Folio* New Series 1-3 (June 1809–March 1810); repr., in *The Poems and Literary Prose of Alexander Wilson, American Ornithologist,* ed. Alexander B. Grosart (Paisley, Scotland, 1876), 2:112–73, lines 5–16.

12. Joseph Hopkinson, "Annual Discourse delivered before the Pennsylvania Academy of the Fine Arts" (Philadelphia, 1810), 33.

13. *Port Folio* 3 (May 23, 1807): 331.

14. Thomas Cole, journal entry, July 6, 1835, in Louis Legrand Noble, *The Life and Works of Thomas Cole,* ed. Elliott Vessell (Cambridge: Harvard University Press, 1964), 148.

15. DeWitt Clinton, "Address to the American Academy of Fine Arts," October 23, 1816, quoted in Thomas S. Cummings, *Historic Annals of the National Academy of Design* (Philadelphia, 1865; repr., New York: Kennedy Galleries, 1969), 12.

16. E. L. Magoon, "Scenery and Mind," in *The Home Book of the Picturesque* (1852; repr. Gainesville, Fla.: Scholars' Facsimiles, 1967), 8, 7.

17. Richard Emmons, *The Fredoniad, or Independence Preserved,* 4 vols. (Boston, 1827), 3:12.

18. Jehu O'Cataract [John Neal], *The Battle of Niagara: A Poem* (Baltimore, 1818); Joseph Rodman Drake, "Niagara," in *Culprit Fay and Other Poems* (New York, 1836), 65–67.

19. James Fenimore Cooper, *The Spy: A Tale of the Neutral Ground,* ed. Warren Walker (New York: Hafner, 1960), 57–58.

20. Ibid., 452.

21. Ibid., 457.

22. N. P. Willis, *Inklings of Adventure,* 2 vols. (New York, 1836), 1:28.

23. A Mississippi Congressman in 1840, quoted in Constance Rourke, *American Humor* (1939; repr., New York: Harcourt, 1959), 63.

24. Caroline Gilman, *The Poetry of Travelling in the United States* (New York, 1838), 88-89; Ralph Waldo Emerson, *Journals and Miscellaneous Notebooks,* 16 vols., ed. William Gilman, et al. (Cambridge: Harvard University Press, 1960–75), 10:396–99.

25. Herman Melville, "Hawthorne and His Mosses," in *Works,* ed. Raymond W. Weaver (New York: Russell, 1963), 13:136–37.

26. Walt Whitman, *Leaves of Grass and Selected Prose,* ed. John Kouwenhoven (New York: Modern Library, 1950), 442-43.

27. Thomas Cole to Robert Gilmor, April 26, 1829, in Noble, *Life and Works of Thomas Cole,* 72.

28. Thomas Cole, "Niagara," in *Thomas Cole's Poetry,* ed. Marshall Tymn (York, Pa.: Liberty Cap, 1972), 50–51, lines 41-49.

29. Margaret Fuller, *Summer on the Lakes,* ed. Arthur B. Fuller (Boston, 1856; repr. New York: Haskell House, 1970).

30. John Quincy Adams, "Speech on Niagara," as quoted in Dow, *Anthology and Bibliography of Niagara Falls,* 1:233–34.

31. James Fenimore Cooper, *The Oak Openings, or the Bee–Hunter* (1848; repr., New York, 1896), 1.

32. Gilbert Haven and Thomas Russell, *Incidents and Anecdotes of Rev. Edward T. Taylor* (Boston, 1872), 214–15.

33. Henry Wadsworth Longfellow, *Kavanaugh; A Tale* (1849; repr., Boston, 1859), 113–14, 122.

34. Ibid., 114, 123.

35. *Table Rock Album and Sketches of the Falls and Scenery Adjacent* (Buffalo, 1848), 65.

36. Frances Trollope, *Domestic Manners of the Americans,* ed. Donald Smalley (New York: Knopf, 1949), 383; William Dean Howells, "Niagara First and Last," in *The Niagara Book* (1893; 2d ed., New York: Doubleday, Page, 1901), 246–47.

37. "Thoughts at Niagara," *Knickerbocker Magazine* 22 (September 1843): 193–94.

38. H. E. D., "The Fugitive Slave's Apostrophe to Niagara," *Boston Courier,* Nov. 1, 1841, repr., in Joseph T. Buckingham, *Personal Memoirs and Recollections of Editorial Life,* 2 vols. (Boston, 1852), 2:192–94.

39. *Littell's Living Age* 55 (October 24, 1857): 254–55, quoted in Dow, *Anthology and Bibliography of Niagara Falls,* 2:911; *Albion,* quoted in Williams, Stevens, Williams Co., *Prospectus: F. E. Church's The Great Fall Niagara* (New York, 1858), 8.

40. W. MacKay Loffan, "The Material of American Landscape," *American Art Review* 1 (1880): 32.

41. "Niagara Seen with Different Eyes," *Harper's Weekly* 17 (August 9, 1873): 698.

42. Henry Adams, *Esther* (1884; repr. New York: Scholars' Facsimiles, 1938), 266–67.

43. Mark Twain, "Niagara," in *Sketches New and Old* (Hartford, 1899), 70.

44. Mark Twain, "The First Authentic Mention of Niagara Falls: Extracts from Adam's Diary," in Howells, et al., *The Niagara Book* (1901), 215, 221.

45. Ibid., 215, 217.

46. William Cullen Bryant, ed., *Picturesque America* 2 vols. (New York, 1874), 1: iii, 435, 438.

47. Henry James, *Portraits of Places* (Boston, 1884), 364–75.

48. See Perry Miller, *Nature's Nation* (Cambridge: Harvard University Press, 1967).

49. Douglas Brooke Sladen, "To the American Fall at Niagara," quoted in Dow, *Anthology and Bibliography of Niagara Falls,* 2:801.

50. Benjamin Copeland, "Niagara," quoted in Dow, *Anthology and Bibliography of Niagara Falls,* 2:826.

Niagara Falls
MUSEUM.
Near Table Rock.

The Proprietor, most grateful for the liberal support he has received from the Ladies and Gentlemen visiting the Falls, begs leave most respectfully to announce to them, that his collection has undergone an entire alteration this Spring, and a numerous variety of fresh specimens have been added to the rooms, the arrangement of which gives the highest satisfaction to the most learned from all parts of the world. The GALLERIES are classically arranged with the rarest and finest specimens the Country can produce. The Collection contains

AN ENTIRE FOREST SCENERY,

Arranged with such taste as to display the nature of every object; exhibiting most of the native Birds and Animals, with their nests and young ones; and showing the voracity of others when seizing their prey. In this splendid collection of natural and artificial curiosities will be found upwards of five thousand interesting specimens, principally collected in this vicinity; and it must be gratifying to visitors to become acquainted with the Birds, Quadrupeds, Reptiles, Fish from Lakes Ontario and Erie, Lake Shells, Insects, Plants, Minerals, Indian Curiosities, &c. that are found in this part of America, including the finest specimens of the Bald Eagle, with all the Falcon order, an extensive variety of rare and beautiful specimens of the Duck and Diver tribe, a great Family of Owls, and a vast variety of other species of rare and fine-plumaged Birds.

QUADRUPEDS,

Comprising the Moose (the largest species of the Deer tribe,) a white Virginia Deer, a Pied Deer, with a large specimen of the common color, the Lynx, Wild Cat, Red and Grey Wolves, many different varieties of Foxes, Porcupines, Oppossums, Otters, Beavers, Marmots, Skunks, Racoons, Muskrats, and a great variety of Hares and Rabbits, Martins or Sables, Ermines, Squirrels of all colors, radiated Moles, White Rats, Mice, &c.

RATTLE SNAKES, AND A NUMBER OF BIRDS AND ANIMALS, ALIVE.

Some very interesting skeletons;—the Eagle, Humming Bird, Rattle Snake, Ducks, Divers, Birds and Animals, of various kinds. Many singular deformities;—a calf with a large protuberance from the head, a Lamb of the same nature, a Chicken with four legs, and one with four legs and four wings, a Goslin with four legs, and many deformities of the Deer's Horn. Bark of trees worn by the natives in different parts of the world. Fine specimens of the saw of the sawfish, and sword of the Swordfish; jaws of a Shark, the Whip of a Sea Spider. A number of different species of Foreign Fish.

A rich collection of Roman, Greek, Egyptian and Polish Coins, some of them upwards of three thousand years old.

A numerous variety of rare and beautiful Birds, Animals, Reptiles, Sea Shells, Minerals, Fossils, Indian Curiosities, &c. from all parts of the world; among which are worthy of notice, a fine specimen of the Barbary Lion, the largest ever imported to this country, a Jackal, (the Lion's Provider,) the Glutton, Civet, Antelope or Gazelle, Agouti, Coatimondi, Leopards, Badger, Duck-billed Platipus, the Alligator, and Crocodile, from the river Nile, Greenland Dog, various kinds of Monkies, Seal, Guana, Green Lizard, the Boa or Ox Serpent.

Also some of the most beautiful of the Feathered race;—the Argus Pheasant, Himalaya Pheasant, the Horned Pheasant, English Pheasant, Pied Pheasant, Pencilled Pheasant, White Grouse, Black Grouse, Wood Grouse, Red Grouse, the Ostrich, Lyre Bird, Bird of Paradise, Toucans, Macows, Cockatoo, Parrots, Penguin, and Albatross which measures 12 feet across the wings, with a numerous variety of interesting objects, both Native and Foreign.

Visitors will find the best general view of the Falls from the verandah of the Museum.

BIRDS, INSECTS, MINERALS, CANES, INDIAN CURIOSITIES, ETC., FOR SALE.

The following extract, written by a scientific gentleman (PROFESSOR SILLIMAN, of *Yale College, U. S.*), is from the Register kept at the Museum, and bears date Niagara Falls, Sept. 13th, 1838 :—"I take the liberty to say, that I have been greatly delighted with this Museum, arranged and prepared as it is, with science, taste and skill. In my judgment, it richly deserves encouragement, and adds an important feature to the attraction of this most interesting region."

The Museum will be open all hours through the day.—Admittance 25 cents, children half price.

THOMAS BARNETT.

by John F. Sears

Doing Niagara Falls in the Nineteenth Century

No natural phenomenon by itself seems adequate to constitute a tourist attraction. Every tourist attraction is a stage upon which some human activity takes place or once took place. Niagara Falls is no exception. The guidebooks are full of accounts of incidents that occurred there. But the human activity that came to characterize the Falls the most was tourism itself; few other places in the world became so closely identified with sightseeing.

Even before the opening of the Erie Canal in 1825, Niagara Falls had become the preeminent American tourist attraction. It soon became the major stop on the American Grand Tour, which encompassed the Hudson Highlands, the Catskills, Lake George, the Erie Canal, Niagara, the White Mountains, and the Connecticut Valley. In addition, the Falls became the most popular destination for honeymooners (fig. 87) and attracted people from all sections of the country and abroad (figs. 88, 89). Most pre-Civil War tourists were well-to-do, but with the advent of cheap, rapid train travel and the growth of the middle classes, tourism became increasingly democratic. Niagara Falls emerged as a national and international gathering place where people could not only escape their daily routines but step out of their social positions and occupations and mix with people from different classes. Whatever the Falls symbolized to tourists, the act of visiting them became one of the primary rituals of democratic life in nineteenth-century America.

Niagara Falls ceased to be merely a spectacular natural phenomenon as early as the 1820s. It became, instead, a natural phenomenon constantly observed by groups of tourists (see fig. 22). Although an artist might imagine the Falls stripped of its trappings as a tourist attraction, no visitor could avoid a consciousness of his fellow tourists or the souvenir shops, guides, and other manifestations of the tourist trade. As a result, the ideas and physical structures that governed the relationship between the Falls and the tourists who visited them in the nineteenth century are of special importance. The ideas tourists brought with them, the physical structures controlling their experiences, and the revision of those structures in the 1880s by those intent on saving the Falls from commercial and industrial desecrations reveal the meaning of Niagara Falls as a tourist attraction.

By far the most important idea nineteenth-century tourists brought to Niagara Falls was the paradigm for the emotional experience of the sublime. Edmund Burke's *A Philosophical Enquiry into the Origin of Our Ideas of the Sublime and Beautiful* was, in effect, the first guidebook to the Falls, for it provided a prescription for the emotions that grand objects were supposed to evoke. By the time the Erie Canal brought the first large influx of tourists to Niagara, Burke's description of the experience of the sublime colored every description of the Falls. The accounts of travelers, like Timothy Dwight, and the early guidebooks are full of Burkean rhetoric

Fig. 86. Niagara Falls Museum Near Table Rock, broadside, 1840s. Library of Congress, Washington, D.C.

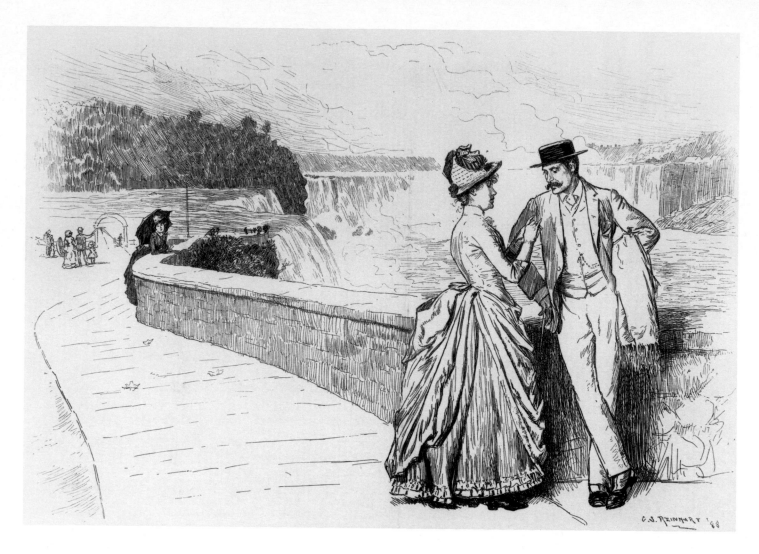

Fig. 87. C. S. Reinhart, *Their Bridal Tour—at Niagara Falls* from *Harper's Weekly*, September 29, 1888. Harvard College Library.

Fig. 88. Page from Bath Island Register, July 25, 1857 (cat. no. 251). Local History Department, Niagara Falls, New York, Public Library.

about the astonishing height, enormous volume, stupendous force, and eternal sound of the Falls; they describe in detail the overpowering effect these qualities had on the mind of the spectator: "Crowding emotions swell the bosom; thoughts that defy utterance, fill the mind. The power and presence of the Almighty seem fearfully manifest. You gaze, and tremble as you gaze!"[1]

This reverent response to Niagara was reinforced by nineteenth-century American tourists who sometimes regarded themselves as pilgrims. Such a notion reflects the evolution of tourism out of the pilgrimage and is found in both serious and ironic form in Hawthorne, Twain, and James. Hawthorne, for example, speaks of himself as a pilgrim in *My Visit to Niagara*, buys what he calls a pilgrim staff from an Indian souvenir shop and approaches Niagara as if it were a religious shrine.[2]

The belief that visiting the Falls was a religious experience and a recapitulation of the soul's journey through life necessarily carried with it another idea: the Falls had a moral effect on the spectator. As Caroline Gilman wrote, "I felt the moral influence of the scene acting on my spiritual nature, and while lingering at the summit alone, offered a simple and humble prayer."[3]

This vision of Niagara Falls as the most sublime and beautiful of God's creations, an object that would have a profound moral influence on the spectator, was certainly very powerful in the nineteenth century. Even the most ordinary tourist must have been aware of this image since it permeated guidebooks, travel literature, paintings, and prints. But we cannot assume that the ordinary tourist stood in awe-struck wonder before Niag-

ara, humbled by the power of God, or felt that he had become a better person through the moral influence of the Falls. This ideal response to the Falls was promoted by America's cultural elite and foreign visitors like Dickens, but there is ample evidence, even in the literature which embodies this view, that many tourists encountered the Falls on less exalted terms. Despite the rhetoric of the sublime, nineteenth-century tourists appear to have been as susceptible as twentieth-century sightseers to boredom and irreverence.

Educated people thought they ought to feel uplifted in the presence of the Falls, but it was inevitable that many people did not respond with the full Burkean intensity. Burke's description of the sublime was difficult to live up to and often led to disappointment, a word that appears in a remarkably high percentage of visitors' accounts and guidebooks. For the worshipers of Niagara, disappointment could be regarded as a stage in the visitor's apprehension of the true wonder of the Falls. When travelers found themselves unmoved at first, it supported the widespread assertion that knowing the Falls required several days—often a week. Initial disappointment would give way to appreciation, even ecstasy, if the visitor took the time to contemplate the magnificent sight. This process resembled the pattern of religious conversion so familiar to nineteenth-century Americans. In *My Visit to Niagara*, for example, one of the most sensitive and perceptive accounts of visiting the Falls, Hawthorne casts his whole experience in terms of a spiritual progress that closely parallels the conversion experience. His initial feelings of unworthiness and insignificance are replaced first by a period of struggle and contemplation and finally by an exhilarating sense of the sublimity of the Falls. "[T]he beholder," he concludes, "must stand beside [Niagara] in the simplicity of his heart, suffering the mighty scene to work its own impression."[4]

But disappointment did not always end in ecstatic recognition of Niagara's sublimity. Some of the tourists who recorded their observations in the albums kept at Table Rock during the first part of the nineteenth century mouthed the usual platitudes about the grandeur of Niagara and its moral influence, but others expressed a mischievous desire to undercut the worshipful pose of the pilgrims and reduce the Falls to the practical or trivial:

> *The roar of the waters! sublime is the sound*
> *Which forever is heard from the cataract's steep!*
> *How grand! how majestic! how vast! how profound!*
> Like the snore of a pig when he's buried in sleep![5]

More important than the subversive responses of some tourists, however, was the commercial nature of tourism, which the sublime to some extent masked, but in a fundamental sense, supported. Tourism was one of the earliest activities in which consuming could be enjoyed as an end in itself rather than an effort to obtain necessities. This was probably because the aesthetic and moral motives associated with the contemplation of the sublime provided a justification for tourism as diversion in a society still devoted to the work ethic. The sublime promised spiritual experience and moral improvement, but it contained within it an invitation to treat grand natural scenery purely as spectacle. Niagara did not always satisfy the tourists' appetite for astonishment, but the sublime raised consumer expectations, and the private individuals who owned Niagara Falls until the 1880s and the writers promoting the Falls made every effort to deliver the goods.

The land around Niagara Falls is exceedingly flat. Visitors usually approached Niagara along the American or Canadian shore at the top of the

Fig. 89. Page from Prospect House Autograph Book (cat. no. 252). Local History Department, Niagara Falls, New York, Public Library.

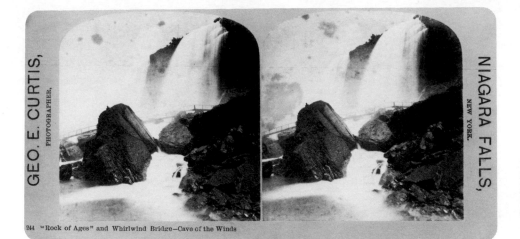

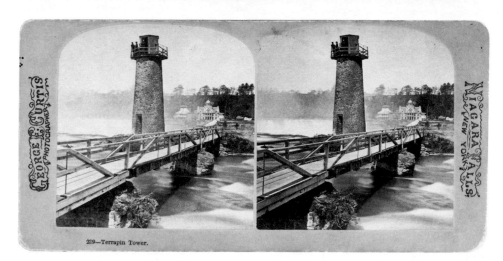

Fig. 91. George E. Curtis, *"Rock of Ages" and Whirlwind Bridge—Cave of the Winds*, late 19th century (cat. no. 65). Private Collection.

Fig. 92. George E. Curtis, *Terrapin Tower*, ca. 1856–73 (cat. no. 62). Private Collection.

Fig. 90. William H. Bartlett, *Niagara Falls*. Illustration from the book, *American Scenery: or, Land, Lake and River . . .* by Nathaniel P. Willis (cat. no. 213). The New-York Historical Society, New York, New York. Photograph courtesy Picture Division, Public Archives of Canada C-466680.

Falls, which makes a much less awesome first impression than Yosemite or even Mount Washington. Marketing the Falls as spectacle posed the problem of how to increase its appearance of height, power, and danger. The proprietors built staircases and walkways to take visitors to the foot of the Falls, behind the Horseshoe Fall to Termination Rock and behind the American Fall to the Cave of the Winds. They also erected a tower with a wooden walkway over the rapids on Terrapin Rocks at the edge of the Horseshoe Fall. In the 1840s the *Maid of the Mist* began carrying tourists into the spray and foam beneath the Falls so that they could experience the sensation of the tumbling waters above them (figs. 90–93).

Although these efforts might be justified as attempts to provide access to the sublime qualities of Niagara, they emphasize the terrifying aspect of the sublime rather than its contemplative and spiritual elements. Sightseers who paid for these excursions were buying sensation, including the thrill of being wetted with spray and buffeted by winds and of negotiating trembling walkways and slippery rocks. In the end, the physical structures (the gates, turnstiles, stairways, walkways, towers, and boats) that brought the thrilling aspects of the Falls closer probably had a greater effect on the actual experience of the average tourist at the Falls than did the aesthetic of the sublime itself.

These structures both sensationalized the Falls and broke up the landscape into numerous points of interest. The guidebooks devoted a section to each attraction: Table Rock, Termination Rock, Prospect Point, Goat Island, the Biddle Staircase, Terrapin Tower, the Whirlpool, the Three Sisters, and so on (figs. 94, 95). As the reading of any able description of the waters, mists, rocks, rapids, and rainbows of the Falls reveals,

these points of interest in no way added up to the Falls. Instead, the points of interest became objects in themselves. Naming and marking them off transformed Niagara into a commodity, making it easy to market the Falls and easy to consume them without the necessity of actually seeing them. Once all the sights were set apart, usually by a fence, gate, ticket booth, or other structure—and this happened very early in the history of the Falls—the structures, guidebooks, popular literature, and hackmen who took people about combined to make "doing the Falls" a matter of covering all the bases. Tourists were told they hadn't really seen the Falls unless they had visited all the major attractions. Because the Falls were divided into these attractions, each of which had an admission fee, visitors could consume the Falls bit by bit, until they felt they had "done" them.

The consumption of Niagara Falls did not stop there, however. Incidents that occurred at Niagara provided further opportunities to call attention to particular places and enhance the exciting qualities of the Falls. In 1829 Sam Patch made a celebrated leap from a 100-foot tower at the base of the Falls, thus inaugurating a long series of stunts performed in the vicinity. The French tightrope walker, Blondin, performed on a rope stretched across the gorge below the Falls from 1859 until 1861; soon several other aerialists followed suit (figs. 96, 97). The barrel craze began later in the century. Accidents and rescues also contributed to the site's sense of danger and excitement. One little girl leapt from the hands of her parents' friend into the rapids and, when he jumped in to rescue her, was swept over the Falls with him. Incidents of this nature were commonly reported in the guidebooks, but they were also given a stamp of approval as part of the genteel experience of Niagara by popular writers like

Fig. 93. Adam Weingartner after Thomas Benecke, *Niagara Falls, Canadian Side*, 1856 (cat. no. 167). Buffalo and Erie County Historical Society, Buffalo, New York.

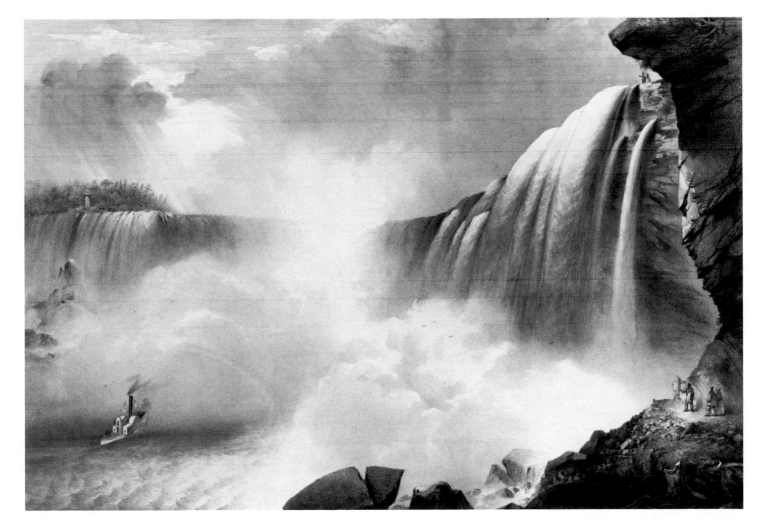

George W. Curtis and William Dean Howells. Howells, for example, wrote a poem called "Avery" about the day-long struggle and ultimate failure to rescue a man stranded on a log near the brink of the Falls (fig. 98).

Most of these incidents, if they had happened somewhere else, would merely have been of passing interest. They would have merited a news item, then been forgotten; but at Niagara Falls they became part of history. This history included people like Sam Patch and Blondin who became famous by performing feats at the Falls; those already famous, like the Prince of Wales; and well-known writers, like Dickens, whose accounts of their visits were widely circulated and quoted in the guidebooks. But it also included ordinary people—tourists and local people—who were rescued from the rapids or swept over the Falls or drowned in the Whirlpool. Most important, it included the tourists who stepped out of their ordinary routines, their familiar and obscure surroundings, and stepped onto the stage of history. Going to Niagara Falls was usually recorded as a significant moment in a tourist's personal history. Souvenirs, letters home, photographs, a certificate from a trip to Termination Rock (figs. 99, 100), and names carved in the trees on Goat Island or Table Rock were a means of securing a place in Niagara's ongoing history. Those who witnessed the aerialists' feats or happened to be present when an accident occurred or a piece of rock fell had that sense of participating in history further reinforced.

The attention given to such incidents and the need of travelers to record their presence at the Falls in some fashion suggest that tourists were seeking a place in public history. If yearly festivals have traditionally enabled residents to join in the ongoing life of their own communities, tourist attractions like Niagara Falls enabled the members of an emerging mass society to participate in a common national experience. The guidebooks, which devote nearly every section to some form of history—whether it be the recession of the Falls over time, the battles fought along the Niagara frontier, or the drowning of some misfortunate tourist—are above all democratic. They equalize all points of interest and all events and memorialize the ridiculous along with the sublime. A description of the Cave of the Winds, the leap of Sam Patch, the story of Avery on the log, the Battle of Lundy's Lane (a bloody encounter during the War of 1812), and a description of Barnett's Museum received roughly equal treatment—all became incorporated into the popular history of the Falls.

The manner in which the cultural content of Niagara Falls—its scenic points of interest and its history—was delivered and consumed closely resembles the methods of several other institutions in nineteenth-century America: the public museum, the exposition, and the popular resort. All these institutions offered diverse attractions under the umbrella of a unifying spectacle and also provided a democratic stage on which the obscure and famous could share the same experience and where, increasingly as the century progressed, members of all classes could mingle.

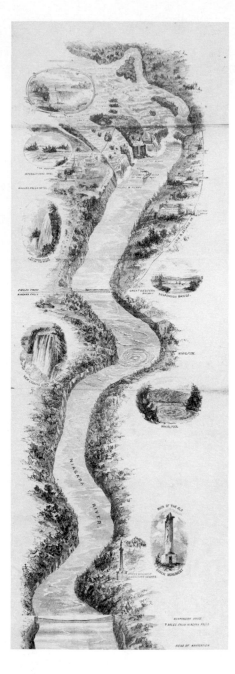

Fig. 94. Fold-out map from *Hunter's Panoramic Guide from Niagara Falls to Quebec*, by William S. Hunter, Jr., 1857 (cat. no. 201). Local History Department, Niagara Falls, New York, Public Library.

Fig. 95. Charles Bierstadt, "Photographic Mementos," 1869 (cat. no. 33). Local History Department, Niagara Falls, New York, Public Library.

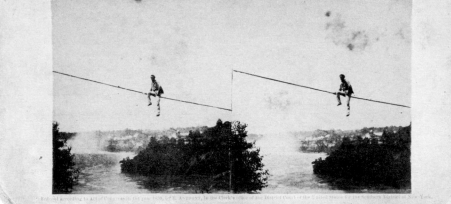

Fig. 96. Edward Anthony, *Niagara, Blondin on the Tight Rope. Anthony's Instantaneous Views No. 125,* ca. 1859 (cat. no. 2). Local History Department, Niagara Falls, New York, Public Library.

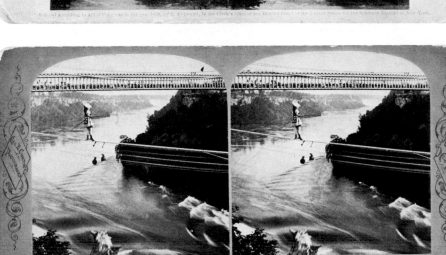

Fig. 97. George E. Curtis, *La Signorina Maria Spelterini in her Grand High Rope Performance— Niagara, July 1876,* 1876 (cat. no. 67). Local History Department, Niagara Falls, New York, Public Library.

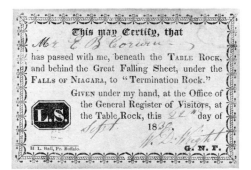

Fig. 99. Termination Rock Certificate, September 22, 1830 (cat. no. 249). Buffalo and Erie County Historical Society, Buffalo, New York.

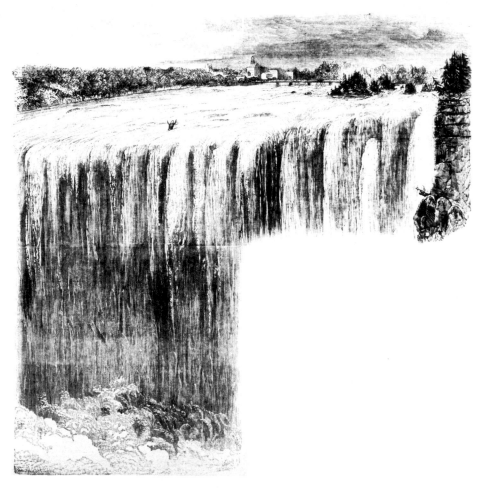

Fig. 98. Joseph Avery on the Rocks, *Illustrated News,* August 6, 1853. Local History Department, Niagara Falls, New York, Public Library.

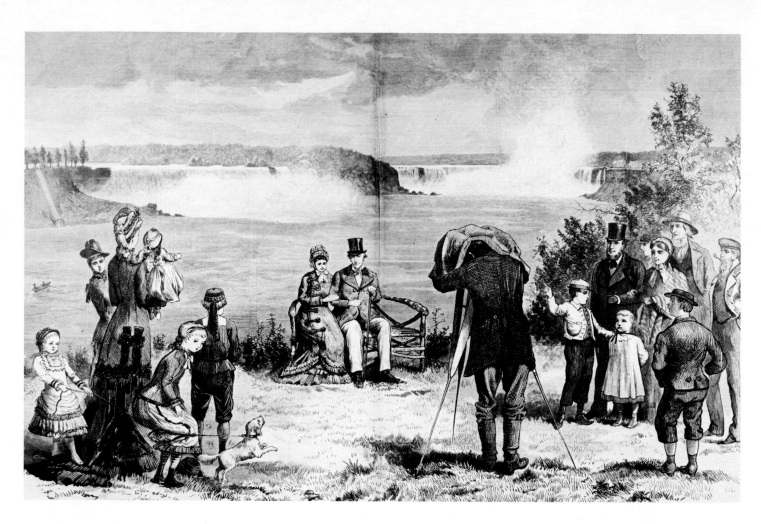

Fig. 100. J. W. Champney, *The Season at Niagara Falls* from *Harper's Weekly*, August 18, 1877. Local History Department, Niagara Falls, New York, Public Library.

Although early American museums ranged in seriousness from P. T. Barnum's American Museum in Manhattan to the Western Museum in Cincinnati to the cabinet of the American Philosophical Society in Philadelphia, most of them began as cabinets of curiosities with extremely diverse collections that included oddities as well as objects of scientific or artistic interest. One nineteenth-century English visitor wrote:

> A "Museum" in the American sense of the word means a place of amusement, wherein there shall be a theatre, some wax figures, a giant and a dwarf or two, a jumble of pictures, and a few live snakes. In order that there may be some excuse for the use of the word, there is in most instances a collection of stuffed birds, a few preserved animals, and a stock of oddly assorted and very dubitable curiosities; but the mainstay of the "Museum" is the "live art," that is, the theatrical performance, the precocious mannikins, or the intellectual dogs and monkeys.[6]

This is not a bad description of Niagara Falls as it was presented to tourists: the phenomena of rapids, falls, and whirlpool mixed indiscriminately with the diversions provided by leapers, tightrope walkers, trips behind the Falls, stories of accidents and rescues, souvenir shops, Barnett's Museum (fig. 86), and the camera obscura that depicted a "miniature and moving Niagara, animated and lifelike."[7] (P. T. Barnum's museum had, in fact, a working model of the Falls, featuring "real water.")

Likewise, the way the proprietors structured the Falls for the tourist anticipates the structure of the expositions made popular by the Crystal Palace Exposition in London in 1851 and imitated with great success in America at the Centennial Exposition in Philadelphia, the Columbian

Exposition in Chicago, and the Pan-American Exposition in Buffalo in 1901 at which Niagara Falls was a major attraction. Like these expositions and the amusement parks at Coney Island and Atlantic City, Niagara Falls provided a heterogeneous group of attractions in a relatively concentrated space through which the tourist was directed. The spectacle as a whole was supposed to awe the tourist and its grandeur provided an ever-present context in which to examine its various parts.

Niagara Falls created the illusion of drawing the diversity of modern knowledge together. The guidebooks stress comprehensiveness and touch, superficially of course, on history, art, poetry, story, geology, and sometimes hydraulics. Niagara was, and is, encyclopedic. In a world growing increasingly complex, it provided a point of convergence for the world's variety.

But, most important, Niagara Falls, the museums, expositions, and amusement parks functioned as instruments of mass consumption. Their structures provided prototypes for the ultimate arena of American consumerism—the shopping mall, where the shoppers' experience is very similar to the tourists' or the museum visitors'. It is appropriate that the latest American contribution to the landscape of Niagara Falls is the Rainbow Center, a fancy indoor shopping mall, within a few steps of Prospect Park, equipped with a Winter Garden, indoor fountains, the usual variety of stores, an atrium, walkways, and escalators. Malls today have become increasingly "awesome"; people visit them to see the sights, be seen, explore the plenitude of goods for sale as well as to buy.

Only a few pre-Civil War visitors appear to have had serious difficulty with the way the Falls was presented to them. Lydia Sigourney, for example, had no difficulty integrating her experience of the Falls as a "living personification" of God's power with the pleasure of shopping for "Indian fancy-work, in beads, bark, and porcupine quills" (figs. 101, 102).[8] But by the 1860s many felt the Falls had been spoiled. Henry James com-

Fig. 101. Indian Beadwork Souvenirs, late 19th century (cat. nos. 233, 236). Iroquois Brands Ltd. Collection, Greenwich, Connecticut.

Fig. 102. George Barker, *Indian Women with Wares on Luna Island*, ca. 1868 (cat. no. 8). The J. Paul Getty Museum, Malibu, California.

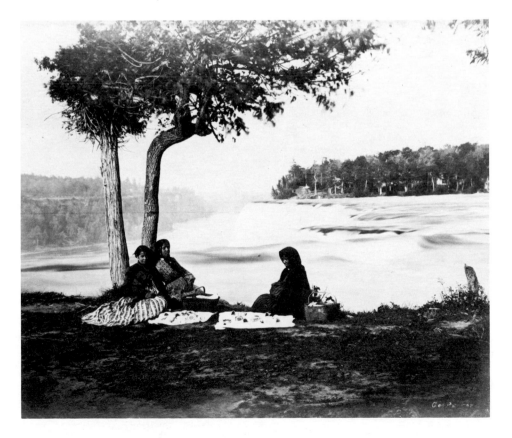

plained in 1871 that the spectacle of the Falls had become

choked in the horribly vulgar shops and booths and catchpenny artifices which have pushed and elbowed to within the very spray of the Falls. . . . the importunities one suffers here, . . . from hackmen and photographers and vendors of gimcracks, are simply hideous and infamous.[9]

Part of the problem, at least for the genteel traveler, was that the kind of person who visited the Falls was changing. Before the Civil War, most tourists were well-to-do. Niagara Falls was a resort, and tourists frequently came to stay for a week or more in one of its grand hotels. But as railroad fares fell and America's urban population increased, clerks, bureaucrats, and others of modest means were able to go on excursions. Unlike the wealthier travelers, the excursionists usually visited Niagara Falls for only a day. They were less cultivated than the better-off tourist and more eager for Coney Island excitements than the quieter pleasures of a sylvan walk. "Like locusts," wrote Henry Norman in 1881, "they sweep everything before them."[10]

The increasing industrialization of the Falls also became obnoxious to many visitors. Niagara "resembles a superb diamond set in lead," complained *Picturesque America* in 1872. "The stone is perfect, but the setting is lamentably vile and destitute of beauty."[11] And the pressures to harness more of Niagara's power were growing.

In response to the threats posed by the commercialization and industrialization of Niagara, Frederic Church, Frederick Law Olmsted, and other prominent individuals proposed that the State of New York establish a park at the Falls which would allow the public free access and protect the Falls from the incursions of souvenir shops, sideshows, mills, and other desecrations. Their proposal was finally enacted into legislation in 1883 after a long campaign of petitions, editorials, and newspaper articles, and in 1887 Olmsted and Calvert Vaux submitted their final plan for the park.

The enemy for Olmsted was precisely the sort of commercial structuring that had turned Niagara Falls into a series of commodities to be consumed by the tourist. "The aim to make money by the showman's methods," Olmsted wrote in the *Special Report of the Commissioners of the New York State Survey of 1879,*

the idea that Niagara is a spectacular and sensational exhibition, of which rope-walking, diving, brass bands, fireworks and various "side-shows" are appropriate accompaniments, is so presented to the visitor that he is forced to yield to it, and see and feel little else than that prescribed to him.

He felt the problem arose from the way the proprietors of the Falls had come to exercise more and more control over the movements of visitors by means of guides, gates, walkways, and toll booths.

Visitors are so much more constrained to be guided and instructed, to be led and stopped, to be "put through," and so little left to natural and healthy individual intuitions.[12]

But it was not merely the means by which the proprietors marketed the sensational aspects of Niagara that Olmsted objected to. He rejected all forms of "astonishment," including the sublime, out of which he clearly felt the sensationalizing of the Falls had sprung. His approach to Niagara depended on the categories of the picturesque and the beautiful, which were not applied to grand natural phenomenon as frequently as the sublime, but were just as well-established and derived from the same body of eighteenth-century English aesthetic theory. For Olmsted the true enjoyment of the Falls required a quiet and pensive contemplation of their

Fig. 103. Jasper Cropsey, *Niagara Falls*, 1860. Jo Ann and Julian Ganz, Jr.

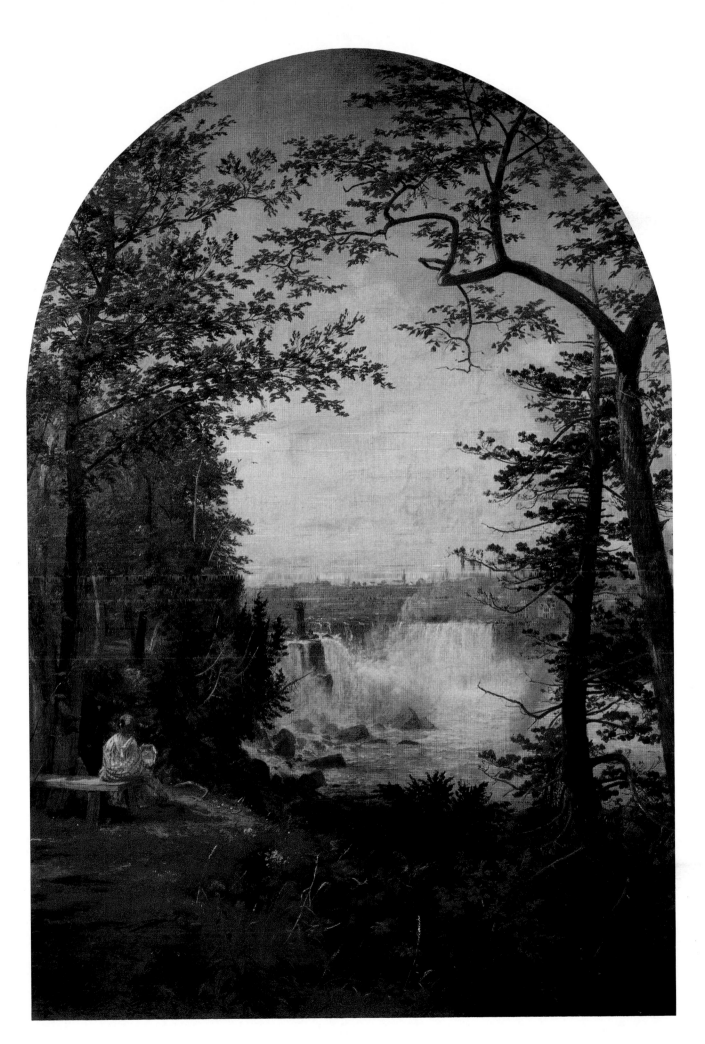

beauty.[13] His firm rejection of the sublime represented an important turning point in the history of the Falls, although his response to the quieter attractions of Niagara had many precedents. Earlier writers, like Harriet Beecher Stowe and Charles Dickens, had emphasized the calmness and the beauty of Niagara rather than its thrilling qualities, and artists, like Jasper Cropsey, had depicted groups of tourists gazing serenely at the Falls amidst pastoral surroundings (fig. 103). But the commercialization and industrialization of the Falls and the changing character of the tourists who frequented them had made it difficult to sustain these visions of Niagara's beauty and picturesque tranquillity.

Olmsted concluded that most of the tourists who visited Niagara had poor taste, were in a hurry and were easily led by the arrangements made for them. No improvements, he felt, were likely to "increase the astonishing qualities" that drew many of them there.[14] But improvements could encourage the excursionist to take a more leisurely approach to the experience of the Falls. In his plan for the reservation, Olmsted set out to redesign the landscape in order to increase what he had called "the influence of the scenery" and allow the tourist to follow his "natural and healthy individual intuitions" rather than the dictates of guides, markers, gates, and so forth.[15]

The landscape that Olmsted proposed was essentially domestic and picturesque: a natural park with carriage roads set back from the edges of the island, giving precedence to winding walks closer to the water; places for sitting and standing; paths for strolling through secluded woodland and viewing the rapids or falls through breaks in the trees. It was a middle-class version of the nobleman's estate and was in harmony with the "mountain house" hotels of the period (which featured long verandas, scenic views, and rustic seats), the picturesque cottage architecture of Andrew Jackson Downing, and the rural cemeteries, like Mount Auburn, all of which appealed to a taste for cultivated naturalness. It would be necessary to construct "walks, roads, bridges, stairways, seats and standing places," in order for visitors to enjoy the scenery, wrote Olmsted in his final plan for the Niagara Falls Reservation in 1887, but such "artificial appliances" should be as unobtrusive as possible and not interfere with the visitor's freedom of movement.[16] All manmade structures still intruding upon the natural landscape were to be hidden by screens of trees.

The results of Olmsted's efforts are vividly preserved in the landscape of Niagara Falls today. Goat Island and the smaller islands above the Falls are covered with vegetation; a band of trees, grass, and walks line the American shore from the head of the rapids down to the brink of the Falls. A more formal park, not designed by Olmsted, protects the Canadian side. But what William Howard Russell, a *London Times* correspondent, called in 1863 the "fixed fair" of Niagara has not disappeared, it has merely been pushed back a bit, and made, just barely, to keep its distance.[17] Henry James's remark that the village is "constantly at your elbow, just to the right or the left of the line of contemplation" still applies.[18] Souvenir shops and sideshows crowd the parks. On the American side, the attractions include a wax museum, the Rainbow Center, and the Turtle (a building in the tradition of the Coney Island Elephant, shaped like the animal of its name and devoted to Native American crafts). The Canadian side features the Niagara Falls Museum (the descendant of Barnett's Museum, a collection of curiosities dating back to the 1830s), a ferris wheel, and three enormous towers that peer over everything into the parks. Souvenir shops have even invaded the parks, though fairly discreetly, and if the tourist is free to wander through the parks for free, the *Maid of the Mist* and the excursions to the Cave of the Winds and the caves behind the Horseshoe Fall,

all of which cost money, continue to be major attractions.

By the 1860s and 1870s the commercial version of Niagara as a spectacle had threatened to swallow up every other experience of the Falls. Olmsted's plan for the reservation made room for the genteel tourist again, but defined the proper experience of the Falls as picturesque contemplation rather than sublime excitement. Within the reservation Olmsted succeeded in transforming the environment from one in which the tourist was processed through the sight to one in which he could direct himself. Thus, Olmsted provided an alternative mode in which the tourist could consume the Falls as a cultural product. But he didn't defeat the sensational version of the Falls; instead, the two versions settled down side by side to compete for the attention of visitors.

J. B. Harrison, who wrote a series of newspaper articles in 1882 in support of Olmsted's efforts to preserve Niagara Falls, argued that the proposed reservation would offer a vital change for those who wished to escape from "the wearing, exhausting quality which is so marked in modern life," and provide a "quickening and uplifting of the higher powers of the mind."[19] The effort to save the Falls was an attempt to assert the values of upper-middle-class society in the name of raising the moral tone of democratic life. Niagara Falls, however, lends itself as much to being a thrilling spectacle, an object in a circus, as it does to being nature's masterpiece in a picturesque park, and it remains both. Perhaps the most remarkable fact about Niagara Falls as a tourist attraction is that nowhere else in the United States can you find the popular and the democratically genteel, Coney Island and Central Park, P. T. Barnum and Frederick Law Olmsted in such vivid juxtaposition.

NOTES

1. J. W. Orr, *Pictorial Guide to the Falls of Niagara: A Manual for Visitors* (Buffalo, N.Y.: Salisbury and Clapp, 1842), 155.

2. Nathaniel Hawthorne, *My Visit to Niagara* in *The Centenary Edition of the Works of Nathaniel Hawthorne*, (Columbus: Ohio State University Press, 1974), 11:281–83.

3. Caroline Gilman, *The Poetry of Travelling* (New York: S. Colman, 1838), 114.

4. Hawthorne, 285.

5. Quoted in *Hackstaff's New Guide Book of Niagara Falls* (Niagara Falls: W. E. Tunis, 1853), 80. See also *Table Rock Album and Sketches of the Falls* (Buffalo, N.Y.: E. R. Jewett, 1859).

6. Edward Hingston, *The Genial Showman, Being Reminiscences of the Life of Artemus Ward* (London: J. C. Hotten, 1870), 1:11–12.

7. Orr, 164.

8. L. H. Sigourney, *Scenes in My Native Land* (Boston: James Munroe, 1845), 12, 11.

9. Henry James, "Niagara" in *The Art of Travel* (Garden City, N.Y.: Doubleday Anchor Books, 1958), 88, 90–91.

10. Henry Norman, *The Preservation of Niagara Falls* (New York, 1881), 13.

11. *Picturesque America* (New York: D. Appleton, 1872), 1:435.

12. Frederick Law Olmsted, "Notes by Mr. Olmsted" in *Special Report of the Commissioners of the New York State Survey of 1879* (Albany, N.Y.: C. Van Benthuysen, 1880), 28.

13. Frederick Law Olmsted and Calvert Vaux, *General Plan For the Improvement of the Niagara Reservation* (Niagara Falls, N.Y.: Gazette Book and Job Office, 1887), 4.

14. Ibid.

15. Olmsted, *Special Report*, 27–28.

16. Olmsted, *General Plan*, 8.

17. William Howard Russell, *My Diary North and South* (New York: Harper and Brothers, 1863), 136.

18. James, 88.

19. J. B. Harrison, *The Condition of Niagara Falls, and the Measures to Preserve Them* (New York, 1882), 8.

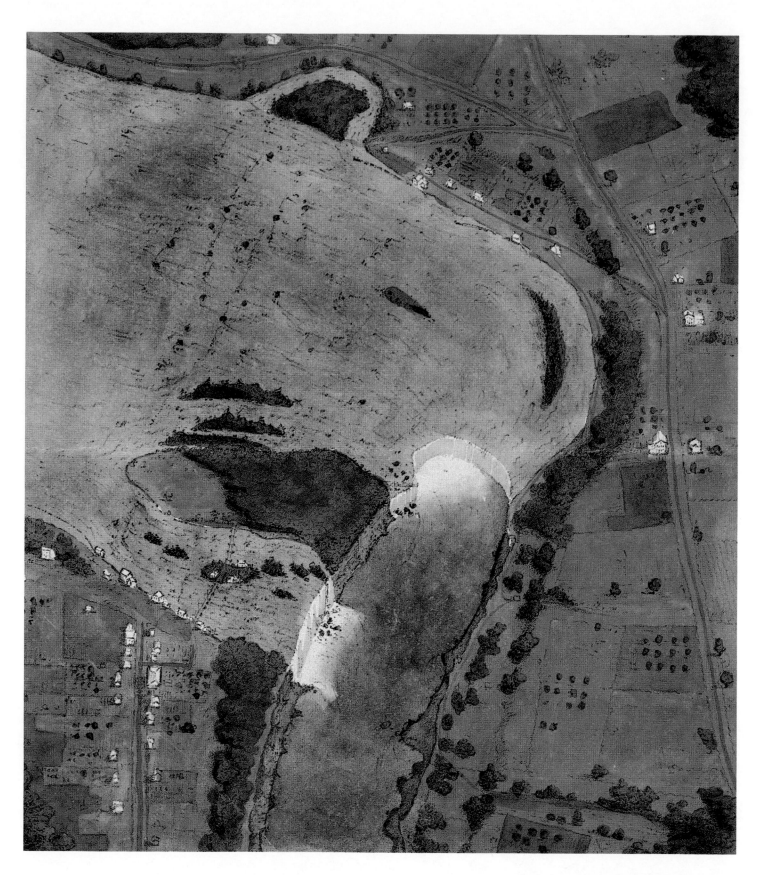

Fig. 104. George Catlin, *Bird's-Eye View of Niagara*, 1831 (cat. no. 42). Buffalo and Erie County Historical Society, Buffalo, New York.

by Alfred Runte

The Role of Niagara in America's Scenic Preservation

The preservation of Niagara Falls, dedicated by New York as a state park on July 15, 1885, represents a unique chapter in the history of American conservation (fig. 105). To be sure, the State Reservation at Niagara was neither the first nor the largest public park devoted to the protection of the American landscape. As early as 1864, Congress granted to California the Yosemite Valley and Mariposa Grove of Giant Sequoias and, in 1872, further established Yellowstone National Park, Wyoming, a preserve encompassing nearly 3,400 square miles of geyser basins, waterfalls, canyons, and mountain ranges. In contrast, the State Reservation at Niagara was but 400 acres in size, of which 300 were underwater.[1]

The park's significance lay not in its area, but in the history of this small piece of real estate as an object lesson for the preservation movement. By the 1860s, most of the riverbank immediately above and below the cataract had been cleared of vegetation and given over to commercial development. No other example of America's widespread callousness toward natural beauty did more to alert artists, journalists, and intellectuals of the nineteenth century to the need for scenic preservation in the United States. The realization, especially among Easterners who ventured across the continent, that Niagara Falls had been shorn of its natural beauty by tourist sharks and land developers figured prominently in the earliest efforts to rescue the newly discovered "wonderlands" of the American West from a similar fate.

Prior to the exploration and settlement of the West, eastern landmarks, such as Niagara Falls, the Natural Bridge in Virginia, and the Hudson River highlands, attracted tourists seeking spectacular scenery. Of these, Niagara was usually the most difficult to reach. The reputation of Niagara Falls as America's "must see" natural wonder of the early nineteenth century was considerably enhanced by the completion of the Erie Canal across upstate New York in 1825. Travelers were now able to escape the discomfort of wagons, stagecoaches, and poorly constructed roads for the relative luxury of the canal boats.[2] As many commentators soon noted, however, the ease of transport also spurred the commercialization of Niagara Falls for both industrial and tourist development. As early as 1831, Alexis de Tocqueville, the young French political philosopher, urged a friend to "hasten" to Niagara Falls if he wished "to see this place in its grandeur. If you delay," he warned, "your Niagara will have been spoiled for you. Already the forest round about is being cleared. . . . I don't give the Americans ten years to establish a saw or flour mill at the base of the cataract."[3] In a similar vein, E. T. Coke, a British journalist, wrote in 1832 of a "company of speculators" who intended to erect "grist-mills, storehouses, saw-mills, and all other kinds of unornamental buildings" in the vicinity. "The die is then cast," he concluded, "and the beautiful scenery about the Falls is doomed to be destroyed."[4]

Especially significant for the 1830s was the tendency of such pessimistic observations regarding the future of Niagara Falls to conclude with a plea for its swift redemption. "'Tis a pity," Coke further wrote,

> *that such ground was not reserved as sacred in perpetuum; that the forest trees were not allowed to luxuriate in all their wild and savage beauty about a spot where the works of man will ever appear paltry, and can never be in accordance. For my own part, most sincerely do I congratulate myself upon having viewed the scene before such profanation had taken place.*

Sharing his lament was Thomas Rolph, another English traveler of the period. "I wish it were provided by law that no building should be erected within sight of the little plot of ground immediately adjoining the cataract," he wrote in 1836, describing his own visit to the Falls in 1833. "As matters are now conducted, another twenty years may see the whole amphitheatre filled with grog-shops, humbug museums, etc., etc.—Who knows but it may be profaned by cotton factories?"[5]

Andrew Reed and James Matheson, two English Congregational ministers who visited Niagara Falls in 1834, offered an even more outspoken description of the commercialization.

> *On the American side they have got up a shabby town, and called it Manchester. . . . On the Canadian side, a money-seeking party have bought up 400 acres, with the hope of erecting "The City of the Falls;" and still worse, close on the Table Rock, some party was busy in erecting a mill-dam! . . . The universal voice ought to interfere, and prevent them. Niagara does not belong to them; Niagara does not belong to Canada or America. Such spots should be deemed the property of civilized mankind.*[6]

If Coke, Reed, Matheson, and other British travelers had been heeded in their own country, Great Britain might have protected the Canadian side of Niagara Falls fifty years before New York State dedicated its own park in 1885. Instead, it remained for the artist George Catlin, a native of Pennsylvania, to suggest in print that Reed and Matheson's "universal voice" calling for preservation ought, in fact, to originate with the United States government. In 1827 Catlin had painted Niagara Falls; even at that date, he must have sensed the significance of the scattered clearings and structures already visible near the cataract (fig. 104). If so, these early warnings suggesting the fate of Niagara Falls may have inspired, in part, his appeal in 1833 for "a *nation's Park*, containing man and beast, in all the wild and freshness of their nature's beauty!"[7] That nothing came of his own idea in the 1830s is not surprising. Catlin maintained his park should be centered in the Great Plains, an area originally described as a desert, but soon recognized as desirable for American settlement after all. More critically, he proposed to create a refuge where Indians and wildlife might coexist unmolested by fur traders and other exploiters, purposes that went against every conceivable demand of the frontier economy.

Speaking more like an ecologist or anthropologist, Catlin was simply far ahead of his time. Not only could the Great Plains be settled and developed, but as landscape, such sweeping, so-called monotonous tracts of level terrain had little appeal to the American imagination of the 1830s. By the time a succeeding generation of American intellectuals caught up with his idea, their own attraction to landscape was still swayed by prejudices for the dramatic and the unusual in nature.

Crucial to the persistence of these "site specific" preferences was the public's growing fascination with the American West and its natural "wonders." For decades American artists, writers, and other intellectuals had suffered the embarrassment of representing a society that lacked world-

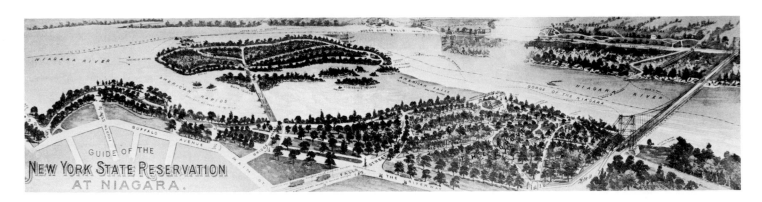

Fig. 105. *Map and Guide of the New York State Reservation at Niagara*, ca. 1888 (cat. no. 222). Local History Department, Niagara Falls, New York, Public Library.

renowned cultural achievements. In contrast to the storied cultures and landmarks of Europe, the United States, especially in its infancy, had no great monuments of literary or artistic achievement. As the noted British critic Sydney Smith asked derisively in 1820, "In the four quarters of the globe, who reads an American book? or goes to an American play? or looks at an American picture or statue?"[8] Smith's insulting tone aside, his point was still well-taken. In terms of cultural heritage, at least, the United States indeed had yet to prove itself.

World-class American literature, art, and architecture, of course, would be decades—even centuries—in the making. In the meantime, though America lacked great artistic achievement, the country by no means lacked beauty. Nature had provided America splendid monuments; the problem in comparing the East to Europe was Europe's combination of beautiful landscapes *and* cultural tradition. Accordingly, as late as 1851, James Fenimore Cooper still conceded the obvious: "As a whole, it must be admitted that Europe offers to the senses sublimer views and certainly grander, than are to be found within our own borders, unless we resort to the Rocky Mountains, and the ranges in California and New Mexico."[9]

Fortunately, Cooper's contemporaries could, as he put it, "resort to the Rocky Mountains, and the ranges in California and New Mexico." Thanks to a combination of diplomacy and conquest, by 1848 the young nation stretched from sea to sea. In 1855 the first party of tourists entered California's fabled Yosemite Valley; elsewhere along the western flank of the Sierra Nevada stood majestic groves of Giant Sequoias, renowned for their huge circumference. Obviously, Yosemite Valley's soaring cliffs, plunging cataracts, and neighboring Big Trees had no peers abroad. In this vein William H. Brewer, a member of the California Geological Survey, declared Bridalveil Falls in Yosemite to be "vastly finer than any waterfall in Switzerland, in fact finer than any in Europe."[10] Samuel Bowles, editor and publisher of the *Springfield* (Mass.) *Republican*, likewise marveled in 1865 at the close resemblance of Cathedral Rocks in Yosemite Valley to

> *the great impressiveness, the beauty and the fantastic form of the Gothic architecture. From their shape and color alike, it is easy to imagine, in looking upon them, that you are under the ruins of an old Gothic cathedral, to which those of Cologne and Milan are but baby-houses.*[11]

The emergence of the "romantic" West, coupled with the attempts among American intellectuals to compensate for their cultural limitations, helps explain why the United States bridged the gap between simply appreciating nature and actually advocating its protection. Steeped in the concerns of their time, knowledgeable Americans reacted strongly to reports that the nation's new-found wonderlands in the West, like Niagara Falls in the East, were jeopardized by souvenir hunters and homesteaders desiring to control access to these areas for private gain. In the instance of

119

Niagara Falls, awareness had come too late to save the cataract and its environs from falling into the hands of tourist sharks, hucksters, and private land developers. Clearly, national pride called for the protection of Yosemite Valley, the Giant Sequoias, and marvels yet to be discovered from a similar fate.

To reemphasize, the stimulus for protection was cultural provocation. Just as Niagara Falls demonstrated the price of past indifference, so the West provided an opportunity for redeeming the nation's reputation. Granted, America's first preservationists may have come to this realization only in retrospect; even so, their rhetoric when they first addressed the problem of protecting natural wonders reveals the bases of preservationists' concerns. As early as 1853 *Gleason's Pictorial,* a widely read British journal, published a letter from an irate Californian who protested the destruction of a famous Giant Sequoia for public display as "a cruel idea, a perfect desecration." In Europe, he maintained, the Discovery Tree undoubtedly "would have been cherished and protected, if necessary, by law; but in this money-making, go-ahead community, thirty or forty thousand dollars are paid for it and the purchaser chops it down and ships it off for a shilling show."[12] The incident was one of numerous schemes to display a Giant Sequoia by simply cutting it down, removing its bark, cutting it into easily transported pieces, and reassembling the pieces for exhibition. Such acts of vandalism underscored the callousness of those seeking to promote the West for personal profit. Within the decade Yosemite Valley itself was similarly threatened; only the federal government, it seemed, could save the West's natural wonders from being auctioned off to the highest bidder.

These provocations for preservation stimulated political action during the winter of 1864. Concerned about the fate of the Giant Sequoias and especially Yosemite Valley, a small group of Californians persuaded their junior United States Senator, John Conness, to introduce legislation protecting both marvels from additional private encroachment. The key to the success of Conness' legislation lay in his appeal to national pride. Specifically, he introduced the Yosemite bill not as an obligation to nature, but as the duty of a patriotic people. The heart of his speech reminded his colleagues that the British had initially debunked the Giant Sequoias in particular as nothing but "a Yankee invention."[13] Put in those terms, the legislation had both cultural and environmental significance. Following approval by the Senate in May, the bill easily cleared the House of Representatives the following month, and on June 30, 1864, President Abraham Lincoln signed the Yosemite Park Act into law.[14]

Actual administration of the Yosemite grant fell to the state of California, which in 1866 formally accepted the valley proper, its immediate environs, and the four square miles of Giant Sequoias known as the Mariposa Redwood Grove. Six years later, in order to protect Yellowstone in the northwestern corner of Wyoming Territory, Congress had no choice but to maintain federal jurisdiction over the area. Because there was no established state government to take charge of the region, Congress kept control of Yellowstone following its establishment as a public park on March 1, 1872.[15] For this reason, Yellowstone soon came to be known as "the national park."

The motivations behind its establishment were nonetheless identical to those of Yosemite. For a second time the nation had discovered a region whose "freaks," "decorations," "curiosities," and other "wonders" grandly compensated for the absence of cultural symbols in the American scene. The nation's dilemma once again was obvious. Yellowstone's geysers, canyons, and waterfalls must not fall into the hands of private claimants, espe-

cially promoters whose sordid commercial developments would rob Yellowstone, like Niagara Falls, of its integrity as a symbol of national pride and achievement. Unquestionably, the objective of park advocates was to prevent another national embarrassment of the equivalent of Niagara Falls. For example, Dr. Ferdinand V. Hayden, the noted geologist who led a government expedition through Yellowstone in 1871, protested to Congress that despoilers hoping to lay claim to the region also intended "to fence in these rare wonders so as to charge visitors a fee, as is now done at Niagara Falls, for the sight of that which ought to be as free as the air or water."[16] Watercolors and sketches by Thomas Moran, a rising artist, coupled with the pioneering photographs of a young frontier photographer, William H. Jackson, underscored Hayden's widely quoted remarks. Each work of art further dramatized what Americans stood to lose if Congress remained indifferent to the legislation introduced in December 1871 for the protection of Yellowstone. Truly, Yellowstone National Park may be considered the end product of a widespread campaign that effectively used Niagara Falls as an object lesson for illustrating Yellowstone's probable fate in the absence of congressional intervention.

The Niagara Falls preservation campaign, a crusade first seriously discussed in 1869, was itself a unique achievement in American conservation history. Both Yosemite and Yellowstone parks had been established from lands totally owned by the federal government as part of the public domain. In the instance of Niagara Falls, New York State and the province of Ontario faced the challenge of actually restoring many pieces of property to their natural condition. Moreover, before any restoration could begin, the offending properties first would have to be condemned, purchased by the governments, and—in the case of the numerous shops, stables, gatehouses, and other tourist traps ringing the cataract—torn down to make room for flowers, trees, and shrubbery. By comparison, the establishment of Yosemite and Yellowstone parks—still in their pristine condition—had been relatively simple and straightforward.

Given the challenge of restoring Niagara Falls to a semblance of its former grandeur, the park campaign that emerged in the late 1870s was indeed fortunate to list America's leading preservationists among its contributors and supporters. Of these, none was more influential than Frederick Law Olmsted, the distinguished landscape architect. Olmsted began his career in 1858 as the first superintendent and co-designer of Central Park in New York City. In 1863 he went west to California, where, as superintendent of the Mariposa Estate in the Sierra foothills near Yosemite, he was probably among the group of California gentlemen who approached Senator John Conness early in 1864 with a proposal to protect the valley and the Giant Sequoias. Olmsted personally did not see Yosemite Valley until August 1864, more than a month after the park had been created. His reputation had, however, long since preceded him; that September, when Governor F. F. Low formally announced the members of a commission he had asked to plan and oversee the new preserve, Olmsted's name headed the list.[17]

His report in 1865 to the Yosemite Park Commission still stands as one of the most profound documents in American environmental history. With amazing foresight, he predicted that the large majority of millions of future visitors to Yosemite would look upon the valley as a mere "wonder or curiosity." This perception would only encourage the public to ignore Yosemite's broader aesthetic values—"the tender foliage of noble and lovely trees and bushes, tranquil meadows, playful streams, and every variety of soft and peaceful pastoral beauty." For Olmsted, the Yosemite resource was simultaneously visual and inspirational. Emphasizing the val-

ley's geological wonders by debasing its natural setting would only destroy Yosemite's powers of suggestion, especially "the effect of refreshing rest and reinvigoration" its scenery seemed to cast over both mind and body.

> *The first point to be kept in mind then is the preservation and maintenance as exactly as is possible of the natural scenery; the restriction, that is to say, within the narrowest limits consistent with the necessary accommodation of visitors, of all artificial constructions . . . which would unnecessarily obscure, distort or detract from the dignity of the scenery.*[18]

Although Olmsted described the conditions at Niagara Falls only by inference, unquestionably the commercialization of the cataract was much on his mind as he urged the Yosemite Park Commission to resist similar pressures for development in the valley. As a boy of twelve, in 1834, he had visited Niagara Falls with his family; even at that early date, the creeping developments beside the cataract certainly made a lasting impression on his aesthetic sensibilities.[19] He nonetheless also gave credit to the noted landscape artist Frederic E. Church for impressing upon him, in 1869, "the rapidly approaching ruin of [Niagara's] characteristic scenery."[20] A short time later, at Olmsted's request, he and his partner, Calvert Vaux, joined Henry Hobson Richardson, the architect, and William Dorscheimer, a New York State district attorney, "to consider this danger" in person.[21] The date of their historic inspection of Niagara Falls was August 7, 1869.

As much as Olmsted's return to New York City in 1866 had jeopardized support for his Yosemite report of 1865, so public apathy in the absence of higher leadership thwarted this initial effort by him and his associates to effect government sanctions against further ruination of Niagara Falls. Not until 1878, following a visit to the Falls by Lord Dufferin, the governor general of Canada, was public interest in the cataract reawakened by Dufferin's condemnation of the scenic decay and sordid tourist traps everywhere in evidence. More to the point, he personally contacted the governor of New York, Lucius Robinson, and inquired about the possibility of cooperating with the state in efforts to restore the site as an international park.[22]

Robinson agreed, pledging his own support for the protection of Niagara Falls in his last annual message to the New York State legislature on January 9, 1879.

> *It is well known, and a matter of universal complaint, that the most favorable points of observation around the falls are appropriated for purposes of private profit, while the shores swarm with sharpers, hucksters and peddlers, who perpetually harass all visitors.*[23]

At the out-going governor's request, the legislature authorized the topographical engineers of the New York State Survey to conduct a study of Niagara Falls. In turn, the commissioners of the survey asked James T. Gardner, the director, and Frederick Law Olmsted to prepare the proposal for preservation and improvement of the cataract. Gardner and Olmsted made their inspection that May; on March 22, 1880, they submitted their final report in separate statements to the state legislature.[24]

In keeping with Olmsted's recommendations to the Yosemite Park Commission fifteen years earlier, the document not only discussed the defacement of Niagara, but simultaneously argued that the governments concerned had both the right and the duty to correct the problem. "It is now a clearly recognized duty of governments to reserve from sale parts of the public domain that contain natural features of such unusual character as to be objects of interest to the whole world," Gardner wrote. "A hun-

dred years ago the land along [the] Niagara River belonged to the State. . . . The error made by the State in parting with this territory will never be fully repaired . . . but much can yet be accomplished at a reasonable expense to restore the lost attractions."[25]

These "attractions," in Olmsted's words, included "the great variety of the indigenous perennials and annuals, the rare beauty of the old woods, and the exceeding loveliness of the rock foliage" surviving on Goat Island, between the American and Horseshoe Falls, and on portions of the islands and riverbank immediately above and below the cataract. To most visitors, he admitted, Niagara Falls was just a sideshow, a "spectacular and sensational exhibition" that to them "would still be a place of singular fascination" even if "it were possible" to remove the forests, wildflowers, and river islands from the scene. As he had argued in Yosemite Valley in 1865, however, scenery without vegetation was lifeless. Without the ordinary beauty found throughout the vicinity of the cataract, Niagara Falls itself would be just another "rope-walking, diving, brass bands, fireworks" display.[26]

Even as matters stood, Gardner lamented, much of the riverbank above and below the Falls was a vision of "solid ugliness"—a wall of hotels, bath houses, laundries, rookeries, jetties, sewer outflows, stables, shops, fences, and patent medicine signs (figs. 106, 107).[27] New York State had no choice, he and Olmsted agreed, but to confiscate through the power of eminent domain the lands on which the offensive structures stood. Similarly, Ontario would have to resort to eminent domain when the Canadians were ready to clean up their side of the cataract. In New York, a strip of land along the riverbank at least one mile in length and from 100 to 800 feet wide would be required for the park. Granted, years would pass before Niagara's "frame of foliage" could be replanted and returned to its former glory. At the very least, when the buildings had been razed, Niagara's best overlooks would be open to free public access once again.[28]

Governor Robinson's successor, Alonzo B. Cornell, opposed the rec-

Fig. 106. *Disfigured Banks. Repulsive Scenery Around Visitor Approaching Goat Island Bridge for First View of Rapids,* ca. 1879. Plate VIII from James T. Gardner, *Special Report of the New York State Survey on the Preservation of the Scenery of Niagara Falls* (cat. no. 194). Local History Department, Niagara Falls, New York, Public Library.

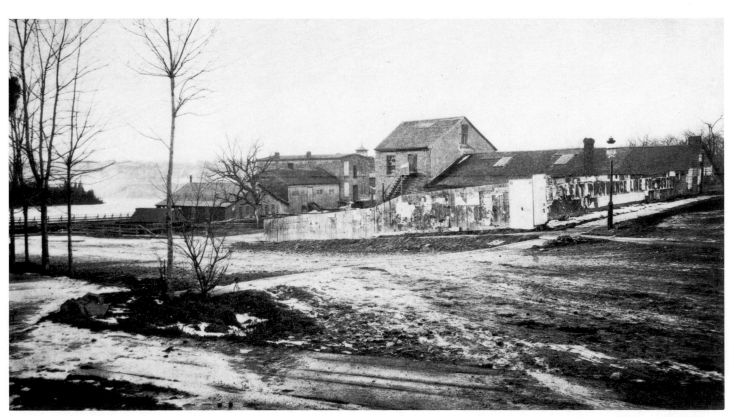

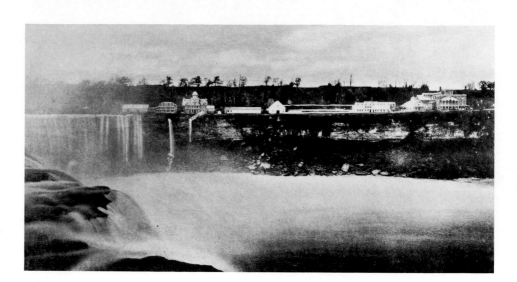

Fig. 107. *Disfigured Banks. Brink of Horse Shoe Falls and Canadian Shore, Seen from Goat Island,* ca. 1879. Plate XI from James T. Gardner, *Special Report of the New York State Survey on the Preservation of the Scenery of Niagara Falls* (cat. no. 194). Local History Department, Niagara Falls, New York, Public Library.

Fig. 108. *Canadian Scenic Route Niagara Falls Park & River Railway,* ca. 1900 (cat. no. 224). Buffalo and Erie County Historical Society, Buffalo, New York.

ommendation as a "luxury"; however, he failed to win renomination at the State Republican Convention in September 1882. The following April, the new Democratic governor, Grover Cleveland, signed a bill authorizing a state reservation at Niagara Falls. Ahead lay two more years of frustration and delay as state officials negotiated the condemnation of the lands finally designated to become part of the park. As late as 1884, outstanding claims to unused water rights amounted to $30 million. Fortunately, the courts denied the validity of these lawsuits, allowing the state to set a final purchase price for the properties involved of just over $1,433,000. On July 15, 1885, formal ceremonies at Prospect Park in Niagara Falls, New York, officially opened the Niagara State Reservation to its first visitors.[29]

The park was by no means complete; more than 150 buildings alone had yet to be demolished and removed. Ultimately, in addition, the scenic integrity of the preserve relied heavily on reciprocity by the Canadian government. Finally, in 1888, Ontario dedicated its own provincial park (fig. 108). To this day, visitors to Niagara Falls see striking differences between the American and Canadian sides of the cataract. Specifically, many visitors find the Canadian side—with its horticultural displays and other ornamentation—far more beautiful. The relative simplicity of the American park is not due to neglect, however, but is, instead, another reflection of the philosophy of Frederick Law Olmsted. In keeping with his firm conviction that natural surroundings ought to prevail in public parks, commissioners of the State Reservation at Niagara Falls generally resisted the inclusion of anything obviously man-made in the preserve, including statues, monuments, and especially, floral arrangements.[30]

With the rise in ecological awareness since World War II, Olmsted's advocacy for the quieter beauties of nature has been appreciated all the

more. During the nineteenth century, however, Niagara's larger significance lay in its ability to stir the nation's conscience. West of the Mississippi River, the defacement of Niagara Falls served as a stern reminder that Yellowstone, Yosemite, the Giant Sequoias, and other wonders could just as easily fall victim to individual greed and public indifference. One price of such indifference was the loss of national prestige. A country that sought its antiquity in natural landmarks could not, at the same time, allow those landmarks to be despoiled. Granted, half of Niagara Falls belonged to Canada; the point was that Americans still had no excuse for compromising that portion of the Falls which belonged solely to the United States.

By the middle of the nineteenth century, many of America's leading artists, journalists, and intellectuals had followed in one another's footsteps to stand beside Niagara Falls as the supreme natural spectacle of their country. That most of them came away both disappointed and ashamed by the commercialization all around them was crucial to the emergence of the park idea. As the nation moved west, the spectre of Niagara Falls remained fresh on the minds of those who had witnessed its disfigurement firsthand. Only if the nation faithfully preserved the wonders of the West from like abuse could the United States lay claim to their own uniqueness as evidence of national achievement. Niagara's misfortune was one of timing; its own lesson was lost on itself. The path to its redemption lay first through its own destruction. Indeed, Niagara's restoration aside, the Falls could never be quite the same again. At least, in the growing strength of the preservation movement was dramatic proof—as well as some measure of consolation—that Niagara's beauty had not been blemished in vain.

Epilogue: The Second "Battle" of Niagara

To many, it seemed as if Niagara Falls had been saved in 1885 through the establishment of the New York State reservation and authorization of Ontario's provincial park, which was formally opened on May 24, 1888. In truth, however, the battle for Niagara Falls had only just begun.

Efforts to protect Niagara Falls in the twentieth century focused on the issue of diverting its waters to generate hydroelectric power. Development interests, thwarted by protection of the Falls proper as state and provincial parks, retaliated throughout the late 1880s and 1890s with proposals to construct huge conduits to capture the river above the Falls. The water was to be diverted entirely around the cataract to powerhouses set downstream in the Niagara Gorge (fig. 109). By the turn of the century such diversions already threatened Niagara Falls with the loss of one-fourth of its average flow. Ultimately, preservationists feared that the amount of water reaching the brink of the American and Horseshoe Falls would be reduced to a mere trickle if diversions of the Niagara River continued.[31]

J. Horace McFarland, president of the American Civic Association, was among the turn-of-the-century preservationists who alerted government, business, and civic leaders to the pending tragedy of a waterless Niagara. In fact, his dedication to urban beautification and horticulture won him the editorship of the "Beautiful America" column in the *Ladies' Home Journal*, already a leading women's magazine. "Every American—nay, every world-citizen—should see Niagara many times, for the welfare of his soul and the perpetual memory of a great work of God." Yet "the engineers calmly agree that Niagara Falls will, in a very few years, be

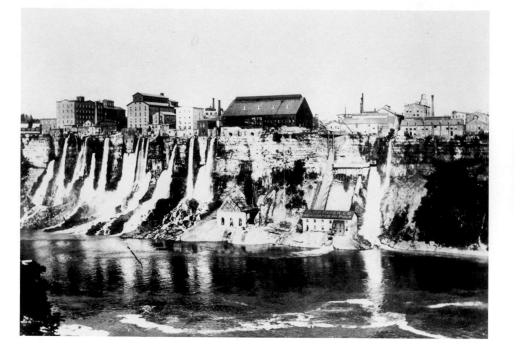

Fig. 109. *Niagara Falls Power Company,* ca. 1895.
Local History Department, Niagara Falls, New
York, Public Library.

[only] a memory. A memory of what? Of grandeur, beauty and natural maj-
esty unexcelled anywhere on earth, sacrificed unnecessarily for the gain of
a few!" Before-and-after illustrations in his article suggested the result:
"The words might well be emblazoned," he concluded, "in letters of fire
across the shamelessly-uncovered bluff of the American Fall: 'The Monu-
ment of America's Shame and Greed.'"[32]

In 1906 Congress authorized the secretary of war to establish mea-
sures needed to protect the Falls; subsequent treaties between Canada and
the United States simply set quotas specifying the amount of water each
country could divert.[33] In this manner, Niagara Falls was well on the road
to becoming an "engineered" landmark. Finally, in 1950 the United States
and Canada signed the Niagara Treaty, an agreement that does much to
explain the conditions at the Falls today. To generate power, up to one-
half of the flow of the Niagara River is diverted around the Falls during
daylight viewing hours. Between midnight and sunrise, when visitation is
minimal, fully three-fourths of the river bypasses the cataract through con-
duits leading to huge turbines set in the Niagara Gorge. In effect, there-
fore, Niagara Falls is literally turned on and off to conform to both peak
sightseeing and power demands. Similarly, the diversions have necessi-
tated stream-channel modifications, including a large jetty immediately
above the cataract to preserve the "spectacle" of the Falls by spreading the
remainder of the flow evenly as it approaches the brink.[34]

With but a few exceptions, such attempts to accommodate both
industrial development and scenic preservation have been avoided in
Yellowstone, the Grand Canyon, and other western national parks with
their own hydroelectric potential. Here again, Niagara Falls has served as
an object lesson for the preservation movement. Throughout the United
States and Canada, the control of Niagara has aroused as much sadness as
pride in technology. Thanks to Niagara's example, more and more people
have questioned the wisdom of controlling everything in nature. Niagara
has indeed been tamed. The virgin grandeur artists knew in the past now
survives only through their works. But where the memory of what Niagara
has lost still stirs the public's conscience, there the waters of the continent
often do flow wild and free.

NOTES

1. I am indebted to the Indiana Historical Society for permission to rewrite and republish select portions of my article, which originally appeared as "Preservation Heritage: The Origins of the Park Idea in the United States," in *Indiana Historical Society Lectures 1983* (Bloomington: Indiana Historical Society, 1984), 52–75.

2. For a lively discussion of changes in transportation technology and their impact on perceptions of landscape, see Hans Huth, *Nature and the American: Three Centuries of Changing Attitudes* (Berkeley and Los Angeles: University of California Press, 1957).

3. As quoted in George Wilson Pierson, *Tocqueville in America*, abridged by Dudley C. Lunt from "Tocqueville and Beaumont in America" (Garden City, N.Y.: Doubleday and Co., 1959), 210.

4. As quoted in Charles M. Dow, ed., *Anthology and Bibliography of Niagara Falls*, 2 vols. (Albany, N.Y.: J. B. Lyon Co., 1921), 2:1059.

5. Ibid., 1059–62.

6. Ibid., 1070–71.

7. George Catlin, *Illustrations of the Manners, Customs, and Conditions of the North American Indians*, 8th ed., 2 vols. (London: H. G. Bohn, 1851), 1:262.

8. Sydney Smith, review of *Statistical Annals of the United States of America*, by Adam Seybert, *Edinburgh Review* 33 (January 1820): 79. The impact of this quote is discussed in Merle Curti, *The Growth of American Thought*, 3d ed. (New York: Harper and Row, 1964), 237–38.

9. James Fenimore Cooper, "American and European Scenery Compared," in Washington Irving, et al., *The Home Book of the Picturesque* (New York: G. P. Putnam, 1852), 52.

10. William H. Brewer, *Up and Down California in 1860–64*, ed. Francis P. Farquhar (New Haven: Yale University Press, 1930), 404–05.

11. Samuel Bowles, *Across the Continent: A Summer's Journey to the Rocky Mountains, the Mormons and the Pacific States, with Speaker Colfax* (Springfield, Mass.: Samuel Bowles and Co., 1865), 226–27.

12. As quoted in Joseph H. Engbeck, Jr., *The Enduring Giants* (Berkeley: University Extension, University of California, in cooperation with the California Department of Parks and Recreation, Save-the-Redwoods League, and the Calaveras Grove Association, 1973), 77.

13. *Congressional Globe*, 38th Cong., 1st sess., May 17, 1864, 2300–01.

14. *Statutes at Large* 1864, 13:325.

15. Ibid. 1872, 17:32-33.

16. House Committee on the Public Lands, *The Yellowstone Park: Report 26 to Accompany H.R. 764*, 42d Cong., 2d sess., February 27, 1872, 1-2.

17. Laura Wood Roper, *FLO: A Biography of Frederick Law Olmsted* (Baltimore and London: The Johns Hopkins University Press, 1973), 268, 282–83.

18. Frederick Law Olmsted, "The Yosemite Valley and the Mariposa Big Trees," ed. Laura Wood Roper, *Landscape Architecture* 43 (October 1952): 16–17, 21–22.

19. Roper, *FLO*, 14, 47.

20. As quoted from *Special Report of New York State Survey on the Preservation of the Scenery of Niagara Falls, and Fourth Annual Report on the Triangulation of the State for the Year 1879* (Albany, 1880), 27.

21. Ibid., Charles M. Dow, *The State Reservation at Niagara: A History* (Albany: J. B. Lyon Co., 1914), 10–12.

22. "The Season at the Falls," *New-York Times*, June 29, 1879, 1.

23. Reprinted in *State Survey on Niagara Falls, 1879*, 41.

24. Ibid., 19.

25. Ibid., 22.

26. Ibid., 28–29.

27. Ibid., 20–21.

28. Ibid., 21, 23.

29. Alfred Runte, "Beyond the Spectacular: The Niagara Falls Preservation Campaign," *New-York Historical Society Quarterly* 57 (January 1973): 43–47.

30. Dow, *State Reservation at Niagara*, 41–44.

31. The history of the early diversion controversy is found in Dow, *State Reservation at Niagara*, 102–74.

32. J. Horace McFarland, "Shall We Make a Coal-Pile of Niagara?" *Ladies' Home Journal* 23 (October 1906): 39.

33. Dow, *State Reservation at Niagara*, 124–46.

34. B. F. Friesen and J. C. Day, "Hydroelectric Power and Scenic Provisions of the 1950 Niagara Treaty," *Water Resources Bulletin* 13 (December 1977): 1175–89.

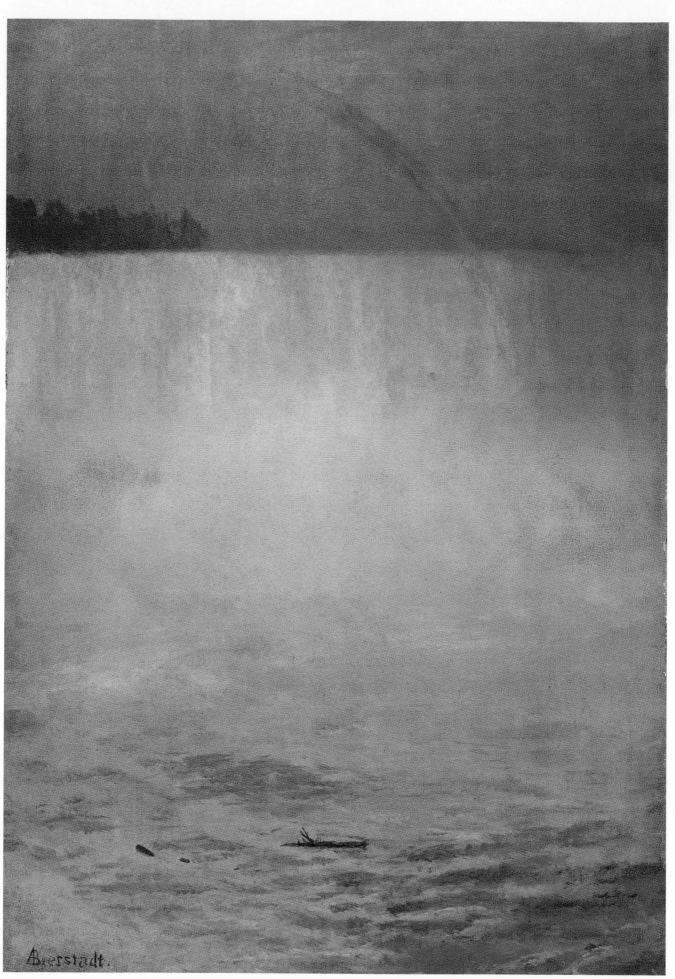

cat. no. 30

Catalogue

Fine Arts

cat. no. 1

American Oleograph Co.

1. *View of the Canada Southern Railway Passing Niagara Falls* ca. 1880
color lithograph
21¼ x 28½ in. (54.0 x 72.4 cm.)
Courtesy of Kennedy Galleries,
New York, New York

Edward Anthony 1818–1888

2. *Niagara, Blondin on the Tight Rope. Anthony's Instantaneous Views No. 125* ca. 1859
stereoscopic card
Local History Department, Niagara Falls, New York, Public Library
(fig. 96)

3. *Niagara in Winter* ca. 1860–61
stereoscopic card
Private Collection
(fig. 48)

Edward and Henry T. (1814–1884) Anthony

4. *Clifton House* ca. 1871–74
stereoscopic card
Private Collection
(fig. 57)

5. *Terrapin Tower* ca. 1863–73
stereoscopic card
Private Collection

cat. no. 5

cat. no. 6

cat. no. 7

cat. no. 15

cat. no. 16

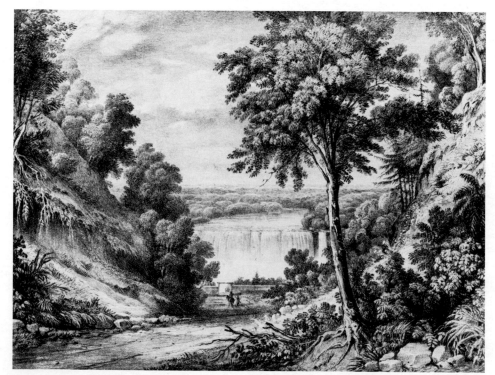

Platt D. Babbitt active 1853–79

6. *American Falls from Below, Ice
 Mountain* ca. 1860
 stereoscopic glass
 Local History Department, Niagara
 Falls, New York, Public Library

7. *American Fall from Luna Island with
 Tourists* ca. 1860
 stereoscopic glass
 Local History Department, Niagara
 Falls, New York, Public Library

George Barker active 1862–91

8. *Indian Women with Wares on Luna
 Island* ca. 1868
 albumen print
 7⅜ x 8⅞ in. (18.8 x 22.6 cm.)
 The J. Paul Getty Museum,
 Malibu, California
 (fig. 102)

9. *Ice Bridge, Ice Mound, and American
 Fall, Niagara* 1883
 albumen print
 7½ x 9⁷⁄₁₆ in. (19.0 x 23.9 cm.)
 Library of Congress,
 Washington, D.C.

10. *Niagara Falls* 1885
 albumen print
 21 x 17 in. (53.3 x 43.2 cm.)
 Library of Congress,
 Washington, D.C.

11. *Horseshoe Fall* 1885
 albumen print
 17 x 21 in. (43.2 x 53.3 cm.)
 Library of Congress,
 Washington, D.C.

12. *Horseshoe Fall, No. 2* 1885
 albumen print
 9⁷⁄₁₆ x 7⅜ in. (23.9 x 18.8 cm.)
 Library of Congress,
 Washington, D.C.

13. *Niagara Falls* 1890
 albumen print
 9³⁄₁₆ x 7³⁄₁₆ in. (23.4 x 18.3 cm.)
 Library of Congress,
 Washington, D.C.

14. *Cave of the Winds* 1891
 albumen print
 9¼ x 7 in. (23.5 x 17.8 cm.)
 Library of Congress,
 Washington, D.C.

15. *Path to the Cave of the Winds—
 Niagara* ca. 1880
 stereoscopic card
 Private Collection

16. *Remains of Table Rock* 1880s
 stereoscopic card
 Private Collection

17. *Horseshoe Fall from Canada—
 Niagara* 1880s
 stereoscopic card
 Private Collection

18. *Niagara Falls* 1880s
 albumen print
 20⅜ x 16⅝ in. (51.8 x 42.2 cm)
 Buscaglia-Castellani Art Gallery of
 Niagara University, Niagara Falls,
 New York. Dr. and Mrs. Armand J.
 Castellani Collection
 (fig. 67)

William Henry Bartlett

See Nathaniel P. Willis (Books)

cat. no. 17

cat. no. 19

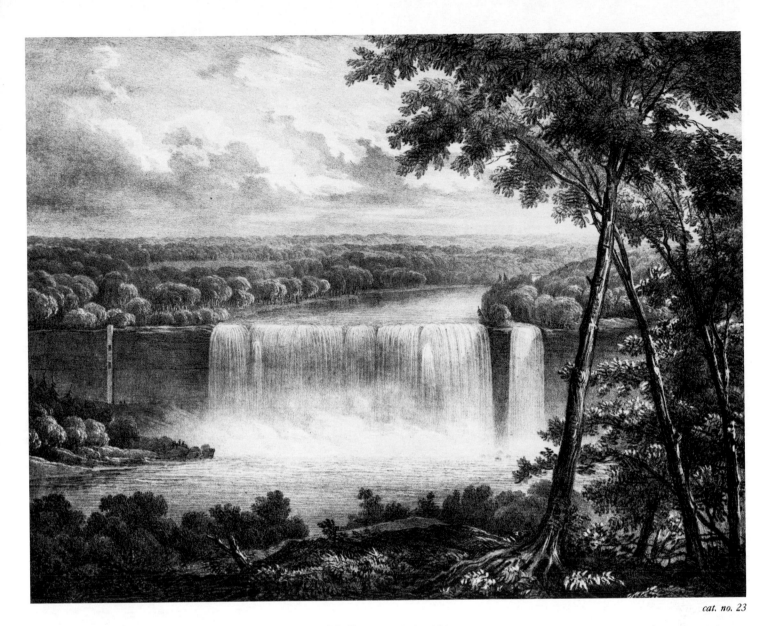

cat. no. 23

cat. no. 21

Thomas M. Baynes 1794–1854

19. *American Fall from a Ravine
 Opposite* 1825
 (after W. Vivian, n.d.)
 lithograph
 7½ x 9½ in. (19.0 x 24.1 cm.)
 Buffalo and Erie County Historical
 Society, Buffalo, New York

20. *British or Horse Shoe Fall* 1825
 (after W. Vivian)
 lithograph
 7½ x 10¼ in. (19.0 x 26.0 cm.)
 Buffalo and Erie County Historical
 Society, Buffalo, New York

21. *Horse Shoe Fall from the Canada Bank,
 Niagara Falls* 1825
 (after W. Vivian)
 lithograph
 7¼ x 10¼ in. (18.4 x 26.0 cm.)
 Buffalo and Erie County Historical
 Society, Buffalo, New York

22. *Side of the American Fall & Horse Shoe
 Fall in the Distance* 1825
 (after W. Vivian)
 lithograph
 7¾ x 9½ in. (19.7 x 24.1 cm.)
 Buffalo and Erie County Historical
 Society, Buffalo, New York

23. *Niagara—American Fall from the Bank
 Above* 1825
 (after W. Vivian)
 lithograph
 7½ x 9½ in. (19.0 x 24.1 cm.)
 Buffalo and Erie County Historical
 Society, Buffalo, New York

George Beck

See T. Cartwright

Thomas Benecke

See Adam Weingartner

cat. no. 27

William James Bennett 1787–1844

24. *Niagara Falls. American Fall from Goat Island* 1831
color aquatint engraving
16¼ x 20⅞ in. (41.3 x 53.1 cm.)
Courtesy of The New-York Historical Society, New York, New York
(fig. 26)

25. *Niagara Falls. View of the British Fall from Goat Island* 1831
color aquatint engraving, printed and colored by John Hill
16½ x 20¾ in. (41.9 x 52.7 cm.)
Courtesy of The New-York Historical Society, New York, New York
(fig. 27)

26. *Niagara Falls from the American Side* ca. 1835
(after John R. Murray, 1774–1851)
color aquatint engraving
16⅛ x 20⅜ in. (41.6 x 51.8 cm.)
Royal Ontario Museum, Toronto, Canada
(fig. 32)

See John Hill

C. Bently n.d.

27. *The Falls of Niagara. This View of the American Fall, from Goat Island* 1857
(after James Pattison Cockburn, 1779–1847)
color aquatint engraving, restrike of plate originally engraved in 1833
20½ x 28⅜ in. (52.0 x 72.1 cm.)
The Charles Rand Penney Collection
(Corcoran Gallery of Art and New-York Historical Society)

See Jonathan Edge
C. Hunt

cat. no. 34

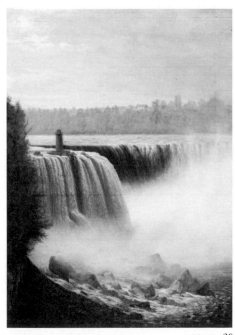

cat. no. 29

Albert Bierstadt 1830–1902

28. *Home of the Rainbow—Horseshoe Fall,*
 Niagara ca. 1869
 oil on canvas
 16½ x 22 in. (41.9 x 55.9 cm.)
 Mr. and Mrs. George Strichman
 (fig. 63)

29. *Niagara* ca. 1869
 oil on canvas
 49¼ x 35¼ in. (125.0 x 89.5 cm.)
 Wake Forest University Simmons
 Collection, Winston-Salem, North
 Carolina

30. *Waterfall and Rainbow* ca. 1870s
 oil on paper
 19 x 13 in. (48.3 x 33.0 cm.)
 Loaned by Ira Spanierman Gallery,
 Inc., New York, New York

31. *Niagara Falls from the Canadian*
 Side ca. 1877
 oil on paper mounted on canvas
 19 x 27⅛ in. (48.3 x 68.9 cm.)
 National Gallery of Canada, Ottawa
 (fig. 64)

32. *Niagara Falls* ca. 1880
 oil on paper
 19 x 27 in. (48.3 x 68.6 cm.)
 Sewell C. Biggs Collection
 (fig. 81)

Charles Bierstadt 1819–1903

33. *Photographic Mementos* 1869
 lithograph after photograph
 diameter: 2³⁄₁₆ in. (5.6 cm.)
 Local History Department, Niagara
 Falls, New York, Public Library
 (fig. 95)

34. *Niagara Falls* ca. 1869–73
 albumen print
 10½ x 13½ in. (26.7 x 34.3 cm.)
 The High Museum of Art, Atlanta,
 Georgia

35. *Looking Under the Falls Canada Side,*
 Niagara, N.Y. late 19th century
 stereoscopic card
 Private Collection
 (fig. 56)

36. *S. J. Dixon Crossing Whirlpool*
 Rapids 1893
 stereoscopic card
 Local History Department, Niagara
 Falls, New York, Public Library

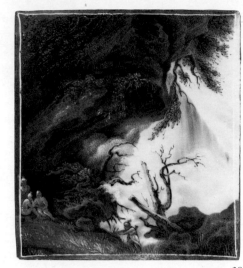

cat. no. 38

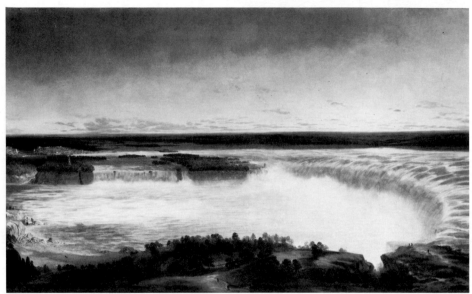

cat. no. 37

cat. no. 40

P. Le Bihan active ca. 1850

37. *An Extensive View of Niagara Falls with a Distant View of Buffalo* ca. 1850
oil on canvas
27 x 60 in. (66.6 x 152.4 cm.)
Kaspar Gallery, Toronto, Canada

William Russell Birch 1755–1834

38. *The Falls of Niagara* ca. 1827
enameled copper
2⅝ x 2⅜ in. (6.6 x 6.1 cm.)
National Museum of American Art,
Smithsonian Institution,
Washington, D.C.

Karl Bodmer

See Lucas Weber

John Bornet

See Nagel and Weingartner, Lithographers

William Byrne 1714–1782

39. *Cataract of Niagara* 1774
(after a painting by Richard Wilson,
ca. 1714–1782; based on a drawing by
Lt. William Pierie, active ca. 1768)
engraving
16⅜ x 20¾ in. (41.6 x 52.7 cm.)
Public Archives of Canada, Ottawa
(fig. 8)

Emil Carlsen 1853–1932

40. *Niagara Falls* n.d.
oil on canvas
35¼ x 30¼ in. (89.5 x 76.8 cm.)
Norton Gallery & School of Art,
West Palm Beach, Florida

T. Cartwright n.d.

41. *The Falls of Niagara* 1805
(after George Beck, 1748–1812)
color aquatint engraving
16⅜ x 22¹¹⁄₁₆ in. (41.6 x 57.6 cm.)
Albright-Knox Art Gallery, Buffalo,
New York

Evelyn R. Cary

See Gies & Co.

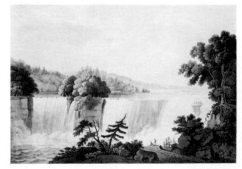

cat. no. 41

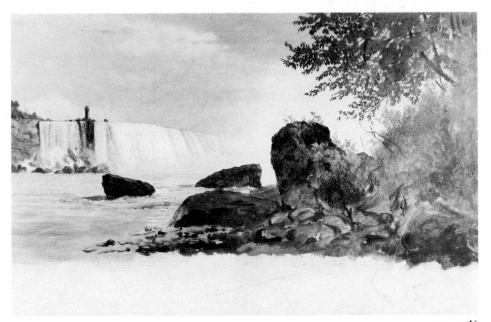

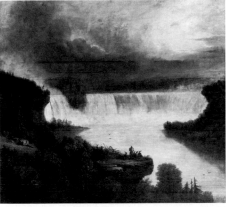

cat. no. 44

cat. no. 48

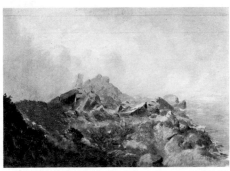

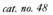

cat. no. 51

George Catlin 1796–1872

42. *Bird's-Eye View of Niagara* 1831
hand-colored lithograph
7¹³⁄₁₆ x 6⅞ in. (19.8 x 17.5 cm.)
Buffalo and Erie County Historical
Society, Buffalo, New York
(fig. 104)

Thomas Chambers 1815–after 1866

43. *Niagara Falls* ca. 1835
oil on canvas
22 x 30¹⁄₁₆ in. (56.1 x 76.4 cm.)
Wadsworth Atheneum, Hartford,
Connecticut, The Ella Gallup
Sumner and Mary Catlin Sumner
Collection
(fig. 37)

Frederic Edwin Church 1826–1900

44. *Niagara Falls* ca. 1844–46
oil on canvas
36 x 39 in. (91.4 x 99.0 cm.)
The Thomas Gilcrease Institute of
American History and Art, Tulsa,
Oklahoma

45. *Niagara from Goat Island, Winter* 1856
oil on cardboard
11½ x 17⅓ in. (29.3 x 44.0 cm.)
Cooper-Hewitt Museum, Smithsonian
Institution, New York, New York
(fig. 58)

46. *Horseshoe Falls from Canada* 1856
oil on cardboard
11⅝ x 17½ in. (29.5 x 44.5 cm.)
Cooper-Hewitt Museum, Smithsonian
Institution, New York, New York

47. *Niagara Falls* 1856
oil on paper mounted on canvas
12 x 35 in. (30.5 x 89.0 cm.)
Private Collection
(Corcoran Gallery of Art)
(fig. 59)

48. *At the Base of the American Falls*
ca. 1856
oil on paper board
11⅝ x 13¾ in. (29.5 x 35.0 cm.)
Cooper-Hewitt Museum, Smithsonian
Institution, New York, New York

49. *Niagara* 1857
oil on canvas
42½ x 90½ in. (107.9 x 229.9 cm.)
The Corcoran Gallery of Art,
Washington, D.C.
(fig. 1)

50. Study for *Niagara* ca. 1857
oil on paper mounted on canvas
12 x 36 in. (30.5 x 91.4 cm.)
New York State Office of Parks,
Recreation and Historic Preservation,
Bureau of Historic Sites, Olana State
Historic Site, Taconic Region
(fig. 60)

51. *Study at Foot of American Fall*
ca. 1856–58
oil on paper board
9¹³⁄₁₆ x 11 in. (25.0 x 28.0 cm.)
Cooper-Hewitt Museum, Smithsonian
Institution, New York, New York

52. Study for *Under Niagara* 1858
oil on canvas
11¾ x 17½ in. (29.8 x 44.4 cm.)
New York State Office of Parks,
Recreation and Historic Preservation,
Bureau of Historic Sites, Olana State
Historic Site, Taconic Region
(fig. 61)

See Day & Son
 William Forrest
 C. Risdon
 Risdon & Day

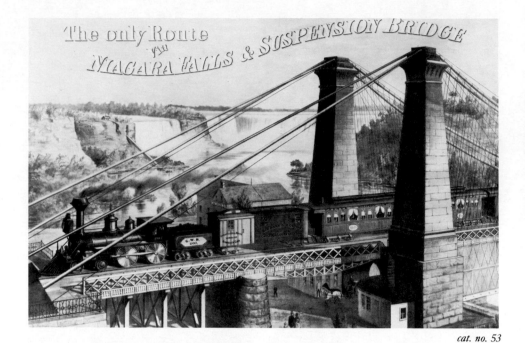

cat. no. 54

Clay, Cosack & Co., Lithographers

53. *The Only Route via Niagara Falls and Suspension Bridge* 1876
lithograph
17¼ x 25⅞ in. (43.8 x 65.8 cm.)
Bella C. Landauer Collection, The
New-York Historical Society,
New York, New York

James Pattison Cockburn

See C. Bently
Jonathan Edge
C. Hunt

Thomas Cole 1801–1848

54. *Niagara Falls* n.d.
oil on panel
15¾ x 24¼ in. (40.0 x 61.2 cm.)
Collection Cranbrook Academy of Art
 Museum, Bloomfield Hills, Michigan
 (Corcoran Gallery of Art and New-
 York Historical Society)

See Fenner Sears & Co.
John Howard Hinton (Books)

Jasper F. Cropsey 1823–1900

55. *Niagara Falls* 1853
oil on canvas
48 x 72 in. (121.9 x 182.9 cm.)
The Newington Cropsey Foundation,
 Greenwich, Connecticut
(fig. 42)

56. *Niagara Falls from the Foot of Goat
 Island* 1857
oil on canvas
15¼ x 24 in. (38.7 x 61.0 cm.)
Museum of Fine Arts, Boston,
 Massachusetts, M. and M.
 Karolik Collection
(fig. 80)

57. *Niagara Falls in Winter* 1868
oil on canvas
12 x 20 in. (30.5 x 50.8)
The Art Institute of Chicago,
 A. A. McKay Fund
(fig. 50)

Currier & Ives active 1862–1901

58. *Niagara from Goat Island* ca. 1865
colored lithograph
9⅜ x 15¾ in. (23.9 x 40.0 cm.)
Royal Ontario Museum, Toronto,
 Canada
(fig. 44)

George E. Curtis active 1856–1907

59. *Street's Pagoda, Overlooking Horseshoe Fall* ca. 1873–87
albumen print
diameter: 6⁵⁄₁₆ in. (16.0 cm.)
Local History Department, Niagara Falls, New York, Public Library

60. *American Fall—Ice Mountain* 1870s
albumen print
7½ x 9³⁄₁₆ in. (19.0 x 23.4 cm.)
Local History Department, Niagara Falls, New York, Public Library
(fig. 47)

61. *Niagara at Night, Photographed by the Electric Illumination* 1907
albumen print
15⅝ x 20½ in. (39.6 x 52.0 cm.)
Buffalo and Erie County Historical Society, Buffalo, New York

62. *Terrapin Tower* ca. 1856–73
stereoscopic card
Private Collection
(fig. 92)

63. *American Fall from Below* late 19th century
stereoscopic card
Private Collection

64. *Prospect Point* ca. 1856–73
stereoscopic card
Private Collection

65. *"Rock of Ages" and Whirlwind Bridge— Cave of the Winds* late 19th century
stereoscopic card
Private Collection
(fig. 91)

66. *Falls from New Suspension Bridge— Moonlight* ca. 1869–73
stereoscopic card
Private Collection
(fig. 45)

67. *La Signorina Maria Spelterini in her Grand High Rope Performance— Niagara July, 1876* 1876
stereoscopic card
Local History Department, Niagara Falls, New York, Public Library
(fig. 97)

Thomas Davies ca. 1737–1812

68. *Niagara Falls from Below* ca. 1762–68
watercolor on paper
13½ x 20⅝ in. (34.3 x 52.3 cm.)
Courtesy of The New-York Historical Society, New York, New York
(fig. 6)

69. *Niagara Falls from Above* ca. 1762–68
watercolor on paper
13½ x 20¾ in. (34.3 x 52.7 cm.)
Courtesy of The New-York Historical Society, New York, New York
(fig. 7)

See Ignace Fougeron

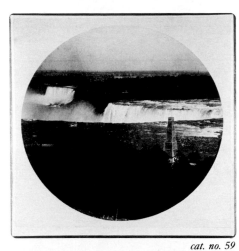

cat. no. 59

cat. no. 63

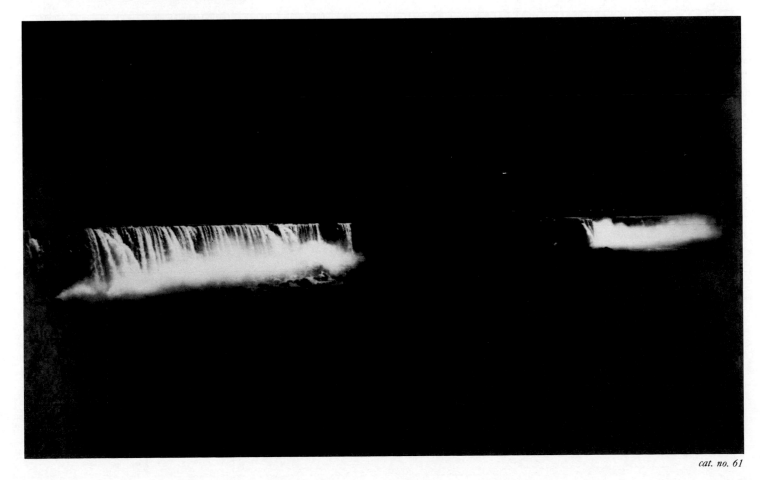

cat. no. 61

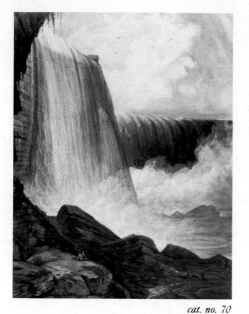

cat. no. 70

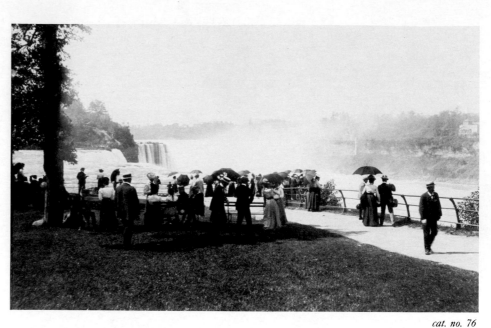

cat. no. 76

cat. no. 71

cat. no. 77

cat. no. 78

Henry Davis active 1818–52

70. *The Horseshoe Fall, from Goat Island* 1846
watercolor and gum arabic
22¹⁵⁄₁₆ x 17⅞ in. (58.2 x 45.5 cm.)
Royal Ontario Museum, Toronto, Canada

71. *The Horseshoe Fall from the Foot of the Shaft from Below Table Rock* 1846
watercolor and gum arabic
23¼ x 20⅛ in. (59.0 x 51.0 cm.)
Royal Ontario Museum, Toronto, Canada

72. *Autumnal Sunset, from Goat Island* 1846
watercolor and gum arabic
17⅜ x 23 in. (44.2 x 58.4 cm.)
Royal Ontario Museum, Toronto, Canada
(fig. 29)

73. *Horseshoe Fall, from Table Rock* 1846
watercolor and gum arabic
18⅛ x 24¾ in. (46.0 x 62.9 cm.)
Royal Ontario Museum, Toronto, Canada
(fig. 30)

Day & Son

74. *Niagara Falls, from the American Side* 1868
(after Frederic Edwin Church, 1826–1900)
chromolithograph
36½ x 30½ in. (92.7 x 76.2 cm.)
Buffalo and Erie County Historical Society, Buffalo, New York

Isidore-Laurent Deroy 1797–1886

75. *Niagara Falls from the American Side* ca. 1828
(after Jacques Milbert, 1766–1840)
lithograph
10½ x 12½ in. (26.7 x 31.7 cm.)
Courtesy of The New-York Historical Society, New York, New York
(fig. 19)

Orin E. Dunlap 1861–1953

76. *American Fall from Prospect Point* ca. 1900
albumen print
5¼ x 8⅛ in. (13.3 x 20.6 cm.)
Local History Department, Niagara Falls, New York, Public Library

77. *President McKinley on Goat Island* 1901
albumen print
6⅜ x 8¹⁵⁄₁₆ in. (16.2 x 22.6 cm.)
Local History Department, Niagara Falls, New York, Public Library

Jonathan Edge n.d.

78. *The Falls of Niagara. This General View Above the English Ferry* 1857
(after James Pattison Cockburn, 1779–1847)
color aquatint engraving, restrike of plate originally engraved in 1833
20½ x 28⅜ in. (52.0 x 72.1 cm.)
The Charles Rand Penney Collection
(Corcoran Gallery of Art and New-York Historical Society)

See C. Bently
C. Hunt

J. W. Edy active 1780–1808

79. *Falls of Niagara* ca. 1794
(after George Bulteel Fisher, 1764–1834)
aquatint engraving
25½ x 38½ in. (64.7 x 97.8 cm.)
Public Archives of Canada, Ottawa
(fig. 11)

James Erskine n.d.

80. *The Horse Shoe, Niagara Falls* ca. 1784
oil on paper, laid down on board
16 x 21¼ in. (40.0 x 54.1 cm.)
Public Archives of Canada, Ottawa
(fig. 9)

Alvan Fisher 1792–1863

81. *A General View of the Falls of
 Niagara* 1820
 oil on canvas
 34⅜ x 48¼ in. (87.4 x 122.5 cm.)
 National Museum of American Art,
 Smithsonian Institution,
 Washington, D.C.
 (fig. 21)

82. *The Great Horseshoe Fall, Niagara* 1820
 oil on canvas
 34⅜ x 48⅛ in. (87.4 x 122.2 cm.)
 National Museum of American Art,
 Smithsonian Institution,
 Washington, D.C.
 (fig. 22)
 (Albright-Knox Art Gallery and
 Corcoran Gallery of Art)

83. *Niagara—The American Falls* c. 1831
 oil on canvas
 34 x 48³⁄₁₆ in. (86.4 x 122.4 cm.)
 Courtesy of The New-York Historical
 Society, New York, New York

George Bulteel Fisher

See J. W. Edy

William Forrest 1803–1889

84. *The Great Fall, Niagara* 1875
 (after Frederic Edwin Church,
 1826–1900)
 engraving
 10¼ x 22 in. (26.0 x 55.9 cm.)
 The New York Public Library,
 New York, New York

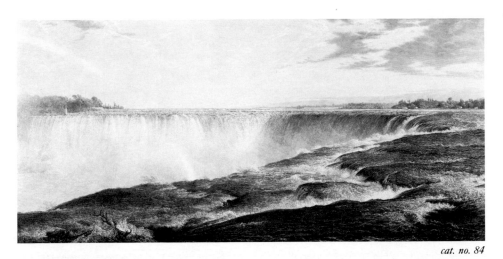

cat. no. 84

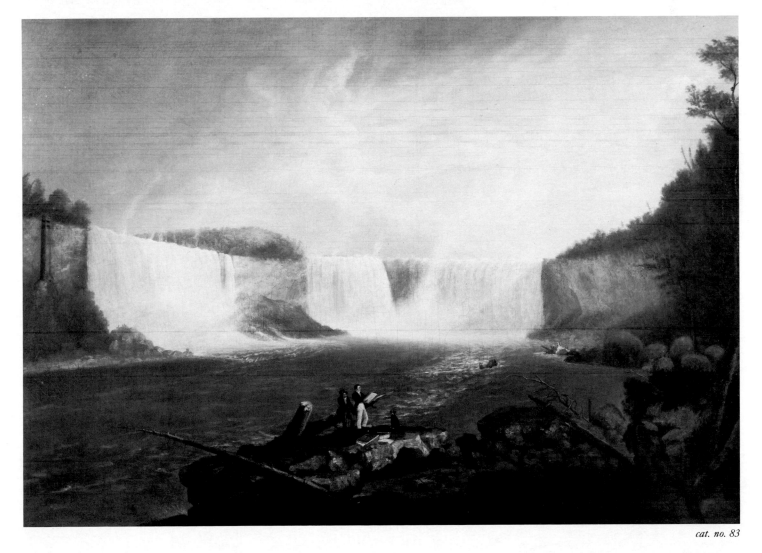

cat. no. 83

cat. no. 89

Ignace Fougeron active ca. 1760–68

85. *An East View of the Great Cataract of Niagara* ca. 1768
(after Thomas Davies, ca. 1737–1812)
engraving
15 x 20¾ in. (38.1 x 52.7 cm.)
Buffalo and Erie County Historical Society, Buffalo, New York
(fig. 5)

Godfrey N. Frankenstein 1820–1873

86. *Niagara Falls from Goat Island* 1848
oil on canvas
48 x 36 in. (121.9 x 91.4 cm.)
Anonymous Loan
(fig. 52)

Washington F. Friend active 1845–86

87. *Niagara Seen from Above the Canadian Falls* ca. 1850
watercolor
21⅝ x 49 in. (54.9 x 124.5 cm.)
Royal Ontario Museum, Toronto, Canada

Heinrich Fuessli 1755–1829

88. *Vue du Cataracte de Niagara, au Pais des Iroquois* ca. 1776
hand-colored etching
10¼ x 14⅞ in. (26.0 x 37.8 cm.)
Royal Ontario Museum, Toronto, Canada
(fig. 76)

Gies & Co.

89. *Spirit of Niagara/Pan-American Exposition* 1901
(after Evelyn R. Cary, 1855–1924)
color lithographic poster
48 x 25⅜ in. (121.9 x 64.5 cm.)
The Charles Rand Penney Collection
(Corcoran Gallery of Art and New-York Historical Society)

Regis Gignoux 1816–1882

90. *Niagara, The Table Rock—Winter* 1847
oil on canvas
53⅜ x 37 in. (135.6 x 93.9 cm.)
U.S. Senate Collection, Washington, D.C.
(fig. 49)

91. *Niagara Falls* 1855
oil on canvas
47¾ x 71⅞ in. (121.3 x 182.6 cm.)
The High Museum of Art, Atlanta, Georgia. Lent by the West Foundation, Atlanta, Georgia.

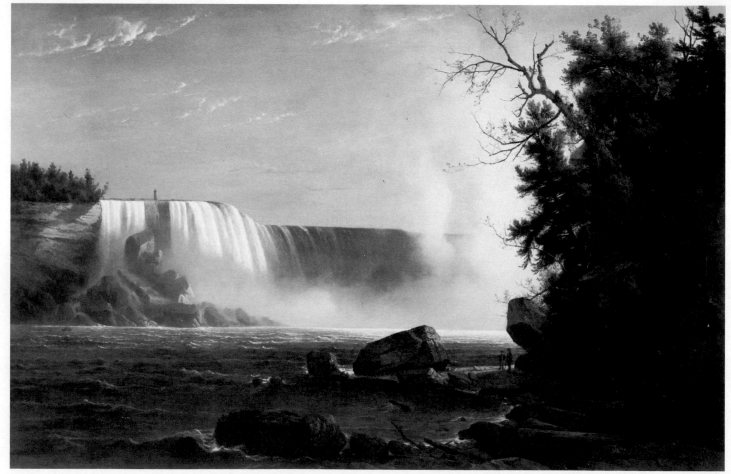

cat. no. 91

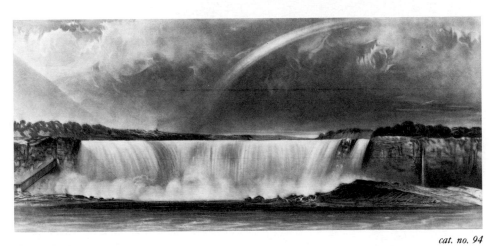

cat. no. 93

cat. no. 92

cat. no. 95

cat. no. 94

cat. no. 96

De Lay Glover ca. 1823–1863

92. *The Great International Railway Suspension Bridge Over the Niagara River* 1859
 (after Ferdinand Richardt, 1819–1895)
 engraving
 20⅜ x 32 in. (51.9 x 81.3 cm.)
 The Charles Rand Penney Collection
 (Corcoran Gallery of Art and New-York Historical Society)

James Graham

See F. C. Lewis

Basil Hall

See Basil Hall (Books)

James Hamilton 1819–1878

93. *Niagara Falls. Canada Side* 1846
 (after T. Taylor, n.d.)
 aquatint engraving
 16¾ x 27¾ in. (42.5 x 70.5 cm.)
 Buffalo and Erie County Historical Society, Buffalo, New York

94. *Niagara Falls. American Side* 1846
 aquatint engraving
 11¼ x 24¾ in. (28.6 x 62.9 cm.)
 Buffalo and Erie County Historical Society, Buffalo, New York

R. Hancock 1730–1817

95. *The Waterfall of Niagara* 1794
 hand-colored engraving
 9¼ x 15¼ in. (23.5 x 38.7 cm.)
 Royal Ontario Museum, Toronto, Canada

Charles Hart, Lithographer

96. *Niagara Leap by the Wonderful Buislay Family* 1866
 lithograph
 22⅞ x 18⅛ in. (58.2 x 46.0 cm.)
 The New-York Historical Society, New York, New York

Robert Havell, Jr. 1793–1878

97. *Niagara Falls from the Chinese Pagoda* 1845
hand-colored etching and aquatint
17¼ x 26¾ in. (43.8 x 67.9 cm.)
Library of Congress,
Washington, D.C.
(Albright-Knox Art Gallery and
Corcoran Gallery of Art)

98. *Panoramic View of the Falls of Niagara* 1846
hand-colored engraving
10½ x 35½ in. (26.7 x 90.2 cm.)
Buffalo and Erie County Historical
Society, Buffalo, New York

99. *View of Niagara Falls from the American Shore* ca. 1850
(attributed to Robert Havell, Jr.)
oil on canvas
36 x 48 in. (91.4 x 121.9 cm.)
United States Department of State,
Diplomatic Reception Rooms,
Washington, D.C.

George Heriot

See George Heriot (Books)

Herman Herzog 1832–1932

100. *Niagara Falls, Brink of Horseshoe* 1872
oil on canvas
32 x 45¾ in. (81.3 x 116.2 cm.)
Wunderlich & Co., Inc., New York,
New York

101. *View of Niagara Falls in Moonlight* 1872
oil on canvas
55¼ x 47 in. (140.3 x 119.4 cm.)
Museum of Fine Arts, Springfield,
Massachusetts, The James Philip
Gray Collection, with additional
funds from the bequests of Richards
Haskell Emerson, Ethel G.
Hammersley, and Henry Alexander
Phillips
(fig. 46)
(Corcoran Gallery of Art)

Edward Hicks 1780–1849

102. *The Falls of Niagara* 1825
oil on canvas
31½ x 38 in. (80.0 x 96.5 cm.)
The Metropolitan Museum of Art,
New York, New York. Gift of
Edgar William and Bernice Chrysler
Garbisch, 1965.
(fig. 36)

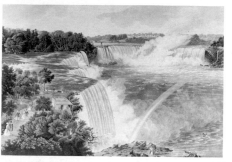

cat. no. 97

cat. no. 99

cat. no. 100

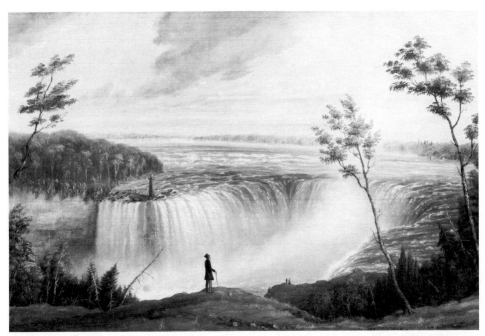

cat. no. 105

John Hill 1770–1850

103. *Niagara Falls. Part of the British Fall
 Taken from Under the Table Rock* 1829
 (after William James Bennett,
 1787–1844)
 color aquatint engraving
 20¾ x 16½ in. (52.7 x 41.9 cm.)
 Courtesy of The New-York Historical
 Society, New York, New York
 (fig. 25)

104. *Niagara Falls. Part of the American Falls
 from the Foot of the Staircase* 1829
 (after William James Bennett)
 color aquatint engraving
 23¼ x 19¼ in. (59.0 x 48.9 cm.)
 Courtesy of The New-York Historical
 Society, New York, New York
 (fig. 24)

Fred H. Holloway active 1840–53

105. *Horseshoe Falls* ca. 1850
 oil on canvas
 21¼ x 31¾ in. (53.9 x 80.6 cm.)
 United States Department of State,
 Diplomatic Reception Rooms,
 Washington, D.C.

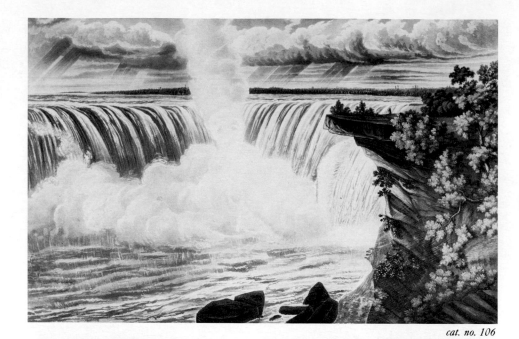

cat. no. 106

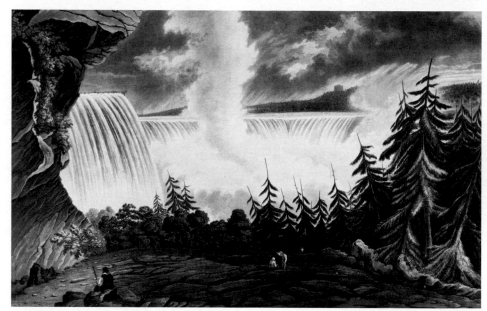

cat. no. 108

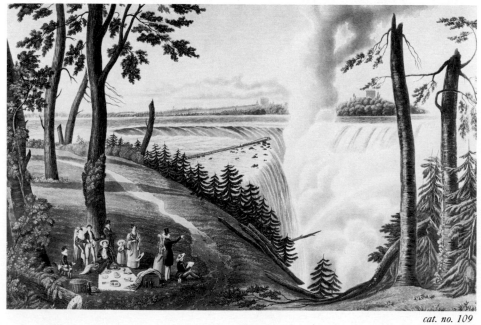

cat. no. 109

cat. no. 112

C. Hunt n.d.

106. *The Falls of Niagara. This View of Table
 Rock & Horse-shoe Fall* 1857
 (after James Pattison Cockburn,
 1779–1847)
 color aquatint engraving, restrike of
 plate originally engraved in 1833
 17¼ x 26¼ in. (43.8 x 66.6 cm.)
 The Charles Rand Penney Collection
 (Corcoran Gallery of Art and New-
 York Historical Society)

107. *The Falls of Niagara. This View from the
 Upper Bank, English Side* 1857
 (after James Pattison Cockburn)
 color aquatint engraving, restrike of
 plate originally engraved in 1833
 20½ x 28⅜ in. (52.0 x 72.1 cm.)
 The Charles Rand Penney Collection
 (Corcoran Gallery of Art and New-
 York Historical Society)

108. *The Falls of Niagara. View of Horse-shoe-
 fall from Below Goat-Island* 1857
 (after James Pattison Cockburn)
 color aquatint engraving, restrike of
 plate originally engraved in 1833
 17 x 26 in. (43.2 x 66.0 cm.)
 The Charles Rand Penney Collection
 (Corcoran Gallery of Art and New-
 York Historical Society)

109. *The Falls of Niagara. This View of the
 Horse Shoe Fall from Goat Island* 1857
 (after James Pattison Cockburn)
 color aquatint engraving, restrike of
 plate originally engraved in 1833
 20½ x 28⅜ in. (52.0 x 72.1 cm.)
 The Charles Rand Penney Collection
 (Corcoran Gallery of Art and New-
 York Historical Society)

See C. Bently
 Jonathan Edge

S. V. Hunt

See William Cullen Bryant (Books)

William Morris Hunt 1824–1879

110. *Niagara Falls* 1878
 oil on canvas
 28 x 24 in. (71.1 x 60.9 cm.)
 Smith College Museum of Art,
 Northampton, Massachusetts
 (fig. 70)

111. *American Fall, Niagara* 1878
 oil on canvas
 30 x 41⅛ in. (76.2 x 104.4 cm.)
 The Corcoran Gallery of Art,
 Washington, D.C.
 (fig. 69)

112. *The Rapids, Sister Islands, Niagara* 1878
 oil on canvas
 30 x 43 in. (76.2 x 109.2 cm.)
 Art Gallery, Ball State University,
 Muncie, Indiana

cat. no. 117

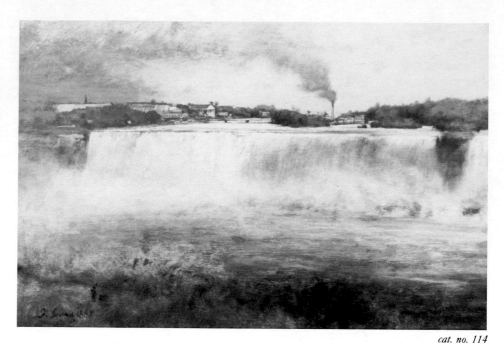

cat. no. 114

cat. no. 118

cat. no. 119

George Inness 1825–1894

113. *Niagara Falls* 1884
 oil on panel
 16 x 24 in. (40.6 x 60.9 cm.)
 The Montclair Art Museum,
 Montclair, New Jersey. Bequest of
 Florence O. R. Lang.
 (fig. 82)

114. *Niagara Falls* 1885
 oil on panel
 16 x 25 in. (40.6 x 60.9 cm.)
 Mr. and Mrs. Meyer P. Potamkin
 (Corcoran Gallery of Art)

115. *Niagara Falls* 1893
 oil on canvas
 46 x 70 in. (116.8 x 177.8 cm.)
 Hirshhorn Museum and Sculpture
 Garden, Smithsonian Institution,
 Washington, D.C.
 (fig. 71)
 (Corcoran Gallery of Art)

William H. Jackson 1843–1942

116. *Niagara Falls from Prospect Point*
 ca. 1898–1908
 colored photo print
 21 x 17 in. (53.3 x 43.2 cm.)
 Library of Congress,
 Washington, D.C.
 (fig. 68)

117. *American Fall from Goat Island*
 ca. 1898–1908
 colored photo print
 21 x 17 in. (53.3 x 43.2 cm.)
 Library of Congress,
 Washington, D.C.

118. *Niagara, American Fall from the
 Foot of the Incline* ca. 1898–1908
 colored photo print
 8¼ x 10½ in. (20.9 x 26.7 cm.)
 Library of Congress,
 Washington, D.C.

119. *Horseshoe Fall from Table Rock*
 ca. 1898–1908
 colored photo print
 9 x 7 in. (22.9 x 17.8 cm.)
 Library of Congress,
 Washington, D.C.

120. *Niagara, Horseshoe Fall, II*
 ca. 1898–1908
 colored photo print
 9 x 7 in. (22.9 x 17.8 cm.)
 Library of Congress,
 Washington, D.C.

121. *Niagara, American Fall and Rock of
 Ages* ca. 1898–1908
 colored photo print
 9 x 7 in. (22.9 x 17.8 cm.)
 Library of Congress,
 Washington, D.C.

cat. no. 121

cat. no. 123

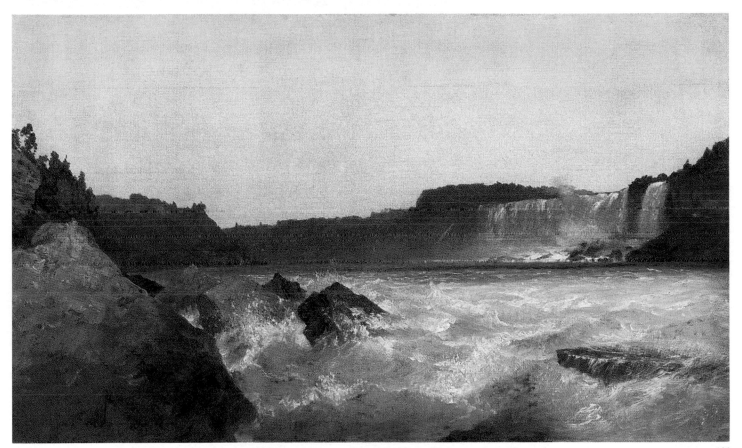

cat. no. 122

John F. Kensett 1818–1872

122. *Niagara Falls* ca. 1852
 oil on canvas
 13 x 21½ in. (33.0 x 54.6 cm.)
 The Denver Art Museum. Gift of
 Mr. and Mrs. H. Richard Williams.

123. *Suspension Bridge, Niagara Falls* 1857
 oil on canvas
 9¾ x 17½ in. (24.8 x 44.4 cm.)
 Thomas Colville Inc., New Haven,
 Connecticut

124. *Rapids Above Niagara* ca. 1857
 oil on board
 9 x 14 in. (22.9 x 35.6 cm.)
 Professor and Mrs. William B. Rhoads
 (fig. 40)

125. *Terrapin Tower, Niagara Falls* 1857
 oil on board
 9 x 14 in. (22.9 x 35.6 cm.)
 Professor and Mrs. William B. Rhoads
 (fig. 41)

See George W. Curtis (Books)

cat. no. 127 cat. no. 128

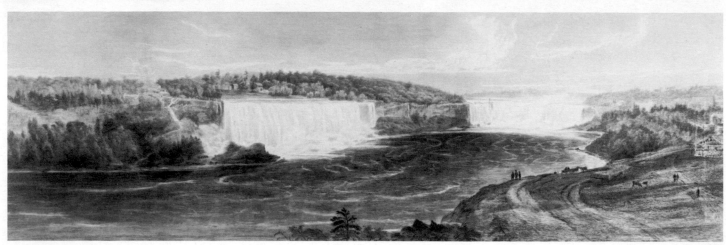

cat. no. 132

Frederick (1807–1874) and **William** (1809–1879) **Langenheim**

126. *Panorama of the Falls of Niagara* 1845
series of five daguerreotypes
12 x 18⅛ in. (30.5 x 46.2 cm.)
Gilman Paper Company Collection, New York, New York
(fig. 55)
(Corcoran Gallery of Art and New-York Historical Society)

127. *Niagara Falls, General View from Point View, Winter* 1855
stereoscopic glass
Local History Department, Niagara Falls, New York, Public Library

128. *Niagara Falls, General View from Point View, Summer* ca. 1856
stereoscopic glass
Local History Department, Niagara Falls, New York, Public Library

See A. de Vaudricourt

Sebastian Leclerc 1637–1714

129. *Elie enlevé dans un Char de Feu* 1700
etching
6½ x 11½ in. (16.5 x 29.2 cm.)
Royal Ontario Museum, Toronto, Canada
(fig. 4)

Noel Marie Paymal Lerebours 1807–1873

130. *Niagara, Chute du Fer à Cheval* 1841–43
(from a daguerreotype by H. L. Pattinson, n.d.)
aquatint etching
5¾ x 7¹⁵⁄₁₆ in. (14.6 x 20.0 cm.)
Buffalo and Erie County Historical Society, Buffalo, New York
(fig. 54)

Frederick Christian Lewis 1779–1856

131. *A View of the Westerly Branch of the Falls of Niagara Taken from the Table Rock, Looking Up the River, Over the Rapids* 1804
(after John Vanderlyn, 1775–1856)
aquatint engraving
21 x 30⅛ in. (53.3 x 76.4 cm.)
Public Archives of Canada, Ottawa
(fig. 13)

132. *General View of the Falls of Niagara* 1845
(after James Graham, active ca. 1845)
engraving
13¼ x 40⅝ in. (33.6 x 103.1 cm.)
Royal Ontario Museum, Toronto, Canada

Frederick W. Lock

See Edmund Walker

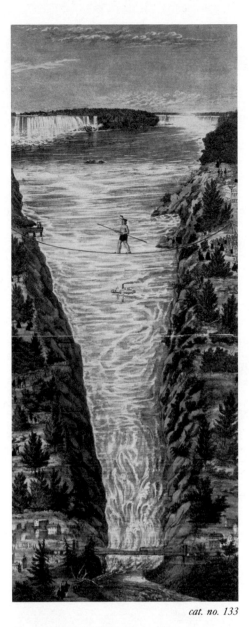

Charles Magnus & Co.

133. *Monsieur Blondin's Walk Across the
 Cataract* 1859
 color lithograph
 25¼ x 11½ in. (64.1 x 29.2 cm.)
 Library of Congress,
 Washington, D.C.
 (Albright-Knox Art Gallery and
 Corcoran Gallery of Art)

Samuel Mason active ca. 1860–65

134. *Niagara Falls—July 26th 1865 with
 Messrs. Medina, Pettis, Adams, Lawrence
 and Trott* 1865
 albumen print
 5¹⁵⁄₁₆ x 8¼ in. (15.0 x 20.9 cm.)
 Local History Department, Niagara
 Falls, New York, Public Library

Peter Maverick

See Theodore Dwight (Books)

J. Merigot n.d.

135. *A Distant View of the Falls of Niagara
 Including Both Branches with the Island,
 and Adjacent Shores, Taken from the
 Vicinity of the Indian Ladder* 1804
 (after John Vanderlyn, 1775–1852)
 aquatint engraving
 21 x 30⅛ in. (53.3 x 76.4 cm.)
 Public Archives of Canada, Ottawa
 (fig. 12)

Jacques Milbert

See Isidore-Laurent Deroy

Minott n.d.

136. *Niagara Falls* 1818
 oil on canvas
 30 x 40⅝ in. (76.2 x 103.1 cm.)
 Courtesy of The New-York Historical
 Society, New York, New York

Thomas Moran 1837–1926

137. *Cave of the Winds, Niagara* ca. 1881
 oil on paperboard
 20⅛ x 14⅛ in. (51.0 x 35.8 cm.)
 Anonymous Loan
 (fig. 66)

138. *Rapids above Niagara* 1885
 oil on canvas
 20¼ x 30¼ in. (51.4 x 76.8 cm.)
 Donald and Kathryn Counts
 (fig. 65)

John R. Murray

See William James Bennett

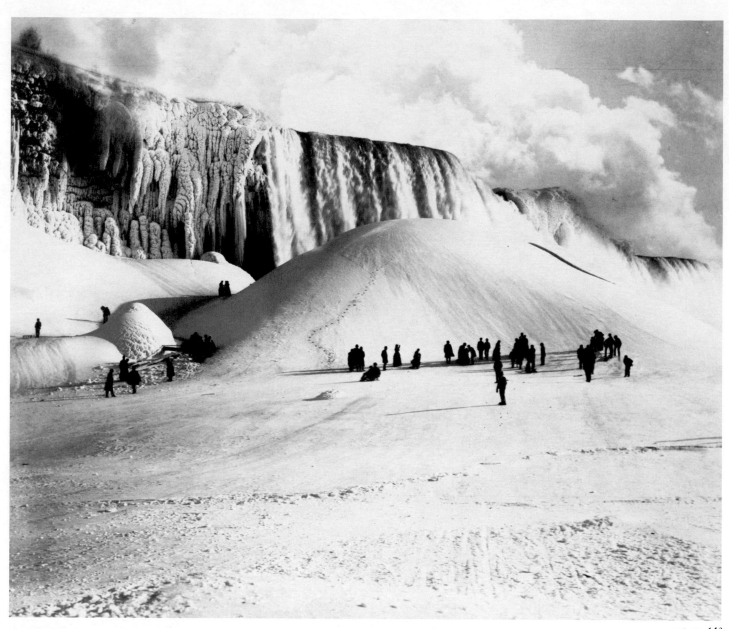

cat. no. 140

Nagel and Weingartner, Lithographers
active 1849–56

139. *Niagara Falls, American Side* 1855
(after John Bornet, n.d.)
color lithograph
27¾ x 28½ in. (70.5 x 72.4 cm.)
Courtesy of Kennedy Galleries,
New York, New York

Herman F. Nielson active after 1883

140. *View of Niagara Falls in Winter* 1885
albumen print
15½ x 18½ in. (39.4 x 47.0 cm.)
The J. Paul Getty Museum,
Malibu, California

H. L. Pattinson

See N. M. P. Lerebours

Lt. William Pierie

See William Byrne

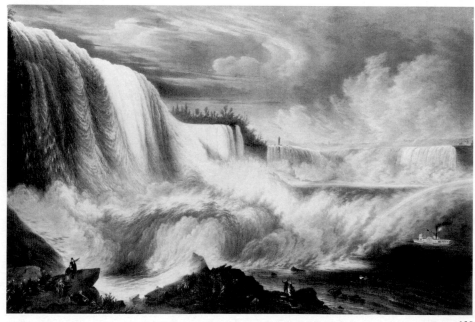

cat. no. 139

cat. no. 142

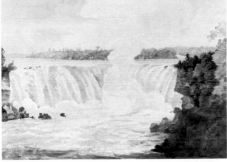

cat. no. 149

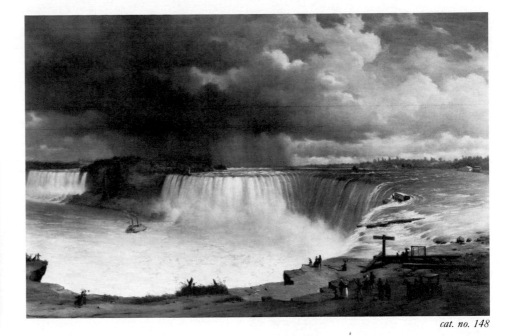

cat. no. 148

Ferdinand Richardt 1819–1895

141. *Niagara* ca. 1855
oil on canvas
25 x 33 in. (63.5 x 83.8 cm.)
Collection of The Heckscher
Museum, Huntington, New York
(fig. 51)

142. *Niagara Falls* 1856
oil on canvas
23⅞ x 34⁹⁄₁₆ in. (60.7 x 87.9 cm.)
The George F. McMurray Collection
at Trinity College, Hartford,
Connecticut

143. *Niagara Falls* 1856
oil on canvas
63 x 95 in. (160.0 x 241.3 cm.)
United States Department of State,
Diplomatic Reception Rooms,
Washington, D.C.
(fig. 53)

144. *Niagara Falls* ca. 1860
oil on canvas
56⅛ x 35⅜ in. (142.5 x 89.9 cm.)
Private Collection
(frontispiece)

See De Lay Glover

C. Risdon

145. *Under Niagara* ca. 1862
(after Frederic Edwin Church,
1826–1900)
chromolithograph over-painted by
the artist
17¼ x 30⅝ in. (43.8 x 77.7 cm.)
New York State, Office of Parks,
Recreation and Historical
Preservation, Bureau of Historic
Sites, Olana State Historic Site,
Taconic Region

Risdon & Day

146. *The Great Fall, Niagara* 1857
(after Frederic Edwin Church,
1826–1900)
chromolithograph
17 x 36½ in. (43.2 x 92.7 cm.)
Buffalo and Erie County Historical
Society, Buffalo, New York

Amos Sangster

See Amos Sangster (Books)

Fenner Sears & Co.

147. *A Distant View of the Falls of Niagara*
1831
(after Thomas Cole, 1801–1848)
engraving
4⅜ x 5½ in. (11.2 x 13.9 cm.)
Private Collection
(fig. 38)

Hippolyte Sebron 1801–1879

148. *View of Niagara Falls* 1850
oil on canvas
40 x 60½ in. (101.6 x 153.7 cm.)
Royal Ontario Museum, Toronto,
Canada

Elizabeth Posthuma Gwillim Simcoe 1762–1850

149. *Niagara Falls, Upper Canada*
ca. 1792–96
watercolor over pencil with scraping
out on laid paper
14 x 18 in. (35.6 x 45.7 cm.)
Public Archives of Canada, Ottawa
(Albright-Knox Art Gallery and
Corcoran Gallery of Art)

John P. Soule n.d.

150. *Cataract House, from Goat Island*
late 19th century
stereoscopic card
Private Collection

Josiah Johnson Hawes (1808–1901)
and **Albert Sands Southworth**
(1811–1894)

151. *Niagara Falls* n.d.
daguerreotype
8½ x 6½ in. (21.6 x 16.5 cm.)
The Metropolitan Museum of Art,
New York, New York. Gift of I. N.
Phelps Stokes, Edward S. Hawes,
Alice Mary Hawes and Marion
Augusta Hawes, 1937.

T. Taylor n.d.

See James Hamilton

cat. no. 150

cat. no. 151

John Trumbull 1756–1843

152. *Niagara Falls from an Upper Bank on
the British Side* 1807
oil on canvas
24⅜ x 36⁹⁄₁₆ in. (70.0 x 93.0 cm.)
Wadsworth Atheneum, Hartford,
Connecticut. Bequest of Daniel
Wadsworth.
(fig. 14)

153. *Niagara Falls from Below the Great
Cascade on the British Side* 1808
oil on canvas
24⁷⁄₁₆ x 36⅜ in. (62.0 x 92.4 cm.)
Wadsworth Atheneum, Hartford,
Connecticut. Bequest of Daniel
Wadsworth.
(fig. 15)

154. *Niagara Falls from Two Miles Below
Chippawa* 1808
oil on canvas
29 x 168 in. (73.7 x 426.7 cm.)
Courtesy of The New-York Historical
Society, New York, New York
(fig. 16)

155. *Niagara Falls from Under Table Rock*
1808
oil on canvas
29 x 168 in. (73.7 x 426.7 cm.)
Courtesy of The New-York Historical
Society, New York, New York
(fig. 17)

John H. Twachtman 1853–1902

156. *Niagara in Winter* ca. 1894
oil on canvas
30 x 25 in. (76.2 x 63.5 cm.)
New Britain Museum of American
Art, New Britain, Connecticut.
Harriet Russell Stanley Fund.
(fig. 72)
(Corcoran Gallery of Art)

157. *Niagara Falls* 1894
oil on canvas
30 x 25⅛ in. (76.2 x 63.7 cm.)
National Museum of American Art,
Smithsonian Institution,
Washington, D.C. Gift of John
Gellatly.
(fig. 73)

158. *Niagara Falls* ca. 1894
oil on canvas
30 x 30 in. (76.2 x 76.2 cm.)
Collection of Mr. and Mrs. Raymond
Horowitz
(fig. 83)
(Albright-Knox Art Gallery and
Corcoran Gallery of Art)

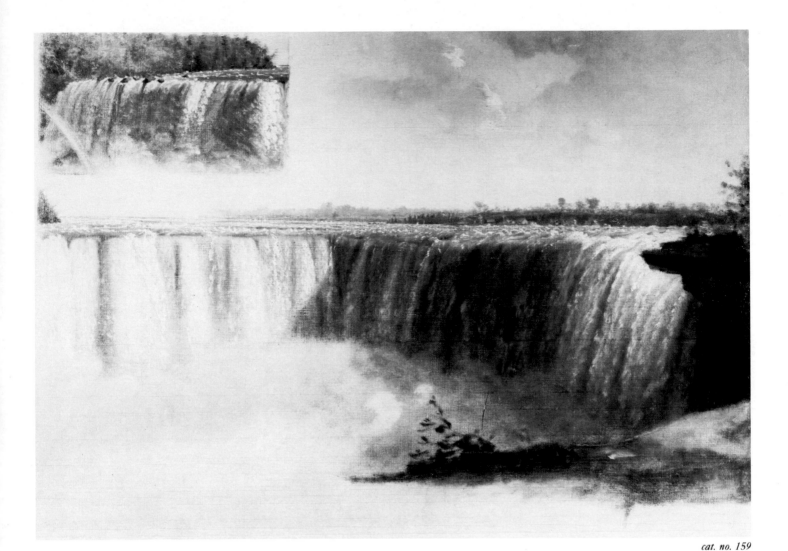

cat. no. 159

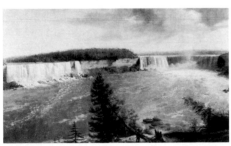

cat. no. 160

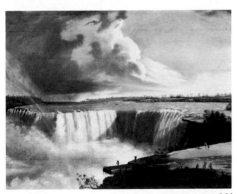

cat. no. 161

John Vanderlyn 1775–1852

159. Study for *Niagara Falls* ca. 1801
 oil on canvas
 18⅞ x 26½ in. (48.0 x 67.4 cm.)
 New York State Office of Parks,
 Recreation and Historic Preservation,
 Bureau of Historic Sites, Senate
 House State Historic Site, Palisades
 Region

160. *View of Niagara Falls* ca. 1803
 oil on canvas
 23½ x 39¼ in. (59.7 x 99.7 cm.)
 Albany Institute of History and Art,
 Albany, New York

161. *Niagara Falls from Table Rock*, n.d.
 (attributed to John Vanderlyn)
 oil on canvas
 24 x 30 in. (60.9 x 76.2 cm.)
 Museum of Fine Arts, Boston,
 Massachusetts, M. and M. Karolik
 Collection

162. *Niagara Falls from the Foot of the
 American Fall* ca. 1832
 (attributed to John Vanderlyn)
 oil on canvas
 84 x 60 in. (213.4 x 152.4 cm.)
 Private Collection
 (fig. 33)

163. *The Horseshoe Fall from Below Table
 Rock* ca. 1832
 (attributed to John Vanderlyn)
 oil on canvas
 84 x 60 in. (213.4 x 152.4 cm.)
 Private Collection
 (fig. 34)

See Frederick Christian Lewis
 J. Merigot

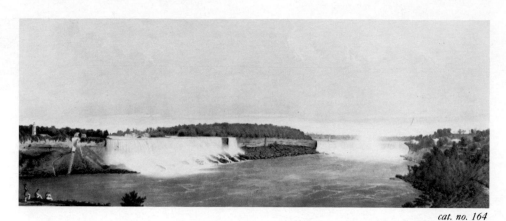

cat. no. 164

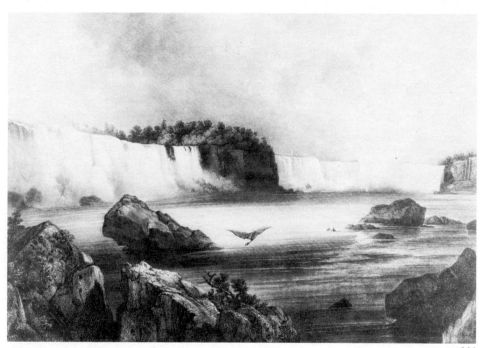

cat. no. 166

cat. no. 169

A. de Vaudricourt active 1845–46

164. *Panoramic View of Niagara Falls* 1846
(after daguerreotypes by Frederick
(1807–1874) and William (1809–1879)
Langenheim)
color lithograph
11¹⁵⁄₁₆ x 28¹¹⁄₁₆ in. (30.1 x 72.9 cm.)
Royal Ontario Museum, Toronto,
Canada

W. Vivian

See Thomas M. Baynes

Edmund Walker n.d.

165. *Niagara Falls. Summer View of the
American and Horseshoe Falls by
Moonlight* 1856
(after Frederick W. Lock, active
1843–60)
color lithograph
19¹⁄₆ x 30 in. (48.8 x 76.2 cm.)
The New York Public Library,
New York, New York
(fig. 43)

Lucas Weber 1811–1860

166. *Niagara Falls* 1843
(after Karl Bodmer, 1809–1893)
aquatint engraving
15¼ x 19½ in. (38.7 x 49.5 cm.)
Library of Congress,
Washington, D.C.
(Albright-Knox Art Gallery and
Corcoran Gallery of Art)

Adam Weingartner active 1849–56

167. *Niagara Falls. Canadian Side* 1856
(after Thomas Benecke, active
1855–56)
color lithograph
28¾ x 34¾ (73.0 x 88.3 cm.)
Buffalo and Erie County Historical
Society, Buffalo, New York
(fig. 93)

John Ferguson Weir 1841–1926

168. *Niagara Falls* 1871
oil on canvas
42¼ x 35⅛ in. (107.3 x 89.1 cm.)
Yale University Art Gallery, New
Haven, Connecticut. Gift of Dr.
Henry Moseley, B.A. 1894.

Isaac Weld

See Isaac Weld (Books)

M. H. Zahner n.d.

169. *Niagara. Assisting Mrs. Taylor Out of the
Barrel After Her Terrible Trip Over the
Falls* 1901
stereoscopic card
Local History Department, Niagara
Falls, New York, Public Library

Alexander Wilson

See Alexander Wilson (Books)

Richard Wilson

See William Byrne

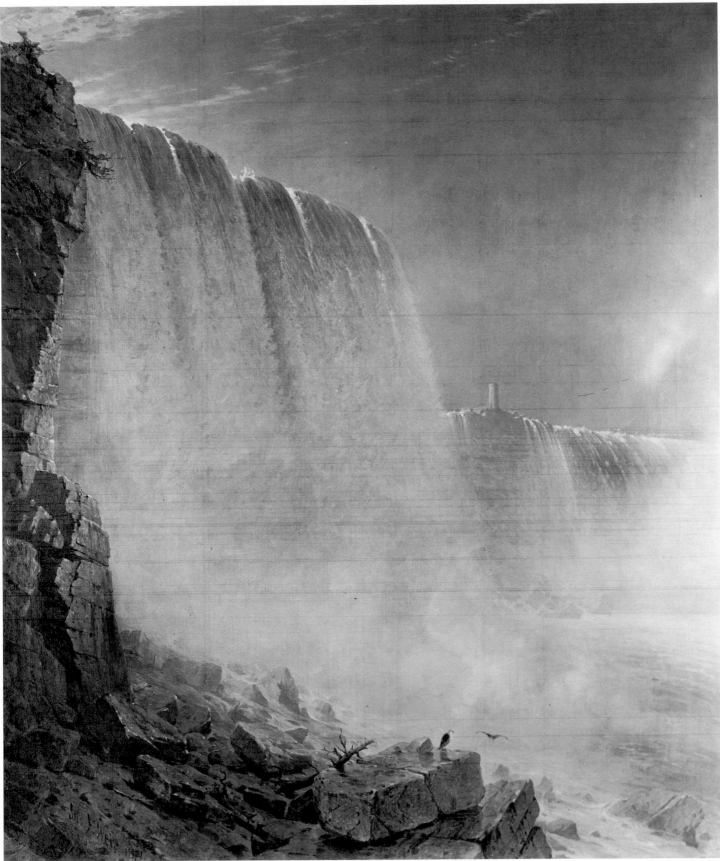

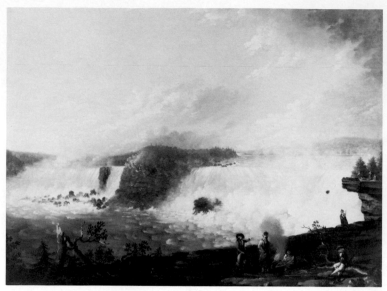

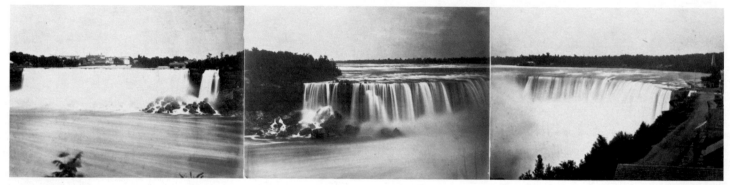

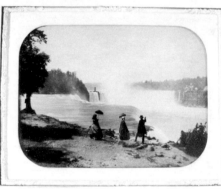

Unidentified

170. *Chute d'eau de Niagara* 1697
engraving, trimmed to plate or inside,
laid down
4⁹⁄₁₆ x 6½ in. (11.7 x 16.5 cm.)
Private Collection
(fig. 2)

171. *View of Niagara Falls* ca. 1780s
oil on canvas
27½ x 35¼ in. (69.8 x 89.5 cm.)
Kasper Gallery, Toronto, Canada

172. *An Emblem of America* 1800
mezzotint
12⅜ x 9¾ in. (31.5 x 24.7 cm.)
Print Collection, The New York
 Public Library, New York, New York;
 Astor, Lenox and Tilden Foundations
(fig. 77)

173. *An Emblem of America* 1809
(after P. Stampa, n.d.)
silk embroidery with paint and ink on
 cream satin
14¾ x 13¼ in. (37.5 x 33.6 cm.)
Mrs. Robert B. Stephens
(fig. 74)

174. *Two Ladies in Front of Backdrop of
 Niagara* late 19th century
tintype
3⁹⁄₁₆ x 2½ in. (9.1 x 6.3 cm.)
Local History Department, Niagara
 Falls, New York, Public Library

175. *The Heroes' Memorial*
lithograph
17 x 15 in. (43.2 x 38.1 cm.)
Buffalo and Erie County Historical
 Society, Buffalo, New York

176. *Niagara Falls* ca. 1890
albumen print in three parts
12¹⁵⁄₁₆ x 51¾ in. (32.8 x 131.4 cm.)
The J. Paul Getty Museum,
 Malibu, California

177. *View of Niagara Falls* mid-19th century
ambrotype
5½ x 7¼ in. (14.0 x 18.4 cm.)
Daniel Wolf, Inc., New York,
 New York

178. *Four Women Before the Falls*
late 19th century
albumen print
4⅛ x 6⅛ in. (10.4 x 15.5 cm.)
Private Collection

179. *Niagara from Point View* ca. 1860–73
stereoscopic card
Private Collection

180. *Goat Island Bridge* late 19th century
stereoscopic card
Private Collection
(fig. 85)

Books

181. *Album of the Table Rock, Niagara Falls and Sketches of the Falls and the Scenery Adjacent* 1851
Jewett, Thomas & Co., Buffalo, New York
The New-York Historical Society, New York, New York

182. **John Gardiner Calkins Brainard**
The Poems of John G. C. Brainard . . . 1846
S. Andrus & Son, Hartford, Connecticut
The New-York Historical Society, New York, New York

183. **William Cullen Bryant**
Picturesque America; or, the Land We Live In (2 vols.) 1872–74
D. Appleton and Co., New York, New York
Frontispiece in volume I by S. V. Hunt.
The Corcoran Gallery of Art, Washington, D.C.

184. **Robert Burford**
Description of a View of the Falls of Niagara, Now Exhibiting at the Panorama . . . 1833
T. Bartell, London
Brock University Library, St. Catharines, Ontario, Canada
(fig. 31)

185. **Andrew Burke**
Burke's Descriptive Guide; or, the Visitors' Companion to Niagara Falls . . . 1853
Andrew Burke, Buffalo, New York
Buffalo and Erie County Historical Society, Buffalo, New York

186. **George W. Curtis**
Lotus-Eating: A Summer Book 1852
Harper & Brothers, New York, New York
Illustrated by John F. Kensett
The New-York Historical Society, New York, New York

187. **Samuel de Veaux**
The Falls of Niagara; or, Tourist's Guide to this Wonder of Nature. 1839
William B. Hayden, Buffalo, New York
Local History Department, Niagara Falls, New York, Public Library

188. **William Dunlap**
A Trip to Niagara: or, Travellers in America . . . 1830
E. B. Clayton, New York
The New-York Historical Society, New York, New York

189. **Theodore Dwight**
The Northern Traveller: Containing the Routes to Niagara, Quebec, and the Springs . . . 1825
Wilder & Campbell, New York, New York
Frontispiece by Peter Maverick
The New-York Historical Society, New York, New York

190. **Timothy Dwight**
Travels in New England and New York (4 vols) 1822
Timothy Dwight, New Haven, Connecticut (vol. IV)
The New-York Historical Society, New York, New York

191. *The Falls of Niagara: Being a Complete Guide to all the Points of Interest . . .* 1860
T. Nelson & Sons, London, Edinburgh and New York
The New-York Historical Society, New York, New York

192. **J. W. Ferree**
The Falls of Niagara and the Scenes Around Them 1876
A. S. Barnes & Co., New York, New York
Local History Department, Niagara Falls, New York, Public Library

193. **Linda deK. Fulton**
Nadia: The Maid of the Mist 1901
White-Evans-Penfold Co., Buffalo, New York
Buffalo and Erie County Historical Society, Buffalo, New York

194. **James T. Gardner**
Special Report of the New York State Survey on the Preservation of the Scenery of Niagara Falls . . . 1880
Charles Van Benthuysen, Albany, New York
Local History Department, Niagara Falls, New York, Public Library
(fig. 106, 107)

195. **James W. Greene**
Free Niagara: Nature's Grandest Wonder, New-York's Imperial Gift to Mankind 1885
Matthews-Northrup & Co., Buffalo, New York
Buffalo and Erie County Historical Society, Buffalo, New York

196. **Basil Hall**
Forty Etchings from Sketches Made with the Camera Lucida, in North America, in 1827 and 1828 (4th ed.) 1830
Cadell & Co., Edinburgh; Simpkin & Marshall, and Moon, Boys, & Graves, London
The New-York Historical Society, New York, New York

197. **R. P. Louis Hennepin**
A New Discovery of a Vast Country in America . . . 1698
Printed for M. Bentley, J. Tonson, H. Bonwick, T. Godwin, and S. Manship, London.
Local History Department, Niagara Falls, New York, Public Library

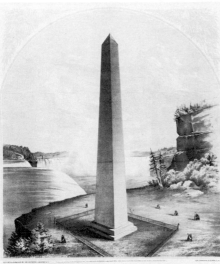

cat. no. 175

198. **George Heriot**
Travels Through the Canadas . . . 1807
Richard Phillips, London
Illustrated by George Heriot
The New-York Historical Society,
New York, New York
(fig. 18)

199. **John Howard Hinton,** ed.
*The History and Topography of the United
States of North America* (2 vols)
1830–32
Simpkin & Marshall, London;
Thomas Wardle, Philadelphia
Frontispiece in volume II by
Thomas Cole
The New-York Historical Society,
New York, New York

200. **George W. Holley**
*The Fall of Niagara: With Supplementary
Chapters on the Other Famous Cataracts
of the World* 1883
A. C. Armstrong, New York,
New York
Private Collection

201. **William S. Hunter, Jr.**
*Hunter's Panoramic Guide from Niagara
Falls to Quebec* 1857
John P. Jewett & Co., Boston; Henry
P. Jewett, Cleveland
Local History Department, Niagara
Falls, New York, Public Library
(fig. 94)

202. **Joseph Wentworth Ingraham**
*A Manual for the Use of Visiters [sic]
to the Falls of Niagara* . . . 1834
Joseph W. Ingraham, Buffalo,
New York
Local History Department, Niagara
Falls, New York, Public Library

203. **F. H. Johnson**
*Every Man His Own Guide at Niagara
Falls* 1852
D. M. Dewey, Rochester, New York
Local History Department, Niagara
Falls, New York, Public Library

204. **Peter Kalm**
"A Letter from Mr. Kalm, a
Gentleman of Sweden, now on his
Travels in America, to his friend in
Philadelphia, containing a particular
Account of the Grat [sic] Fall of
Niagara." *Gentleman's Magazine* (vol.
XXI) January 1751
The New-York Historical Society,
New York, New York
(fig. 75)

205. *The Niagara Book: A Complete Souvenir
of Niagara Falls* . . . 1893
Underhill and Nichols, Buffalo,
New York
Local History Department, Niagara
Falls, New York, Public Library

206. *Niagara through the Stereoscope* 1900
Underwood & Underwood, New York
and London
Local History Department, Niagara
Falls, New York, Public Library

207. **Myron T. Pritchard,** ed.
Poetry of Niagara 1901
Lothrop Publishing Company, Boston
Private Collection

208. **Amos Sangster**
*Niagara River and Falls from Lake Erie
to Lake Ontario* 1886–88
(edited by James W. Ward, vol. I,
sec. 5, Remarque Edition)
Thomas T. Fryer, Buffalo, New York
Illustrated by Amos Sangster
Local History Department, Niagara
Falls, New York, Public Library

209. **Lydia H. Sigourney**
Scenes in My Native Land 1847
T. Allman, London
The New-York Historical Society,
New York, New York

210. **Thomas Tugby**
*Tugby's Illustrated Guide to Niagara
Falls* 1890
Thomas Tugby, Niagara Falls,
New York
Private Collection

211. **W. E. Tunis**
*Tunis's Topographical and Pictorial Guide
to Niagara* . . . 1855
W. E. Tunis, Niagara Falls, New York
Local History Department, Niagara
Falls, New York, Public Library

212. **Isaac Weld**
*Travels Through the States of North
America, and the Provinces of Upper and
Lower Canada, During the Years 1795,
1796, and 1797* (2 vols) 1799
John Stockdale, London
Volume I illustrated by Isaac Weld
The New-York Historical Society,
New York, New York
(fig. 10)

213. **Nathaniel P. Willis**
*American Scenery: or, Land, Lake, and
River Illustrations of Transatlantic
Nature* (2 vols.) 1840
G. Virtue, London; R. Martin, New
York, New York
Volume I illustrated by William Henry
Bartlett
The New-York Historical Society,
New York, New York
(figs. 28, 90)

214. **Alexander Wilson**
"The Foresters: a Poem . . ." *Port
Folio* (vol. III, no. 3) March 1810
Illustrated by Alexander Wilson
The New-York Historical Society,
New York, New York

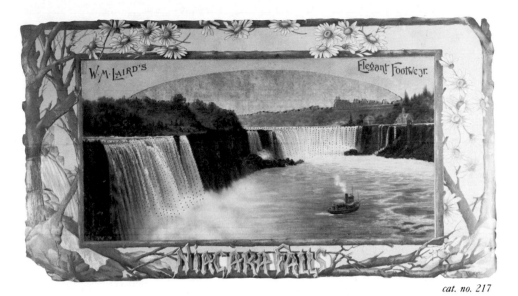

cat. no. 217

cat. no. 216

Advertisements

215. *Samuel Hooker as Guide* ca. 1834
Buffalo and Erie County Historical
Society, Buffalo, New York
(fig. 23)

216. *Oldridge's Balm of Columbia for
Restoring Hair* 1838
Library of Congress,
Washington, D.C.
(Albright-Knox Art Gallery and
Corcoran Gallery of Art)

217. *W. M. Laird's Elegant Footware* 1892
Local History Department, Niagara
Falls, New York, Public Library

218. *Annual Excursion of the First and Second
Free Baptist Sunday Schools to Niagara
Falls* late 19th century
Buffalo and Erie County Historical
Society, Buffalo, New York

219. *The New York Advertising Sign Co.*
late 19th century
Staples & Charles, Washington, D.C.

ANNUAL
EXCURSION
OF THE
First and Second Free Baptist
SUNDAY SCHOOLS
TO
NIAGARA FALLS

Fare for round trip ✸ ✸ ✸
50 cts.
CHILDREN
UNDER TWELVE **25 CTS.**

Tuesday, July 21st
IS THE DAY.

BE on hand at N. Y. C. Depot, Exchange Street, at
10 o'clock sharp. For the convenience of those
unable to reach the Depot, the train will stop, both
going and returning, at Terrace Station, Porter Ave.,
Ferry St. and Black Rock. There will be plenty of
room and a seat for everybody.
Every arrangement is made for the convenience
and comfort of all who go with us. The Hood Bros.
will accompany the excursion, as usual, with an abun-
dant supply of REFRESHMENTS of all kinds which
will be on sale on the grounds at reasonable rates.

Tickets can be had of the members and at the train.

cat. no. 218

cat. no. 230

cat. no. 229

Brochures

220. *Niagara Falls, N.Y., Goat Island Group*
1873–85
Buffalo and Erie County Historical
Society, Buffalo, New York

221. *Official Programme of the Opening of the
State Reservation at Niagara Falls,
N.Y., Wednesday, July 15, 1885*
Buffalo and Erie County Historical
Society, Buffalo, New York

222. *Map and Guide of the New York State
Reservation at Niagara* ca. 1888
Courier Lithographs Co.
Local History Department, Niagara
Falls, New York, Public Library
(fig. 105)

223. *Queen Victoria Niagara Falls Park*
before 1898
Buffalo and Erie County Historical
Society, Buffalo, New York

224. *Canadian Scenic Route Niagara Falls
Park & River Railway* ca. 1900
Buffalo and Erie County Historical
Society, Buffalo, New York
(fig. 108)

225. *Maid of the Mist Steamboat Company*
ca. 1900
Buffalo and Erie County Historical
Society, Buffalo, New York

226. *Buffalo and Niagara Falls, The Coming
Industrial Center of the United States,
Electricity the Power, Niagara the Source*
1904
Buffalo and Erie County Historical
Society, Buffalo, New York

Maps

227. Herman Moll
*A New and Exact Map of the Dominions
of the King of Great Britain on Ye
Continent of North America* 1715
engraving
25 x 41 in. (62.0 x 103.0 cm.)
Library of Congress,
Washington, D.C.
(fig. 3)

228. H. Wellge
Niagara Falls, N.Y. 1882
lithograph
17⁵⁄₁₆ x 29⅛ in. (44.0 x 74.0 cm)
Library of Congress,
Washington, D.C.

cat. no. 231

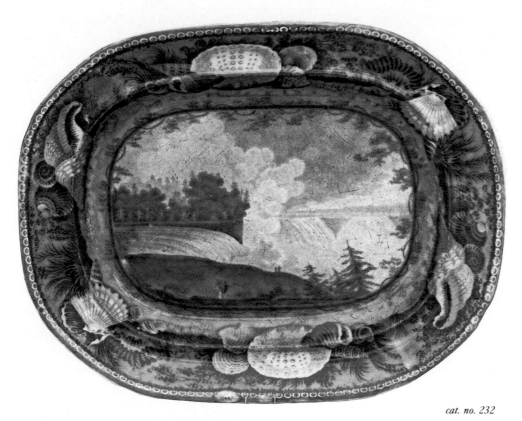

cat. no. 232

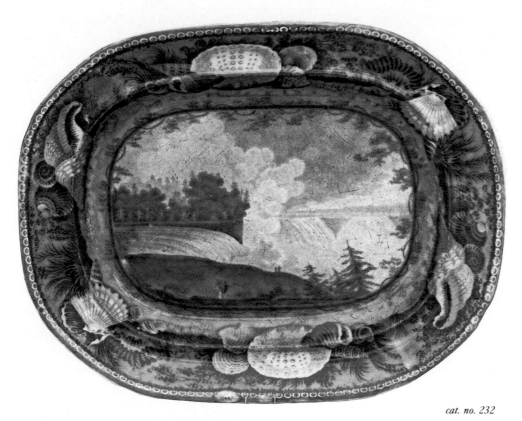

cat. no. 235

Objects

229. Glass Cup Plate (The *Maid of the Mist*
 and Suspension Bridge) ca. 1855
 Boston and Sandwich Glass Co.
 glass
 diameter: 3½ in. (8.9 cm.)
 Courtesy of The New-York Historical
 Society, New York, New York

230. Niagara Branch Biscuit Box 1892
 wood, metal, paper
 11 x 11 x 19 in. (27.9 x 27.9 x 48.3 cm.)
 Nabisco Brands Inc., Archivist,
 Parsippany, New Jersey

231. Niagara State Reservation
 Commemorative Medal 1885
 base metal
 diameter: 1¼ in. (3.2 cm.)
 Buffalo and Erie County Historical
 Society, Buffalo, New York

232. Oval Platter (Niagara from the
 American side) ca. 1829–46
 Enoch Wood and Sons, Staffordshire,
 England
 glazed pottery
 14⅞ x 11⅝ in. (37.8 x 29.5 cm.)
 The Metropolitan Museum of Art,
 New York, New York. Bequest of
 Mrs. Mary Mandeville Johnston,
 1914.

233. Pin Cushion late 19th century
 muslin and glass beads
 5¾ x 3⅞ in. (14.6 x 9.9 cm.)
 Iroquois Brands Ltd. Collection,
 Greenwich, Connecticut
 (fig. 101)

234. Plate (Table Rock, Niagara)
 ca. 1829–46
 Enoch Wood and Sons, Staffordshire,
 England
 glazed pottery, transfer decoration
 diameter: 10¼ in. (26.0 cm.)
 Courtesy of The New-York Historical
 Society, New York, New York

235. Purse ca. 1890
 cotton, glass beads, embroidery
 7⁵⁄₁₆ x 3⁹⁄₁₆ in. (18.5 x 9.0 cm.)
 Collections of The Strong Museum,
 Rochester, New York

236. Purse with Flap late 19th century
 cardboard, twill, glass beads
 3¼ x 5½ in. (8.2 x 14.0 x 5.0 cm.)
 Iroquois Brands Ltd. Collection,
 Greenwich, Connecticut
 (fig. 101)

237. Souvenir Spoon ca. 1891
 sterling silver
 4¼ in (10.8 cm.)
 Iroquois Brands Ltd. Collection,
 Greenwich, Connecticut

238. Souvenir Spoon ca. 1900
 H. Glenny, Sons & Co.
 sterling silver
 4⅛ in. (10.4 cm.)
 Iroquois Brands Ltd. Collection,
 Greenwich, Connecticut

cat. no. 247

cat. no. 245, 246, 239

cat. no. 253

Post Cards

239. *Niagara Falls* 1893
 Local History Department, Niagara
 Falls, New York, Public Library

240. *Niagara Falls* 1897
 Local History Department, Niagara
 Falls, New York, Public Library

241. *Horseshoe Fall Canada* 1898
 Local History Department, Niagara
 Falls, New York, Public Library

242. *Niagara Falls* 1898
 Local History Department, Niagara
 Falls, New York, Public Library

243. *Niagara Falls. American Fall from Goat
 Island* 1898
 Local History Department, Niagara
 Falls, New York, Public Library

244. *Niagara Falls by Moonlight* 1898
 Local History Department, Niagara
 Falls, New York, Public Library

245. *Niagara Falls, N.Y.* (Rock of Ages)
 1898
 Local History Department, Niagara
 Falls, New York, Public Library

246. *Whirlpool Rapids and Capt. Webb* 1898
 Local History Department, Niagara
 Falls, New York, Public Library

Sheet Music

247. Sarony and Major
 Table Rock Schottisch ca. 1850
 color lithograph
 Public Archives of Canada, Ottawa

248. Sadie Koninsky
 Maid of the Mist Waltzes ca. 1900
 lithograph
 Koninsky Music Co.
 Private Collection

Miscellaneous

249. Certificate for Passing Beneath Table
 Rock, and Behind the Great Falling
 Sheet, Under the Falls of Niagara, to
 Termination Rock 1830
 Buffalo and Erie County Historical
 Society, Buffalo, New York
 (fig. 99)

250. Cave of the Winds Certificate 1855
 Buffalo and Erie County Historical
 Society, Buffalo, New York

251. Bath Island Register 1856–57
 Local History Department, Niagara
 Falls, New York, Public Library
 (fig. 88)

252. Prospect House Autograph Book
 (vol. A)
 Local History Department, Niagara
 Falls, New York, Public Library
 (fig. 89)

253. Bill of Fare, Cataract House
 mid-19th century
 Buffalo and Erie County Historical
 Society, Buffalo, New York

Lenders to the Exhibition

Albany Institute of History and Art, New York
Albright-Knox Art Gallery, Buffalo, New York
The Art Institute of Chicago, Illinois
Art Gallery, Ball State University, Muncie, Indiana
Sewell C. Biggs Collection
Brock University Library, St. Catharines, Canada
Buffalo and Erie County Historical Society, Buffalo, New York
Buscaglia-Castellani Art Gallery of Niagara University, Dr. and Mrs.
 Armand J. Castellani Collection, Niagara Falls, New York
Thomas Colville, Inc., New Haven, Connecticut
Cooper-Hewitt Museum, Smithsonian Institution, New York, New York
The Corcoran Gallery of Art, Washington, D.C.
Donald and Kathryn Counts
Cranbrook Academy of Art Museum, Bloomfield Hills, Michigan
The Denver Art Museum, Colorado
The J. Paul Getty Museum, Malibu, California
The Thomas Gilcrease Institute of American History and Art, Tulsa,
 Oklahoma
Gilman Paper Company Collection, New York, New York
The Heckscher Museum, Huntington, New York
The High Museum of Art, Atlanta, Georgia
Hirshhorn Museum and Sculpture Garden, Smithsonian Institution,
 Washington, D.C.
Mr. and Mrs. Raymond Horowitz
Iroquois Brands Ltd. Collection, Greenwich, Connecticut
Kaspar Gallery, Toronto, Canada
Kennedy Galleries, New York, New York
Library of Congress, Washington, D.C.
Local History Department, Niagara Falls, New York, Public Library
The Metropolitan Museum of Art, New York, New York
The Montclair Art Museum, New Jersey
Museum of Fine Arts, Boston, Massachusetts
Museum of Fine Arts, Springfield, Massachusetts
Nabisco Brands Inc., Parsippany, New Jersey
The National Gallery of Canada, Ottawa
National Museum of American Art, Smithsonian Institution,
 Washington, D.C.
The New Britain Museum of American Art, Connecticut
The Newington Cropsey Foundation, Greenwich, Connecticut
The New-York Historical Society, New York, New York
The New York Public Library, New York, New York
New York State Office of Parks, Recreation and Historic Preservation,
 Waterford, New York

Norton Gallery and School of Art, West Palm Beach, Florida
The Charles Rand Penney Collection
Private Collections
Mr. and Mrs. Meyer P. Potamkin
Public Archives of Canada, Ottawa
Professor and Mrs. William B. Rhoads
Royal Ontario Museum, Toronto, Canada
Smith College Museum of Art, Northampton, Massachusetts
Ira Spanierman Gallery, Inc., New York, New York
Staples & Charles, Washington, D.C.
Mrs. Robert B. Stephens
Mr. and Mrs. George Strichman
The Strong Museum, Rochester, New York
Trinity College, The George F. McMurray Collection, Hartford, Connecticut
United States Department of State, Diplomatic Reception Rooms, Washington, D.C.
U.S. Senate Collection, Washington, D.C.
Wadsworth Atheneum, Hartford, Connecticut
Wake Forest University, Winston-Salem, North Carolina
The West Foundation, Atlanta, Georgia
Daniel Wolf, Inc., New York, New York
Wunderlich & Company, Inc., New York, New York
Yale University Art Gallery, New Haven, Connecticut

Index